T0140396

Computational Synthesis and Creative Systems

Series Editors

François Pachet, Laboratoire d'Informatique de Paris (LIP 6), Sony Computer Science Laboratory, Paris, France

Pablo Gervás, Director, NIL Research Group, Universidad Complutense de Madrid, Madrid, Spain

Andrea Passerini, DISI, Università di Trento, Trento, Italy

Mirko Degli Esposti, Dipartimento di Matematica, Università di Bologna, Bologna, Italy

Creativity has become the motto of the modern world: everyone, every institution, and every company is exhorted to create, to innovate, to think out of the box. This calls for the design of a new class of technology, aimed at assisting humans in tasks that are deemed creative.

Developing a machine capable of synthesizing completely novel instances from a certain domain of interest is a formidable challenge for computer science, with potentially ground-breaking applications in fields such as biotechnology, design, and art. Creativity and originality are major requirements, as is the ability to interact with humans in a virtuous loop of recommendation and feedback. The problem calls for an interdisciplinary perspective, combining fields such as machine learning, artificial intelligence, engineering, design, and experimental psychology. Related questions and challenges include the design of systems that effectively explore large instance spaces; evaluating automatic generation systems, notably in creative domains; designing systems that foster creativity in humans; formalizing (aspects of) the notions of creativity and originality; designing productive collaboration scenarios between humans and machines for creative tasks; and understanding the dynamics of creative collective systems.

This book series intends to publish monographs, textbooks and edited books with a strong technical content, and focuses on approaches to computational synthesis that contribute not only to specific problem areas, but more generally introduce new problems, new data, or new well-defined challenges to computer science.

More information about this series at http://www.springer.com/series/15219

Mahsoo Salimi

Swarm Systems in Art and Architecture

State of the Art

 Springer

Mahsoo Salimi
Metacreation Lab for Creative AI
School of Interactive Arts and Technology (SIAT)
Simon Fraser University (SFU)
Surrey, BC, Canada

ISSN 2509-6575 ISSN 2509-6583 (electronic)
Computational Synthesis and Creative Systems
ISBN 978-981-16-4359-0 ISBN 978-981-16-4357-6 (eBook)
https://doi.org/10.1007/978-981-16-4357-6

This Springer imprint is published by the registered company Springer Nature Singapore Pte Ltd.
The registered company address is: 152 Beach Road, #21-01/04 Gateway East, Singapore 189721,
Singapore

Foreword

Swarm simulations are a paradigmatic example of a bottom-up modelling approach, in which rich and diverse phenomena can be synthetically obtained by implementing local interactions among simple entities. Since the invention of the *Boids* algorithm by Craig Reynolds in 1986, these types of simulations have made great inroads into various artistic domains. Here, these simulations have been adopted as generative systems that shape how media are created and/or how the audience can engage with an artwork.

The reasons for the popularity of these simulations are likely as manifold as there are different artistic approaches. Nevertheless, when looking at both past and current swarm-based artworks, some recurring topics can be identified. These topics revolve around aspects of naturalness, interaction, immersion, adaptability.

Naturalness
Swarms are a fascinating and universal natural phenomenon. Using swarm simulations, artists can endow their creations with a behaviour and appearance that is reminiscent of nature, which captivates audiences and viewers.

Interaction
Swarms are social systems in which the interplay between individuals and groups is the most prominent aspect. The role of individuals in a swarm can be assumed by simulated entities, robotic objects or humans. Therefore, swarms lend themselves to the establishment of interactive scenarios in which artwork and audiences engage with each other through social principles.

Immersion
Swarms are inherently spatial phenomena. Accordingly, they are particularly suitable for presentation formats which emphasize spatial aspects of experience and engagement. In such a spatial setting, the audience is surrounded by a swarm. This creates an immersive experience of perception and possibly interaction.

Adaptability
Swarm simulations can easily be modified by altering and/or adding agent properties and behaviours. Therefore, swarm simulations are flexible artistic tools that can be adapted to create different types of media or different interaction scenarios.

The artistic use of swarm simulations will likely continue to play an important role in the art world. Ongoing science and engineering research has the potential to deepen existing artistic approaches and inspire new forms of artistic experimentation. For example, Fan et al. (2018) employ a swarm of mobile devices to perform collaborative computation of sensory data streams. This approach opens the possibility of exploiting the ubiquity of smart phones as personalized and decentralized computers for the purpose of deepening the connection between swarm-like behaviours of humans and the computational simulation of swarms. This in turn would allow for the creation of interactive situations in which participants engage as hybrid entities that exhibit partially natural and partially synthetic swarm behaviours.

Swarm principles can also be used to explain cultural phenomena such as the formation and propagation of opinions in social media (e.g. Kaiser et al., 2011). This extension into the cultural domain opens up the possibility for artists to employ swarm simulations to explore such things as the spread of cultural memes or the trending of artistic styles.

Recent advances in machine learning have also been used in the context of swarm simulations. Hüttenrauch et al. (2019) employed deep reinforcement learning to develop swarm simulations that exhibit more complex collective behaviours than their conventional counterparts. In a similar vein, machine learning could also achieve more complex forms of interactions between audiences and swarm artworks. This could include interactions that adapt over time to the specifics of a particular exhibition situation.

Moreover, progress in the field of virtual and augmented reality both with respect to technology and the authoring of content is offering new opportunities for working with immersion. A recent and swarm-specific example of this approach is *Boidance* (Caporal et al., 2020), a software tool. This tool combines dance performance and swarm simulations with the use of virtual reality. It will be interesting to see how artists explore virtual reality to expand the level of immersion for swarm artworks.

March 2021 Daniel Bisig
Institute for Computer Music and Sound
Technology (ICST), Zurich University of the Arts
(ZHdK.ch), Zürich, Switzerland

References

Caporal, C. (2020). *Software expanding dance using virtual reality, BOIDs and genetic algorithms.*
Fan, S., Salonidis, T., & Lee, B. (2018, July). Swing: Swarm computing for mobile sensing. In *2018 IEEE 38th International Conference on Distributed Computing Systems (ICDCS)* (pp. 1107–1117). IEEE.
Hüttenrauch, M., Adrian, S., & Neumann, G. (2019). Deep reinforcement learning for swarm systems. *Journal of Machine Learning Research, 20*(54), 1–31.

Kaiser, C., Piazza, A., Krockel, J., & Bodendorf, F. (2011, October). Are humans like ants? Analyzing collective opinion formation in online discussions. In *2011 IEEE Third International Conference on Privacy, Security, Risk and Trust and 2011 IEEE Third International Conference on Social Computing* (pp. 266–273). IEEE.

Preface

Swarm intelligence is widely used in optimization and robotics but less so in the domains of art and architecture. State-of-the-art swarm systems in an artistic and architectural context are described. The growing interest in multi-agent systems inspired by natural ecosystems with a focus on social colonies is also explored. Swarm artworks and architectural projects are reviewed, and their underlying algorithms, presentation details and interaction strategies are explained. A systematic category with four dimensions is proposed which includes Architecture (Agent Architecture, System Dynamic and audience interaction), Model (Features and Principles), System Output, and Presentation Format. With this lens, more than one-hundred artworks that employ swarm intelligence, dating from 2000 to 2021, are examined. Insights, challenges and potentials for swarm art and architecture are identified.

Keywords State of the art · Taxonomy · Swarm Intelligence · Multi-agent System · Swarm System · Ecosystem Art · BOID · Flocking · Emergence

Motivation

Swarm systems inspired by swarm intelligence and natural ecosystems (i.e. birds flocking, ants foraging) present unique frontiers for art and architecture. Many artists and architects have applied swarm systems in their practice and utilized swarm principles such as indirect communication, self-organization and emergent behaviours to create new aesthetics.

Bornhofen et al. (2012) explored swarm intelligence in the context of artistic creation as part of the growing interest in ecosystem art. Similarly, Greenfield and Machado (2014), curators at the Leonardo Swarm Art Gallery, described some of the historical highlights of the use of swarm systems for art and introduced a broad range of techniques for swarm art.

However, to my knowledge there is no comprehensive taxonomy of the application of swarm systems in art and architecture. This book surveys state-of the-art artistic and architectural swarm practices. I describe the scientific context of the swarm

systems and the technical details, and provide examples showcasing existing and potential applications.

Organization of Book

In this book, I consider the complex landscape of swarm and its applications in art and architecture from different perspectives as shown in Fig. 1. First, I explain swarm intelligence and its characteristics, and review some of the basic concepts. In Chap. 2, I examine swarm architecture by exploring agent interaction (internal interaction) and the system dynamic (external interaction). I then review audience interaction and its influence on the overall outcome of the system. In Chap. 3, I explore the underlying concepts, principles, and commonly used algorithms in artistic and architectural practices. I continue the discussion by giving an overview of swarm system outputs in Chap. 4 and their presentation formats in Chap. 5. In Chap. 6, I discuss the challenges and potential of swarm systems and give an overview of future applications. I conclude with a comprehensive taxonomy of the reviewed projects (Tables 7.1 and 7.2) and a detail analysis of their features in the Index Section.

Contribution

I examine the use of swarm systems in art and architecture and explain pioneering works from each presented category. I emphasize the impact of swarm dynamics on the overall system for the selected works which resulted in interaction(s), architecture and unique output(s). It would be over-whelming to trace the history of all swarm systems in art and architecture and consider existing works. Hence, I only highlight the more recent and unique pieces.

Surrey, Canada Mahsoo Salimi

References

Greenfield, G., & Machado, P. (2014). Swarm art. *Leonardo, 47*(1), 5–7.
Bornhofen, S., Gardeux, V., & Machizaud, A. (2012). From swarm art toward ecosystem art. *International Journal of Swarm Intelligence Research (IJSIR), 3*(3), 1–18.

MODEL

FEATURES

MODELS

·STIGMERGY
- Pheromones
- Primitive Pheromones
- Multiple Pheromones
- Complex Environments

·FLOCKING
- ISO Flock
- ISO Synth

·FORAGING
- Seed Foraging
- Sand Grain Foraging

·OTHER ALGORITHMS
- Swarm Grammar
- Intrinsic Adaptive Curiosity Model (swarm-like)

COMMONLY USED ALGORITHMS

·BOIDS
·ANT SYSTEM (AS)
·ANT COLONY OPTIMIZATION (ACO)
·PARTICLE SWARM OPTIMIZATION (PSO)
·STOCHASTIC DIFFUSION SEARCH (SDS)
·KOHONANTS (KANTS)

INTERACTION

AGENT ARCHITECTURE (INTERNAL)
- Reactive
- Deliberative
- Cognitive
- BDI
- Layered/Hybrid

SYSTEM DYNAMIC (EXTERNAL)
- Static
- Dynamic/Passive
- Dynamic/Interactive

AUDIENCE

ACTIVE

PASSIVE

OUTPUT

VISUAL
- Digital Drawing
- Image Rendering
- Drawing and Painting
- Visual Map

MOVING IMAGES

AUDIO
- Music Composition
- Music Improvisation

AUDIOVISUAL

STRUCTURAL
- Robotic Sculptures
- Robotic Constructions

MODELING (FORM FINDING)

OTHER

FORMAT

SOUNDSCAPE/ SONIC ECOSYSTEM

VISUALIZATION TOOL

INSTALLATION
- Visual Installation
- Audio Installation
- Multisensory Installation
- Light Installation

PERFORMANCE, DANCE & CHOREOGRAPHY
- Performance
- Dance
- Choreography

SCULPTURE
- Kinetic Sculpture

PAVILION

ECOSYSTEM
- Adaptive Ecologies
- Liminal Responsive Architecture (swarm-like)

SWARM TECTONIC & SWARM URBANISM

Fig. 1 Taxonomy of artistic and architectural swarm systems (courtesy of the author)

Contents

Acronyms

ACO	Ant Colony Optimization
ACS	Ant Colony System
AS	Ant System
ASI	Artificial Swarm Intelligence
BS	Bee System
CBLA	Curiosity-based Learning Algorithm
CD-MISFA	Curiosity-Driven Modular Incremental Slow Feature Analysis
EAs	Evolutionary Algorithms
GAs	Genetic Algorithms
IAC	Intelligent Adaptive Curiosity
LID	Learning–Interaction–Diversification
NPR	Non-Photorealistic Rendering
PSO	Particle Swarm Optimization
SDS	Stochastic Diffusion Search
SOM	Self-Organizing Maps

Chapter 1
Introduction

Swarm intelligence is one of the most beautiful and strange phenomena in nature. It emerges from the interaction of a group of agents (individuals) with their environment. The agents follow simple rules and, although there is no centralized control dictating how individuals should behave, actions or interactions between them lead to the emergence of intelligent global behaviour, unknown to each agent.

Swarm agents are autonomous agents. They are self-organized entities with at least two of the following characteristics. They have the ability to sense, to actuate, to communicate and to make decisions without central or external control. Autonomous agents in the swarm perform in an ensemble and can perceived as a single entity or *super-organism* (Randall et al., 2016). Widely recognized examples of swarms include but are not limited to birds flocking, bacteria growing, fish schooling, and the societal superorganisms of ant colonies (i.e., foraging).

Gerardo Beni (1988) explored swarm intelligence in the context of cellular robotics where simple agents organize themselves through neighborhood interactions. Beni also researched the use of swarm intelligence with colleagues (Wang & Beni, 1989; Hackwood & Beni, 1992; Branke, 1999). In the 1990s, studies of swarm behaviour was mostly based on *ant colony optimization (ACO)* (Dorigo et al., 1991) and *particle swarm optimization (PSO)* (Eberhart & Kennedy, 1995).

Computational developments inspired by swarm intelligence influenced a new category of art known as *swarm art*. Leonel Moura (2002) coined the term *swarm art* and was the first to identify a new kind of art based on swarm behaviours (i.e., flocking, foraging and stigmergy). The pioneer artworks were mostly inspired by ant colony behaviours and Reynolds *Boids* system (1987).

Over the last decade, architects have begun to also use swarm techniques in their practice (Snooks & Jahn, 2016a, b; Wiesenhuetter et al., 2016). Swarm behaviours such as emergence, self-organization, communications and interactions are of special interest to artists and architects.

M. Salimi, *Swarm Systems in Art and Architecture*, Computational Synthesis and Creative Systems, https://doi.org/10.1007/978-981-16-4357-6_1

1.1 Basic Definitions

In this section, I will give an overview of the origins and the concepts related to swarms.

What is an agent?

The definition of agent varies widely depending on the field of study. Wooldridge (1997) defined agent as "an encapsulated computer system that is situated in some environment and that is capable of flexible, autonomous action in its environment in order to meet its design objectives." At the extreme, an agent can be formalized as a function from percepts to actions with the following properties:

- Autonomy: capability of cation without external intervention and control over the internal state,
- Situatedness: partial capability of preforming actions in the environment,
- Sociability: interacting with other agents (and possibly humans),
- Reactivity: perceiving the environment and react to changes in a timely fashion,
- Proactivity: ability to not only react to the environment but also exhibit goal-oriented behaviour (Wooldridge & Jennings, 1995).

Intelligent agents can have additional characteristics including Mobility, Benevolence (Rosenschein & Genesereth, 1994), Rationality (Galliers, 1994), Adaptivity and Collaboration (Eichmann, 1994).

1.1.1 Self-organization

Self-organization is a unique and complex swarm behaviour common in animals, especially social insects. Self-organization is the result of simple and local interactions between agents (members of the group), and emerges at the colony level. It explains different aspects of colony behaviour and usually happens via four main mechanisms: multiple interactions between agents, positive or negative feedback, amplification of fluctuations, randomness, and reliance on multiple interactions (Bonabeau et al., 1999; Ducatelle et al., 2011). Self-organization in social colonies usually happens by means of stigmergy, which is an indirect random communication strategy through the environment.

1.1.2 Stigmergy

Grasse (1959) described stigmergy as the "stimulation of workers by the performance they have achieved." Stigmergy results in a complex emerging intelligence at the colony level without any planning, control or direct communication between agents.

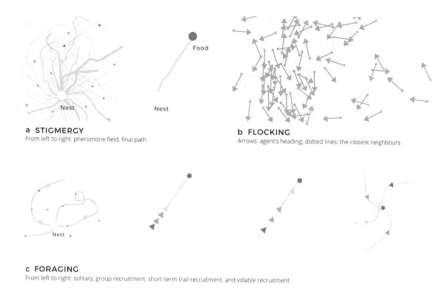

a STIGMERGY
From left to right: pheromone field, final path

b FLOCKING
Arrows: agent's heading, dotted lines: the closest neighbours

c FORAGING
From left to right: solitary, group recruitment, short-term trail recruitment, and volatile recruitment

Fig. 1.1 Abstract representations of stigmergy, flocking and foraging behaviours (Courtesy of the author)

It supports collaborative interaction between simple agents without any memory, intelligence or awareness of other agents (Marsh & Onof, 2008; Heylighen, 2015). For example, leafcutter ants forage for foliage, cut it into pieces and carry the pieces back to their nest. They then grind up the plant matter to grow fungi, which is used as a food source for the ant colony. Weaver ants build bridges with their bodies to span gaps between leaves. They then fill the gap with silk that is produced by mature larva. Other examples include the ability of termites to build complex nests, and bees and ants to find and plan paths in their environment.

Stigmergic indirect communication usually happens between natural agents (i.e., ants) through traces that are left in the environment (to stimulate future action). For example, communication among social insects is achieved using pheromones[1] (a chemical signature).

Stigmergy is a key concept in swarm intelligence and mediates the interaction between social insects as shown in Fig. 1.1. For example, ants communicate with each other by laying down pheromone trails when returning to the nest after foraging for food (Sumpter & Beekman, 2003). These trails result in self-reinforcement, self-organization, and complex seemingly intelligent structures without any global planning or control (Bonabeau et al., 1999).

[1] Pheromones are chemicals capable of acting like hormones outside the body of the secreting individual, to affect the behaviour of the receiving individuals (MedicineNet Inc., March 2012).

Similarly, termites use pheromones to build their complex nests by following a simple decentralized rule set (Karlson & Butenandt, 1959). Pheromonal communication is evolvable because it depends on chemical evaporation which varies between species and tasks (Morgan, 2009; Witte et al., 2007).

1.1.3 Flocking

Flocking is a natural phenomenon observed in birds. It is a group formation for foraging or travelling toward a target location as shown in Fig. 1.1. Other examples are fish schooling, swarming behaviour of insects, and ungulate herding. Flocking is an emergent global behaviour that stems from the collective distribution of local interactions between individual autonomous agents.

1.1.4 Foraging

Foraging is a commonly studied swarm behaviour as the collective behaviour of ants while searching for food. Ants and other social insects effectively search for food using indirect interactions with their nest-mates. In simulated foraging in an artificial swarm system, a specific area known as nest is needed. The objective of the swarm is to find scattered items in the arena and return them to the nest. In an extended version of a foraging task, different types of items must be collected and stored in specific nests.

Many swarm studies have analyzed the dynamics of foraging activities, which generally involve artificial agents that collect items and storing them in a nest (Liu & Winfield, 2010; Wang et al., 2004). A visualization of the foraging pattern that occurs from simulating the search phase is shown in Fig. 1.1.

1.2 Swarm Characteristics

Swarm dynamics are a mystery and very complex to define. However, there are a few structural frameworks that aim to demystify swarm characteristics. Dréo et al. (2007) proposed the *Adaptive Learning Search (ALS)* framework to explain the structure of swarm metaheuristics, Taillard et al. (2001) unified swarm dynamics of ant systems with *genetic algorithms (GA)* as *adaptive memory programming (AMP)* which is a memory-based metaheuristic. Chu et al. (2018) proposed the *learning–interaction–diversification (LID)* framework to understand the learning phases of swarms. Here, learning involves communication, processing of information, and synthesizing knowledge by each agent. An agent can be the *self*, *local*, *global* or *naive*

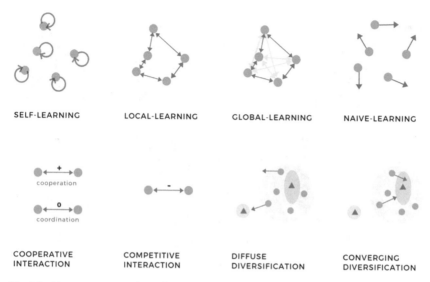

Fig. 1.2 Abstract representations of LID framework (Courtesy of the author)

learner. Interaction is the relationship between agents (i.e., cooperative or competitive). Diversification describes the control system and the algorithmic refinements such as diffuse and converging efforts (Fig. 1.2).

1.3 Swarm Algorithms

In this section, I review and discuss swarm algorithms and their characteristics by comparing and contrasting commonly used techniques. As mentioned before, studies of swarm behaviour are primarily based on *ant colony optimization (ACO)* (Dorigo et al., 1991) and *particle swarm optimization (PSO)* (Eberhart & Kennedy, 1995).

Starting in the 2000s, scholars have been developing intelligent algorithms inspired by natural behaviours. Passino (2002) proposed bacterial foraging optimization which is inspired by the foraging behaviour of bacterias (E. coli and M. xanthus). Krishnanand and Ghose (2005) developed *glowworm swarm optimization (GSO)* that simulates the behaviour of the lightingworms. Pham et al. (2006) developed *bees algorithm (BA)*, inspired by the foraging behaviour of bees. Yang (2008) proposed the *firefly algorithm (FA)*, inspired by the flashing behaviour of fireflies. Similarly, Yang developed (2010) the *bat algorithm (BA)*, a metaheuristic method based on the echolocation behaviour of bats. A comprehensive list of swarm algorithms inspired by social insects is presented in Table 1.1.

Most contemporary algorithms are either deterministic or stochastic, and almost all swarm algorithms are stochastic in nature (Yang et al., 2016). Swarm algorithms are diverse in terms of their sources of inspiration in nature. There are several different

Table 1.1 Taxonomy of swarm algorithms inspired by social insects (Courtesy of the author)

1990-97	2000-04	2005	2006-07	2008	2009-10	2012-13	2014	2015	2017	2018
		BA* Bees Algorithm (Pham et al., 2005)								
		ABC Artificial Bee Colony (Karaboga, 2005)								
BS Bee System (Sato & Hagiwara 1997)		BCO Bee Colony Optimisation (Teodorovic & Dell'Orco, 2005)	HBF Honey Bee Foraging (Balg & Rashid, 2007)		TCO Termite Colony Optimization (Hedayatzadeh et al., 2010)					
PSO Particle swarm optimization (Eberhart & Kennedy 1995)	BH BeeHive (Wedde et al., 2004)	VBA Virtual Bee Algorithm (Yang, 2005)			SBC Simulated Bee Colony (McCaffrey, 2009)					
ACO Ant Colony Optimization (Dorigo, 1992)	SOMA Self-Organizing Migrating Algorithm (Zelinka, 2004)	BSO Bees Swarm Optimization (Drias et al., 2005)	FMHBO Fast Marriage in Honey Bees Optimization (Yang et al., 2007)	FA Firefly Algorithm (Yang, 2008)	BBMO Bumble Bees Mating Optimization (Marinakis et al., 2009)	SSO.2 Social Spider Optimization (Cuevas et al., 2013)		DA Dragonfly Algorithm (Mirjalili, 2015)		
WSO Wasp Swarm Optimization (Theraulaz et al., 1991)	HBA Fish Swarm Optimization (Nakrani & Tovey, 2005)	CSO Glow-worm Swarm Optimization (Krishnanan & Ghose, 2006)	HBMO Honey Bees Mating Optimization (Haddad et al., 2006)	BCPA Bee Collecting Pollen Algorithm (Lu & Zhou, 2008)		BLA Bees Life Algorithm (Bitam & Mellouk, 2013)	WO Worm Optimization (Arnaout, 2014)	MFO Moth-Flame Optimization (Mirjalili, 2015)		
AS Ant System (Dorigo et al., 1991)	MBO Marriage in Honey bees Optimization (Abbass, 2001)	TA Termite Algorithm (Roth, 2005)	VAA Virtual Ants Algorithm (Yang et al., 2006)	RIO Roach Infestation Optimization (Havens et al., 2008)	MHSA Mosquito Host-Seeking Algorithm (Feng et al., 2009)	SUA SuperBug Algorithm (Anandaraman et al., 2012)	SMO Spider Monkey Optimization (Chand Bansal et al., 2014)	ALO Antlion Optimizer (Mirjalili, 2015)	GOA Grasshopper Optimisation Algorithm (Saremi et al., 2017)	EWA Earthworm Optimization Algorithm (Wang et al., 2018)

Legend: OTHER INSECTS / ANT / BEE

ways of analyzing the essential components of swarm intelligence, such as focusing on the key factors for self-organization. Current research has shown that certain criteria are essential for the success of emergent intelligence through self-organizing behaviours. They include feedbacks, stigmergy, multiple interactions, memory and environmental setting, all of which are very important (Yang et al., 2016).

All swarm algorithms share similar characteristics including having a population of individual agents capable of moving in a quasi-deterministic manner (algorithmic dynamics). These algorithmic dynamics regulate how the systems evolve, either by a set of predefined procedures (as used in a genetic algorithm) or by a set of equations (as used in *PSO*).

Swarm algorithms also need a selection mechanism to find the best solution (or best solution to pass on to the next generation). The selection of these states/solutions together with the evolution of the population, allow the system to converge on a set of solutions (often the optimal set). As a consequence, some convergent states or solutions may emerge as iterations.

Randomness is a key force that drives the system from equilibrium and to potentially abandon a local optimal situation. For example, both *PSO* and *FA* algorithms use randomization by selecting random numbers and stochastic models to generate solutions that are new in each iteration and sufficiently different from existing solutions. However, there are significant differences between *PSO* and *FA*. *PSO* uses the best solution found so far (g^*), but *FA* does not. Also, *PSO* is a linear system in terms of updating equations, but *FA* is nonlinear. The attraction mechanism in *FA* allows the swarm to subdivide into multiple small sub-swarms, which allows *FA* to solve multimodal problems more effectively. On the other hand, *PSO* cannot subdivide the swarm.

Furthermore, most swarm algorithms show some level of evolution toward finding the best solution. At the initial stage, the found solutions have a much higher diversity and are usually different and uniformly distributed in the search space. In each iteration, due to their evolutionary nature, solutions become more similar to each other based on the selection mechanism and the fitness criteria (Lones, 2014). As noted before, the selection mechanism acts as a driving force for the evolution of the system and the fitness properties (based on some objective values), and dictates the behaviour of the individual agents to adapt and react as they move toward the system goal (some specific, selected state or solution).

There are many other ways of studying swarm intelligence to understand its algorithmic behaviour (Blum, 2003; Corne, 2012; Yang & He, 2013) such as combinatorial metaheuristic optimization (the use of exploration and exploitation) that was suggested by Blum (2003).

References

Beni, G. (1988, August). The concept of cellular robotic system. In *Proceedings IEEE International Symposium on Intelligent Control 1988* (pp. 57–62). IEEE.

Bonabeau, E., Marco, D. D. R. D. F., Dorigo, M., Théraulaz, G., & Theraulaz, G. (1999). *Swarm intelligence: from natural to artificial systems (No. 1).* Oxford university press.

Blum, C., & Roli, A. (2003). Metaheuristics in combinatorial optimization: Overview and conceptual comparison. *ACM computing surveys (CSUR), 35*(3), 268-308.

Branke, J. (1999, July). Memory enhanced evolutionary algorithms for changing optimization problems. In *Proceedings of the 1999 Congress on Evolutionary Computation-CEC99 (Cat. No. 99TH8406)* (Vol. 3, pp. 1875–1882). IEEE.

Chu et al., 2018.Chu, X., Wu, T., Weir, J. D., Shi, Y., Niu, B., & Li, L. (2018). Learning-interaction-diversification framework for swarm intelligence optimizers: A unified perspective. *Neural Computing and Applications* 1–21. https://doi.org/10.1007/s00521-018-3657-0.

Corne, D. W., Reynolds, A., & Bonabeau, E. (2012). Swarm intelligence. *Handbook of natural computing,* 1599–1622.

David Morgan, E. (2009). Trail pheromones of ants. *Physiological entomology, 34*(1), 1–17.

Dorigo, M., Maniezzo, V., & Colorni, A. (1991). The ant system: An autocatalytic optimizing process.

Dréo, J., Aumasson, J. P., Tfaili, W., & Siarry, P. (2007). Adaptive learning search, a new tool to help comprehending metaheuristics. *International Journal on Artificial Intelligence Tools, 16*(03), 483–505.

Ducatelle, F., Di Caro, G. A., Pinciroli, C., & Gambardella, L. M. (2011). Self-organized cooperation between robotic swarms. *Swarm Intelligence, 5*(2), 73. https://doi.org/10.1007/s11721-011-0053-0.

Eberhart, R., & Kennedy, J. (1995, November). Particle swarm optimization. In *Proceedings of the IEEE International Conference on Neural Networks* (Vol. 4, pp. 1942–1948).

Eichmann, D. (1994). Ethical web agents. *Computer Network ISDN System, 28*(1–2), 127–136. https://doi.org/10.1016/0169-7552(95)00107-3.

Grasse, P. P. (1959). Reconstruction of the nest and coordination between individuals in terms. Bellicositermes Natalensis and Cubitermes sp. the theory of stigmergy: test interpretation of termite constructions. *Insectes Sociaux, 6*(1), 41–80.

Galliers, J. R. (1994). A theoretical framework for computer models of cooperative dialogue, acknowledging multi-agent conflict. *Doctoral dissertation.* The Open University. (pp. 49–54).

Hackwood, S., & Beni, G. (1992, January). Self-organization of sensors for swarm intelligence. In *Proceedings 1992 IEEE International Conference on Robotics and Automation* (pp. 819–820). IEEE Computer Society.

Heylighen, F. (2015). Stigmergy as a Universal Coordination Mechanism: components, varieties and applications. *Human Stigmergy: Theoretical Developments and New Applications*. Springer: New York, NY, USA.

Karlson, P., & Butenandt, A. (1959). Pheromones (ectohormones) in insects. *Annual review of entomology, 4*(1), 39–58.

Krishnanand, K. N., & Ghose, D. (2005, June). Detection of multiple source locations using a glowworm metaphor with applications to collective robotics. In *Proceedings 2005 IEEE Swarm Intelligence Symposium, 2005. SIS 2005.* (pp. 84–91). IEEE.

Liu, W., & Winfield, A. F. (2010). Modeling and optimization of adaptive foraging in swarm robotic systems. *The International Journal of Robotics Research, 29*(14), 1743–1760. https://doi.org/10.1177/0278364910375139.

Lones, M. A. (2014, July). Metaheuristics in nature-inspired algorithms. In *Proceedings of the Companion Publication of the 2014 Annual Conference on Genetic and Evolutionary Computation* (pp. 1419–1422).

Marsh, L., & Onof, C. (2008). Stigmergic epistemology, stigmergic cognition. *Cognitive Systems Research, 9*(1–2), 136–149.

Moura, L. (2002). Swarm paintings-non-human. ARCHITOPIA Book, art, architecture and science (pp. 1–24).

Passino, K. M. (2002). Biomimicry of bacterial foraging for distributed optimization and control.*IEEE control systems magazine, 22*(3), 52–67

Pham, D. T., Ghanbarzadeh, A., Koç, E., Otri, S., Rahim, S., & Zaidi, M. (2006). The bees algorithm—a novel tool for complex optimisation problems. In *Intelligent production machines and systems* (pp. 454–459). Elsevier Science Ltd.

Randall, A., Klingner, J., & Correll, N. (2016, August). Simulating chemical reactions using a swarm of miniature robots. In *International Conference on Simulation of Adaptive Behavior* (pp. 305–316). Springer, Cham.

Rosenschein, J. S., & Genesereth, M. R. (1994). Deals among rational agents. In: *Proceedings of the Ninth International Joint Conference on Artificial Intelligence (IJCAI-85)* (pp. 91–99).

Snooks, R., & Jahn, G. (2016a). Closeness: on the relationship of multi-agent algorithms and robotic fabrication. In *robotic fabrication in architecture, art and design* (pp 218–229). Springer. https://doi.org/10.1007/978-3-319-26378-6_16.

Snooks, R., & Jahn, G. (2016b). Stigmergic accretion. In *Robotic fabrication in architecture, art and design* (pp. 398–409). Springer. https://doi.org/10.1007/978-3-319-26378-6_32.

Sumpter, D. J., & Beekman, M. (2003). From nonlinearity to optimality: pheromone trail foraging by ants. *Animal behaviour, 66*(2), 273–280.

Taillard, É. D., Gambardella, L. M., Gendreau, M., & Potvin, J. Y. (2001). Adaptive memory programming: A unified view of metaheuristics. *European Journal of Operational Research, 135*(1), 1–16. https://doi.org/10.1016/S0377-2217(00)00268-X.

Wang, J., & Beni, G. (1989, September). Cellular robotic system with stationary robots and its application to manufacturing lattices. In *Proceedings IEEE International Symposium on Intelligent Control 1989* (pp. 132–137). IEEE.

Wang, L., Shi, H., Chu, T., Zhang, W., & Zhang, L. (2004). Aggregation of foraging swarms. In Australasian Joint Conference on Artificial Intelligence (pp. 766–777).Berlin, Heidelberg: Springer. https://doi.org/10.1007/978-3-540-30549-1_66.

Wiesenhuetter, S., Wilde, A., & Noennig, J. R. (2016). Swarm intelligence in architectural design. In *International Conference on Swarm Intelligence* (pp. 3–13). Cham: Springer. https://doi.org/10.1007/978-3-319-41000-5_1.

Witte, V., Abrell, L., Attygalle, A. B., Wu, X., & Meinwald, J. (2007). Structure and function of Dufour gland pheromones from the crazy ant Paratrechina longicornis. *Chemoecology, 17*(1), 63–69.

Wooldridge, M. (1997). Agent-based software engineering. *IEE Proceedings-software, 144*(1), 26–37. https://doi.org/10.1049/ip-sen:19971026.

Wooldridge, M., & Jennings, N. R. (1995). Intelligent agents: Theory and practice. *The Knowledge Engineering Review, 10*(2), 115–152. https://doi.org/10.1017/S0269888900008122.

Yang, X. S. (2008). Nature-inspired metaheuristic algorithms. *Firefly algorithm*, 81–95. Luniver Press.

Yang, X. S. (2010). A new metaheuristic bat-inspired algorithm. In *Nature inspired cooperative strategies for optimization (NICSO 2010)* (pp. 65–74). Springer.

Yang, X. S., Deb, S., Fong, S., He, X., & Zhao, Y. X. (2016). From swarm intelligence to metaheuristics: natureinspired optimization algorithms. *Computer, 49*(9), 52–59. *Inspired Computation, 3*(5), 267–274.

Yang, X. S., & He, X. (2013). Bat algorithm: literature review and applications. *International Journal of Bio-inspired Computation, 5*(3), 141–149.

Chapter 2
Architecture

2.1 Agent Architecture (Internal Interaction)

Agent architecture is the control system that depicts the arrangement of artificial agents, the relationships between, and the communications among them. Agents usually have an interaction module which enhances communication with users and other agents (Shehory & Sycara, 2000). Agent architecture can be classified into a few general categories with respect to their function and decision-making mechanism: reactive, deliberative, cognitive, and layered/hybrid.

Reactive agents are characterized by their behaviours i.e., how they react to perceived stimuli in their environment and map perceived input to effectual output that is generally executed immediately. Purely reactive agents have no internal history or long-term plans, but choose their next action solely on the basis of the current perceived situation (Love et al., 2011).

Deliberative agents have an explicit symbolic model of the world in which decisions are made via logical reasoning, and based on pattern matching and symbolic manipulation (Wooldridge, 2009).

Cognitive agents maintain internal symbolic representations of their environment which can be viewed as an extension of symbolic AI techniques. A classic paradigm to formalize the internal architecture of cognitive agents is *belief-desire-intention (BDI)*. BDI agents are built using symbolic representations of the intentions, beliefs, and desires of agent form its reasoning process (Rao & Georgeff, 1991) as shown in Table 2.1.

Layered/hybrid agents combine reactive and cognitive components to balance reactiveness and deliberativeness. In a hybrid model, agents are divided in a set of modules which can in turn be reactive or cognitive. However, it is difficult to control the interaction between different agents or to integrate specific temporal sequences (Guessoum, 1997).

The most common approach in swarm systems is to construct an agent with one (or more) reactive and one (or more) deliberative components. Reactive components are responsive to changes in the world (artificial/physical) without any complex

© The Author(s), under exclusive license to Springer Nature Singapore Pte Ltd. 2021
M. Salimi, *Swarm Systems in Art and Architecture*, Computational Synthesis and Creative Systems, https://doi.org/10.1007/978-981-16-4357-6_2

Table 2.1 *Belief-desire-intention (BDI)* Architecture. Adapted from Rao and Georgeff (1991)

BIOLOGY
(Individual Learning)

LEARNING BEHAVIOR
-Naive
-Self
-Local
PSYCHOLOGY -Global
(Organizational behavior)

INTERACTION RELATIONSHIP
-Cooperative
ENVIRONMENT -Competitive
(External force)

DIVERSIFICATION
-Diffuse
-converging
LID FRAMEWORK -Nonspecific

reasoning and decision-making. Deliberative systems are responsible for abstract planning and decision-making using symbolic representations.

In most swarm systems (66/120), individual agents behave like simple reactive agents. However, the entire swarm is able to achieve a much more complex behaviour without a centralized control.

2.2 System Dynamic (External Interaction)

A key distinguishing feature of swarm systems (specific to the context of art and architecture) is the type of interaction between swarm agents, artist/architect, viewer and the environment. Edmonds et al. (2004) developed categories for interactive artworks that are applicable to swarm systems and for my evaluation. They defined the core types of interactions as: static, dynamic-passive, and dynamic-interactive (varying).

Static system does not change or react to an input or context and there is no connection between the viewer and the art that can be observed by another person (despite the fact that the viewer might have an emotional response to what they are viewing). For example, most ant paintings such as *Sand Paintings* (Urbano, 2011) are autonomous and generative. It means that the interaction of the swarm agents

is internal and only within their (artificial) environment. Therefore, viewers or the artist/architect have no or minimum influence on the outcome.

Dynamic-passive system has an internal component that allows it to evolve or be modified by environmental factors such as temperature, sound, or light. Most swarm musical artworks such as *Trails II* (Bisig & Kocher, 2013) fall into this category. Swarm agents not only interact with each other and their internal environment but are also influenced by the external music, generated by an artist. The viewer here is a passive observer of a dynamic performance by the swarm agents and artist(s) that are interacting to each other.

In dynamic-interactive systems, the viewer has an active role in influencing the outcome. For example, by touching the screen the viewer can directly modify the swarm movements or visual appearance. Movement and sound capture and analysis strategies can be utilized to incorporate human actions into the visual and or audio representation(s) of the agents. In this way, the artwork/architecture performs according to the human input (actions). Among more recent artworks, our taxonomy includes examples of this type of interaction. *Nike Flyknit* (Universal Everything, 2013), an interactive audiovisual installation for the Milan Furniture Fair that uses input from people walking in front of multiple screens displaying swarm visuals. The shape, weight, texture, and form of these visuals are influenced by the movement of viewers. For example, while a group of visuals quickly moves across the screen, another group moves gradually due to their weight and seemingly sticky texture resulting from the running or walking behaviour of the viewers. Another interactive artwork is *Portrait on the Fly* (Sommerer et. al., 2015), that was first exhibited as part of ISEA International Symposium of Electronic Arts at Vancouver Art Gallery, that uses the movement of three or more people as input.

2.3 Audience Interactions

Audience interaction refers to the role of the audience in its interaction with the swarm system. The audience actively alter or influence the swarm system output directly via their actions, or they can be passive observers of the installation, performance, pavilion, etc.

Almost half (58/120) of the analyzed systems are non-interactive and no one can interact and influence the behaviour of swarm agents (externally). In general, the artworks with passive audiences (spectators) are open to larger groups. However, some installations aim to create an intimate environment and limit the number of participants who can be present at the same time. For example, *Emergent Harmony* (Tricaud, 2018) allows only a few spectators at a time to create an interactive sonic experience.

In the case of interactive swarm systems, the number of active audience members varies. The common approach is for only one viewer at a time to interact with the swarm agents. However, some systems utilize two or more inputs. One of the early examples of interactive swarm systems with active audience is *Swarm* (Shiffman,

2004), an interactive video installation, exhibited at Savannah College of Art and Design (SCAD), Savannah.

In other instances, artist(s) uses the collective activities of viewers to influence real-time behaviour of the swarm agents. For example, the continuous feedback loop between the sonic environment and the participants' movements in artworks such as *Swarms* (Bisig & Unemi, 2009), *Shin'm 2.0* (Kang et al., 2012), and *STOCOS* (Bisig & Palacio, 2012) create dynamic and collaborative aesthetics.

References

Bisig, D., & Kocher, P. (2013). Trails II. In *Proceedings of the Consciousness Reframed Conference*. Cairo, Egypt.

Bisig, D., & Palacio, P. (2012). STOCOS-Dance in a Synergistic Environment. In *Proceedings of the Generative Art Conference* (Lucca, 2012).

Bisig, D., & Unemi, T. (2009). Swarms on stage-swarm simulations for dance performance. In *the Proceedings of the Generative Art Conference*. Milano, Italy.

Edmonds, E., Turner, G., & Candy, L. (2004). Approaches to interactive art systems. In *Proceedings of the 2nd International Conference on Computer Graphics and Interactive Techniques in Australasia and South East Asia* (pp. 113–117).

Guessoum, Z. (1997). A hybrid agent model: a reactive and cognitive behavior. In *Proceedings of the Third International Symposium on Autonomous Decentralized Systems. ISADS 97* (pp. 25–32). IEEE.

Kang, E. Donald, C., & Garcia-Snyder, D. (2012). Shin'm 2.0. In *SIGGRAPH Asia 2012 Art Gallery* (p. 17). ACM.

Love, J., Pasquier, P., Wyvill, B., Gibson, S., & Tzanetakis, G. (2011). Aesthetic agents: swarm-based non-photorealistic rendering using multiple images. In *Proceedings of the International Symposium on Computational Aesthetics in Graphics, Visualization, and Imaging* (pp. 47–54). ACM. https://doi.org/10.1145/2030441.2030452.

Rao, A. S., & Georgeff, M. P. (1991). Modeling rational agents within a BDI-architecture. KR, 91, 473–484.

Shehory, O., & Sycara, K. (2000, June). The RETSINA communicator. In *International Conference on Autonomous Agents: Proceedings of the Fourth International Conference on Autonomous Agents* (Vol. 3, No. 07, pp. 199–200). https://doi.org/10.1145/336595.337363.

Shiffman, D. (2004). Swarm, ACM SIGGRAPH 2004 Emerging Technologies Proceedings (p. 26). New York, ACM Press. https://doi.org/10.1145/1186155.1186182.

Sommerer, C., Mignonneau, L., & Weil, F. (2015). The Art of Human to Plant Interaction. *The Green Thread: Dialogues with the Vegetal World, 233*.

Tricaud, (2018). https://www.margueritetricaud.com/emergent-harmony.

Urbano, P. (2011). The T. albipennis sand painting artists. In *European Conference on the Applications of Evolutionary Computation* (pp. 414–423). Berlin, Heidelberg: Springer. https://doi.org/10.1007/978-3-642-20520-0_42.

Wooldridge, M. (2009). *An Introduction to Multiagent Systems*. John wiley & sons.

Chapter 3
Model

3.1 Features

Swarm intelligence is a complex phenomenon involving a population of agents (homogeneous or heterogeneous) and their local interaction. The complexity arises from simple rules, efficiency, and adaptability coupled with emergent behaviours such as self-organization.

Blackwell (2007) suggested grouping artificial swarms into three categories in order of their accuracy compared to natural swarms:

- Bio-swarms: to develop scientific models of natural systems such as honeybee (Couzin et al., 2005).
- Simulation swarms: for aesthetic and artistic purposes and real-time interaction (Reynolds, 1987; Burton & Franks, 1985).
- Social swarms: to define a neighbourhood for interactions to solve mathematical problems, as in *ACO* and *PSO* using an information network rather than a spatial region. Most swarm systems I reviewed employed elements of simulation and social swarms in which the evolution of learning is a key aspect of swarm phenomenon.

The intelligence behind swarm behaviour relies on the interaction between agents. As noted in Sect. 1.2, each agent can update its information (ΔInfo) by learning from itself, its local neighbours, global exemplars, and/or through naïve learning (*LID* framework).

For a population of $P = (a_1, a_2, \ldots, a_p)$, where a_i is an individual i of the swarm, *LID* principles (learning–interaction–diversification) can be defined as:

$$L\left(a_i \rightarrow a_i'\right) \tag{3.1}$$

$$I\left(a_i \leftrightarrow a_j\right) \tag{3.2}$$

$$D(P \rightarrow P|P')$$ (3.3)

where, the state of each individual agent is updated from a_i to a_i', and the population evolves from P to P' (Chu et al., 2018).

3.2 Principles

3.2.1 Stigmergy

As discussed before, stigmergy is a common swarming principle inspired by behaviours of ant and ant colonies. Greenfield and Machado (2015) suggested using ant and ant-colony inspired algorithms for artistic exploration. They used artificial ants to simulate complex behaviours of real ants (i.e., foraging, stigmergy, etc.) inspired by previous surveys about ant behaviours (Gordon, 2010; Wilson & Hölldobler, 1994) and promising arrays of artistic endeavours. In the following sections, I explore common stigmergy techniques to create art.

3.2.2 Pheromones

As explained before, the behaviour of the most-social insects is complex and exceeds the sum of the individual insect's actions. This is known as emergence. For example, most ants forage collectively using pheromone to influence the behaviour of their nest-mates and direct them towards food source(s). Dorigo (1992) suggested *Ant System (AS)*, a computational model that simulates the pheromonal communication between ants with no particular representational scheme of the environment. This model demonstrated the emergence of complex global behaviours from the simple interaction between agents at local level.

Similarly, Ramos and Almeida (2004) proposed ant pheromones for visual purposes using artificial ants that interact with their environment via pheromonal response. They suggested the following:

$$\phi = \left(1 + \frac{\sigma}{1 + \delta\sigma}\right)^{\beta}$$ (3.4)

where ϕ is the pheromone response, and $\sigma = \sigma(r, \theta)$ is the pheromone strength perceived by an ant at position r and direction of θ. β and δ are the pheromone sensitivity and sensing capacity of the ant.

Ramos and Almeida used this pheromone response to map the movement of the ant in a 3×3 *Moore neighbourhood* (Weisstein, 2005). The assumption is that an ant moves from its current cell to one of the eight other cells (numbered from 1 to 8) within the grid with the following probability:

$$p_i = \frac{\phi_i d_i}{\sum \phi_i d_i} \tag{3.5}$$

where ϕ is the pheromone response, and d_i is the weight of the ith cell.

3.2.2.1 Primitive Pheromones

In a different approach, both Aupetit et al., (2003) and Greenfield (2005) focused on interactive algorithms and genetic evolution as opposed to pheromone update for artistic exploration. They used fixed-length strings of parameters as ant genomes with the following genome for each ant:

$$(C_R, C_G, C_B, F_R, F_G, F_B, P_l, P_r, P_a, D_o, D_d, P_s) \tag{3.6}$$

where, (C_R, C_G, C_B) is the colour that each ant deposits and (F_R, F_G, F_B) is the colour to follow. (P_l, P_r, P_a) is the probability of moving (l)eft, (r)ight, or (a)head in the absence of pheromone. P_s is the probability of following the desired colour, and (D_o, D_s) is the ant's type of movement (oblique [45°] or right-angle [90°] turn).

In primitive pheromones model, each ant is a *cellular automaton* wandering on a grid depending on how the colour are assigned to each cell (Aupetit et al., 2003).

The difference between the Aupetit et al. (2003) and the Greenfield (2005) approach is the pheromone distribution. For Monmarché et al., the pheromone is a scalar (the colour brightness) and for Greenfield, the pheromone is a vector (the RGB). In both cases, pheromone detection corresponds to sensing its presence above a certain threshold, and the fitness functions are simple arithmetic expressions as they search for a certain colour or to follow their preference. Thus, the generated paintings evolve, based on these collective behaviours. Moreover, they used genetic algorithms to create ants of different classes with different colour preferences to promote inter-action and feedback. Aupetit et al. (2003) used an interactive genetic algorithm with 4–6 ant genomes, and Greenfield (2005) used an interactive genetic algorithm with 8–12 ant genomes. These two different approaches have subtle ramifications in the generated paintings as shown in shown in Fig. 3.1 and 3.2.

Urbano (2005, 2006) used a different technique for ant painting. He treated each cell of the grid as a scent emitter (as an attraction) until it was first visited by an artificial ant. At this point, the visited cell gets painted a colour different from the original grey background and ceased to function as an emitter. An ant painting is generated once all the cells had been visited.

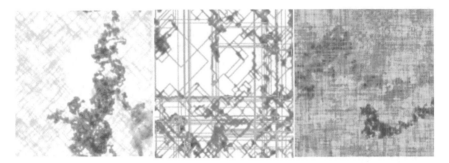

Fig. 3.1 *Ant Paintings* (2003) Obtained with different parameter settings, each ant tries to replace the colour deposited by one of its rivals by its own colour. © Image Credit: Aupetit et al. (2003)

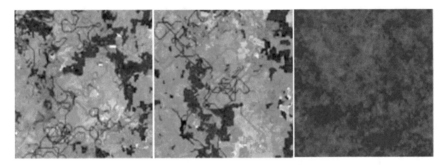

Fig. 3.2 *Ant Paintings* (2005) Left and center, examples of the balanced style (following scent and explore); right, an example of the degenerate fitness function. © Image Credit: Greenfield (2005)

3.2.2.2 Multiple Pheromones

Greenfield (2006b) proposed a collision avoidance policy by using an invisible evaporation and diffusion mechanism for pheromones emitted by ants. He added a gradient to the pheromone trails influenced by the attraction emitters (of the cells) to leverage ant behaviour. In this way, ants avoided visiting regions of the environment that had already been explored. In avoidance mode, ants deposited a different colour (from the preference) that got blended and diffused on the canvas. To avoid certain areas, ants developed emerging rotational patterns that added new aesthetics.

Another strategy reinforced by an *Evolutionary Algorithm (EA)* is to divide ants into two initial clusters (using two different colour schemes), as opposed to randomly distributing them on the canvas (Greenfield, 2006a).

3.2.2.3 Complex Environments

Many artists have used ant-inspired models for non-photorealistic rendering by using pixels of the original image as background to create a complex environment or

non-photorealistic rendering (NPR). Semet et al. (2004) proposed an evolutionary interactive algorithm that lets the user control the composition and style of non-photorealistic ant paintings. In their model, ants sense the local environment without changing it, and their activities depend only on what they encounter. Therefore, a colony of a few hundred ants is simulated by having one ant (at a time) wandering over the environment for a fixed number of time steps.

In a different approach, Machado and Pereira (2012) proposed *Photogrowth* for *NPR*, in which ants sense the environment and lay marks (inks) on the canvas. The brightness value of the pixels in the original image was used as food to attracts ants. Each ant (with an initial energy) travels toward an illuminated area of the image to gain more energy and leaves traces behind. An ant's energy level determines the width of the trace, which varies with the fluctuation in energy levels. Each ant has 10 sensory vectors and senses the environment by looking in several directions that determines ant's direction of movement relative to its current position, and returns the luminance value of the area where each vector ends. Machado and Pereira (2012) scaled the sums of the sensory vectors according to the velocity of the ants, the luminance of their end point, and the weight the ant gives to each sensor update the position of each ant.

Finally, Fernandes (2010) proposed *Pherographia* model for *NPR* with singular trails of individual ants (pheromone) to create artistic results. In this model, ants lay down marks according to the *Moore neighbourhood* (3×3 cells) and then move in response to the pheromone strength similar to the techniques proposed by Ramos and Almeida (2004) as described in Sect. 3.2.2. *Pherographia* model control T units of evaporating pheromone as:

$$T = \eta + \rho \left(\frac{\Delta_{gl}}{\Delta_{max}} \right) \tag{3.7}$$

where Δ_{max} is the difference between the darkest and the lightest pixel in the original image; Δ_{gl} is the contrast in the current neighbourhood; and η and ρ are constants.

There are two options for implementing agents (artificial ants) in a two-dimensional environment and they can result in significant differences in the visual outcomes. Ants can either jump from cell to cell, similar to *cellular automata* (discrete approach), or they can move smoothly through the environment by maintaining position, orientation, and velocity and relying on scaling to sense and modify grid cells (continuous approach).

Greenfield (2006a, b), Fernandes (2010), and Semet et al. (2004) used the discrete method. Greenfield (2012, 2013a, b), and Machado et al. (2013) used the continuous approach.

3.2.3 Flocking

Many artists have used flocking behaviours for artistic creations. This includes musical compositions (Blackwell, 2003), orchestral performances (Unemi & Bisig, 2005), paintings (Moura, 2002), interactive video installations (Sayles et al., 2003; Boyd et al., 2004) and moving images (Shiffman, 2004). In the following sections, I explain two flocking techniques for artistic exploration.

3.2.3.1 ISO Flock

Bisig et al. (2011) developed a flocking Library known as *ISO Flock*[1] create interactive and immersive environments. *ISO Flock* is an innovative strategy for establishing meaningful relationships between swarm behaviour, interaction, perception, and musical and artistic expression. Bisig (http://swarms.cc) and colleagues utilized *ISO Flock* in a series of artworks known as *Interactive Swarm Space* (ISS) and explored multi-modal feedback and audiovisual spatialization for creative engagement with autonomous, self-organized, and spatially distributed systems.

ISO Flock is a multi-agent simulation for creating and exploring virtual swarms (using *OpenGL*) in which the artificial agents can have different properties and behaviours to interact with their neighbours or the entire swarm. The algorithm has the ability to simulate up to 15 predefined behaviours such as acceleration, alignment, mirror, wrap, repulsion, cohesion, and damping.

In addition to swarm agents, Bisig et al. (2011) developed other classes for the *ISO Flock*. For example, environmental agents organized in an n-dimensional grid (i.e., to define separate spaces with distinct properties). In another class, swarm parameters can be altered by an event-based system or the event system that allows the score-like arranging of agent parameters. Events can also be created on the fly when, for example, certain conditions are observed by the camera-tracking software.

The *ISO Flock* Library also has a group of specialized algorithms to create space objects and redefine the controls and relationships between the parameters of agents such as *NTreeAlg, AnnAlg, KDTreeAlg, RTreeAlg,* and *GridAlg*. The output of *ISO Flock* can be assigned to display specific data at runtime (i.e., the location of the individual agents or their headings and speeds at each time-step). This real-time information can be utilized by other *ISO* systems or other OSC-compatible software products like *MaxMSP, SuperCollider*. An *ISO Flock* can be controlled at runtime via *OSC* (i.e., by sending a command to raise the number of agents in a particular swarm, change certain qualities, or change environmental parameters that influence the entire swarm).

[1] *ISO Flock* Library is free and open to use and can be accessed here: http://swarms.cc/documenta tion/isoSynth/.

3.2.3.2 ISO Synth

Similar to *ISO Flock*, *ISO Synth*[2] is a Library developed by Bisig et al. (2011) for real-time sound synthesis, signal processing, and sound spatialization. It is a practical tool that can be used to create swarm music. Bisig and colleagues utilized *ISO Synth* in *Interactive Swarm Orchestra (ISO)* series (e.g., *Flowspace, STOCOS*) for swarm simulation, sound synthesis, sound spatialization, and video tracking.

ISO Synth controls the audio data with no limits to the topology of the interconnections. Scores and MIDI-based control are realized via the ISO event system. Audio-rate and control-rate are treated the same, but the specification of different sampling rates for individual units and ports is allowed.

3.2.4 Foraging

As mentioned before, Aupetit et al. (2003) proposed *Ant painting* as a way to create digital drawings in which artificial collective agents are capable of distributing paint (colour). Similarly, Urbano (2011) used virtual canvas to depicting colour and pheromones as painting patterns. In the following sections, I explain common foraging techniques for artistic exploration.

3.2.4.1 Seed Foraging

A pioneer artwork in this category is *Ant Brush* (Tzafestas, 2000), a drawing tool with artificial agents capable of collecting crumbs and distributing colour on a drawing canvas. *Ant painting* (Aupetit et al., 2003) is an evolutionary computation system that combines Genetic Algorithm (GA) and virtual scent, and is able to generate abstract images (Fig. 3.1). Similarly, *Ant painting* (Greenfield, 2005) is the first autonomous evolutionary tool for ant paintings inspired by Monmarché's technique (2003). It consists of 8–12 artificial ants, does not rely on human input for fitness evaluation, and is capable of generating evolutionary artworks autonomously (Fig. 3.2).

Another approach for ant painting is to assign virtual scent to individual cells in the environment to attract artificial ants. Ants are each assigned a different colour and as they visit each cell, they paint the environment. The painting is the result of all the artificial ants having visited all the cells (Urbano, 2005, 2006). One of the differences is that the artistic ants are not charged for pheromone production, and the diffusion process does not occur on previous *Ant paintings* (Greenfield, 2005). Here, the virtual pheromones are responsible for the micro-painter's movement and consequent traces.

[2] *ISO Synth* Library is free and open to use and can be accessed here: http://swarms.cc/documenta tion/isoSynth/.

Greenfield (2006a) updated this approach by adding virtual scents to the artificial ants as a means of attraction and repulsion. He combined multiple pheromones with an *EA* to create a biological model representing more plausible behaviours.

Following the work of Kaplan (2000) on convention emergence in multiagent systems, Urbano (2006) introduced the *Gaugants*, a society of mimetic micro-painters where consensus (collective choice) around some attributes i.e., position, orientation, colour, force, equals-threshold, and Rot. The source of artistic pattern (continuous and collective choices) derives from the Rot degrees and going forward a number of steps (speed) and results in diversity and non-homogeneity (Fig. 3.3). In contrast with the *Colombines* (Urbano, 2005), the *Gaugants* communicate directly and do not use any form of virtual chemical for interaction. Urbano (2008) further explored variations on the *Colombines* model and introduced a new mimetic class where agents' colour and position are subject to imitation (Fig. 3.4).

In a different approach, Greenfield (2013a, b) proposed an ant-painting model based on the seed-foraging behaviour of the ant species *P. barbatus*. The product of this model is governed by the rate of interaction between ants. *P. barbatus* ants do not use pheromone trails when foraging for seeds, but rather use a hydrocarbon

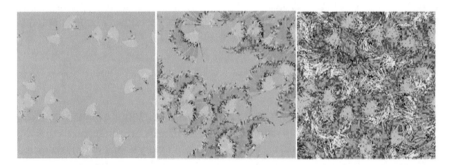

Fig. 3.3 *Gaugant Paintings* (2006) made by 2000 micro-painters with different population dimensions, initial group divisions, speed and Rot. © Image Credit: Urbano (2006)

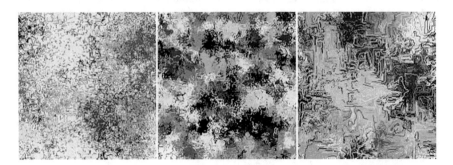

Fig. 3.4 *Swarm Exquisite-Corpses* (2008) Paintings made with 2000 painters with different vision-radius (left and center: 5, 15); right: painting made with 100 painters with a random initial colour and a vision radius of 10. © Image Credit: Urbano (2008)

profile that guides them when returning to the nest. The seed-forager recruitment is controlled by the rate of return of seed bearers. The foraging is sustained on the basis of a high enough rate of ant-ant interactions occurring between successful returning foragers and queued idle foragers waiting at the nest entrance, and working from parameter values estimated from primary source materials (Greenfield & Machado, 2015).

3.2.4.2 Sand Grain Foraging

A radical example in this category is *Transport Network Overlay* (Greenfield, 2011), a series of pseudo-randomly coloured images known as abstract overlays that are generated by a virtual ant colony. The model was inspired by the evolution and formation of plasma transport networks of the slime mold Physarum (Jones, 2010) and the remote sensing capabilities of ants. The plasma transport networks visualized the distributions and diffusions of pheromone trails laid down by virtual ants.

In a different approach Urbano (2011) proposed a method for ant painting inspired by the nesting behaviour of *T. albipennis* ants called *Sand Paintings* as shown in Fig. 3.5. These ants collect and deposit sand grains to form simple circular walls, at a given distance from the central cluster of their nest. The ants' cluster functions as a template, which combined with self-organization, are responsible for the particular wall-pattern formation.

Greenfield (2012) updated Urbano's method (2011) by carefully assigning the set parameters (radii, centres, and colour preferences) instead of randomly choosing them. The parameters are chosen to simulate the stigmergy behaviour of ants and create uniform density distribution of virtual sand on the canvas. The results are a series of ant paintings knowns as *Stigmmetry Prints* as shown in Fig. 3.6. Greenfield and Sarhangi (2014) further extended the Urbano's nesting model by specifying a grid cell (or neighbourhood of cells) using polar or Cartesian curves.

Greenfield and Sarhangi (2014) modeled the stochastic behaviour of ants by three parameters: a constant drop probability k_d, a constant pick-up probability k_u, and a

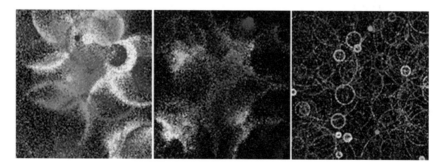

Fig. 3.5 *Sand Paintings* (2011) made from different parameter configurations where grains are deposited randomly on the canvas with a black background. © Image Credit: Urbano (2011)

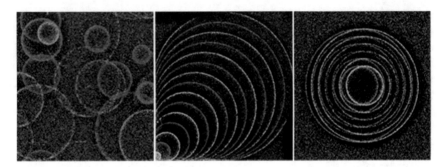

Fig. 3.6 *Stigmmetry Prints* (2012) Left, randomly assigned nest centers and radii; center, nested symmetrical circles; right, paired overlapping circles, coloured so that vertical symmetry is colour reversing. © Image Credit: Greenfield (2012)

constant $\tau > 0$. So, the probability of dropping and picking up a sand grain by ants can be defined by by P_d and P_u as:

$$P_d = \frac{k_d}{1 + \tau(r - R)^2} \tag{3.8}$$

$$P_u = k_u\left(1 - \frac{1}{1 + \tau(r - R)^2}\right) \tag{3.9}$$

where R is the nest radius and r are the current position of an ant from the nest centre.

3.2.5 Other Techniques

3.2.5.1 Swarm Grammars

Swarm grammars are a computational concept that combine the developmental features of *L-system* with agent-based modelling and present highly dynamic, complex networks of interactions (von Mammen et al., 2008). Swarm grammars can be used to replicate the coordination movement of birds, reproduction growth of cell colonies or plants, and the indirect communication of social insects to create life-like artifacts that both resemble organic forms and capture the dynamics of the construction processes (von Mammen & Jacob, 2007a; von Mammen et al., 2008). An example of swarm grammars is a series of evolutionary designs by von Mammen and Jacob (2007b) as shown in Fig. 3.7.

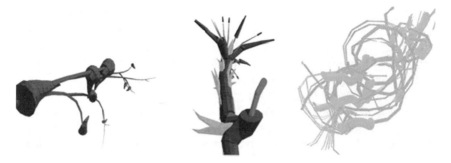

Fig. 3.7 Examples of evolved *Swarm Grammar* (2007) phenotypes. Left, pointy yet smooth nodes connect with long, thin branches; center, a flower-like structure created by a single mutation; right, groups of swarm agents create a woven 3D pattern. © Image Credit: von Mammen and Jacob (2007b)

3.2.5.2 Intelligent Adaptive Curiosity (IAC) Model (swarm-like)

Another approach for creating complex phenomena is to mimic natural swarms without any explicit modelling. An example of this approach is a learning technique known as *Intelligent Adaptive Curiosity (IAC)* (Oudeyer et al., 2007). The goal of Oudeyer et al. (2007) was to build a robot capable of life-long learning. The robot comprehends the mapping between its actuators and sensors through continuous self-experimentation, without any explicit instruction from humans.

On a basic level, *IAC* is a reinforcement-learning algorithm with the goal to expand learning progress. Learning progress is the reduction in prediction error. *IAC* relies on a memory which stores all the experiences encountered by the robot in vector formats and in different regions. Each region is characterized by an exclusive set of exemplars and is associated with its own learning machine, called an expert. This expert is trained with the exemplars available in its region.

When a prediction corresponding to a given situation has to be made by the robot, the expert of the region covering this situation is picked up and used for the prediction. Each time an expert makes a prediction associated with an action, its error is measured and stored in a list which is associated to its region. In other words, the robot explores the region of the sensorimotor space that prompts the least prediction error (Oudeyer et al., 2005).

Subsequently, *IAC* algorithm avoids learning in the pieces of sensorimotor space that are either excessively arbitrary or too predictable which leads to continuous changes in the system behaviour over time, as areas of the state space that are initially interesting become less intriguing (as the system becomes more knowledgeable about them).

An example of the self-organization of structured developmental trajectories driven by curiosity-driven exploration is a series of tests, called *Playground Experiments* (Oudeyer et al., 2005, 2007). These experimentations represent how mechanisms of curiosity-driven exploration, dynamic communication, and physical

and social imperatives can self-organize developmental directions. Moreover, they demonstrated that the robot is able to acquire complex interaction behaviours with the environment, which was important to improve its knowledge about the complex relationships between the sensorimotor settings and the results. Additionally, the experiments displayed intrinsic human drive for curiosity in robots, by exploring new territories that have the most noteworthy potential for adapting new information.

The interactive behaviours in IAC system is similar to the *Curiosity-Based Learning Algorithm (CBLA)* proposed by Chan et al. (2015). By utilizing its own internal motivation (the curiosity drive), the system collaborates with and reacts to the human spectator, and makes evolving actions. The *CBLA* model presents intelligence as a set of agents with a natural urgency to learn. Given a lot of information and yield factors that it can observe and control, each agent attempts to comprehend its own mechanism, encompassing environment, and the inhabitants by learning models that relate the inputs and outputs.

Chan et al. (2015) developed *CBLA* based on the *IAC* algorithm (Oudeyer et al., 2007). However, they expanded its application to architectural and distributed interactive sculptures to create evolving dynamic interaction(s) and explored the ways that humans interact with robots, to enhance the system learning over time. The proposed *CBLA* framework was tested in a series of interactive sculptures and installations by Beesley et al. (2004–19).

3.3 Commonly Used Algorithms

3.3.1 Boids

A commonly used algorithm in swarm art and architecture is *Boids* (Reynolds, 1987). In the late 1980s, Reynolds proposed *Boids* as a new technique to model natural behaviours such as flocks, herds, and schools inspired by Braitenberg's vehicle (1986) and Walter's Tortoises (https://americanhistory.si.edu/collections/search/obj ect/nmah_879329) (1951).

Boids have had a significant and continuous influence on computer graphics and *ALife* (artificial life), as well as other techniques. Delgado-Mata et al. (2007) extended Reynolds model to incorporate the effects of fear in artificial agents (through olfactory pheromones). Hartman and Benes (2006) introduced a corresponding force to the alignment known as change of leadership, that allows the *Boids* to become the leader and escape the flock.

In a different approach, Jacob et al. (2007) proposed a flocking simulation of artificial agents that fly through a virtual 3D world in which the agents are limited to a bounding space and steer away from the boundaries when they get too close. Here, the collision of agents with one another and their environment is enforced by an evolutionary breeding system to create interesting swarm dynamics.

Many artists have used *Boids* algorithm for artistic explorations. Blackwell and Bentley (2002) created the first interactive music improviser called *SWARMUSIC* using the *PSO* and *Boids* algorithms. *SWARMUSIC* generates music by mapping the position of particles onto MIDI events. Interaction with external musical sources is the result of the attraction of the swarm to a target. Blackwell (2003) further explored music improvisation using *Boids* algorithms and dynamics of particle swarms. Here, the interactions between performers (in a freely improvised ensemble) is modelled by the self-organization behaviour of agents in a multi-swarm in which each swarm is a musical entity, comprised of particles that interact with a target group (derived from other swarms or human performers) and particles correspond to a musical event. Please refer to Blackwell (2007, 2008) for a comprehensive review of improvised and evolutionarily swarm music.

Jones (2008) developed *AtomSwarm*, a framework for sound-based performance using swarm dynamics using *Boids* algorithm. *AtomSwarm* is augmented with genetically-encoded behaviours, artificial pheromones, and imitations to create a complex sonic ecosystem capable of sonic spatialization and self-organizing regulations.

3.3.1.1 Procedure

Boids follow a few simple rules including separation to avoid collision (between agents), alignment (to allow movement in the same general direction), and cohesion (to avoid exposure). The dynamics of *Boids* are updated through discretization of *Newton's Laws of Motion.*

$$a_i = \frac{1}{m} f(S(i), \alpha) \tag{3.10}$$

$$v_i(t+1) = v_i(t) + a_i \tag{3.11}$$

$$v_i(t+1) = \min(v_i(t), v_{max}) \tag{3.12}$$

$$x_i(t+1) = x_i(t) + v_i(t+1) \tag{3.13}$$

where $S(i)$ is the sub-swarm of i and its neighbours, f is the function of dynamic variables $S(i)$ and α. The optional speed clamp to limit particle velocity in high accelerations is $v_i(t+1)$. The attraction (steering) acceleration is calculated by (Blackwell, 2007):

$$a_i = \frac{x_j - x_i}{|x_j - x_i|} \tag{3.14}$$

Fig. 3.8 Particle i, positioned at x and moving with velocity v, attracts particle j and repels particle k. The other particles are outside of the particle perception $S(i)$. © Image Credit: Blackwell (2007)

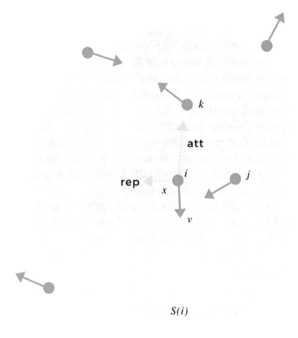

Typically, particles repel each other at close range, attract each other at medium range, and are oblivious to each other at long range as illustrated in Fig. 3.8.

3.3.2 Ant System (AS)

Ant System (AS) algorithm proposed by Dorigo et al. (1991, 1996) is another commonly used algorithm in swarm music inspired by collective behaviours of ants.

Minsky (1982) described a musical melody as a repetition of notes and rhythms. Todd and Miranda (2006) proposed three ways to generate music with a multi-agent system. First, musical expression can be produced by the movement of artificial agents in their environment (which are not aware of what they produce). Second, each agent can generate music and its survival is a function of that creation. Third, not only do individual agents generate music but they can also influence the behaviour of other agents.

Agents (artificial ants) in the *AS* algorithm are in the third category and generate music as a result of multiple social interactions with other agents. Artificial ants create melodies based on transition probabilities and collective pheromonal markings. Agents are locally arranged on vertices in a graph. They can move freely and deposit pheromones on the edges. Normally, the vertices correspond to MIDI events (note, duration, etc.) and a melody corresponds to a path between several vertices (Guéret et al., 2004).

3.3.2.1 Procedure

Each edge (i, j) between vertices i and j is weighted by a positive pheromone value ϕ_{ij}. A transition rule decides which vertices an artificial ant will choose next when located in vertex i. The probability of choosing vertex j is given by:

$$p_{ij} = \frac{\phi_{ij}^{\alpha} d_{ij}^{\beta}}{\sum_{i,j=1}^{n} \phi_{ij}^{\alpha} d_{ij}^{\beta}} \tag{3.15}$$

where $\alpha > 0$ and $\beta > 0$ are the influence parameters that control the style. Their typical values are $\alpha \approx \beta \approx 2$. ϕ_{ij}, which is the pheromone concentration of the route between i and j, and d_{ij}, is the desirability (the distances or the cost) of all existing paths.

Some a priori knowledge such as the distance s_{ij} is often used. This indicates that shorter routes will be selected due to the shorter travelling time, and thus the pheromone concentrations on these routes are higher $(d_{ij} \infty 1/s_{ij})$. Finally, n stands for the set of possible vertices that can be reached from i (Dorigo et al., 1991, 1996).

Desirability encourages ants to choose the closest edges from their current position to form a melody. High d_{ij} numbers increase the importance of the desirability and low values give more importance to the pheromone values for the transition choices between the nodes. The ants deposit pheromones moving from vertex i to j with ϕ_0 quantity, and the path gets more desirable as visited by more ants:

$$\phi_{ij} \leftarrow \phi_{ij} + \phi_0 \tag{3.16}$$

However, similar to natural systems, pheromones evaporate over time:

$$\phi_{ij} \leftarrow (1 - \rho)\phi_{ij} \tag{3.17}$$

where ρ, is evapouration $(0 \leq \rho \leq 1)$.

Guéret et al. (2004) proposed using AS algorithm for swarm music by simulating the movements of an artificial ant on a graph to generate melodies. The algorithm reinforces and encourages movements via pheromonal deposits in the graph to generate harmonic melodies. AS generates a melody, T_{max} through the following steps:

randomly choose a vertex for the initial position of each ant
initialize pheromone values:$\phi_{ij} \leftarrow \phi^0 \forall i, j$

$$t \rightarrow 0$$

while $t < T_{max}$:
choose the next MIDI event j according to the transition rule
deposit pheromones on chosen edge (ϕ_{ij})
move to vertex j and play the corresponding MIDI event

$$t \rightarrow t+1$$

Similarly, *AS* algorithm can be used simultaneously for numerous artificial ants to compose other expressions. There is no need for all the agents to play the MIDI events they encounter, which is useful to quickly build a path in the graph. Additionally, some agents can stay silent and collectively build the melody (Guéret et al., 2004).

3.3.3 Ant Colony Optimization (ACO)

Dorigo and colleagues introduced *ant colony optimization (ACO)* (Dorigo et al., 1991). The major difference between *ACO* and AS algorithms is the decision rule used by ants during the construction process which is known as the pseudorandom proportional rule (Dorigo & Gambardella, 1997).

3.3.3.1 Procedure

ACO minimizes a cost function through a few probabilistic steps using history (pheromone) and heuristic information. Similar to *AS*, an artificial ant moves from node i to node j with probability:

$$p_{ij} = \frac{\phi_{ij}^{\alpha} d_{ij}^{\beta}}{\sum_{i,j=1}^{n} \phi_{ij}^{\alpha} d_{ij}^{\beta}} \tag{3.18}$$

where d_{ij} is the heuristic information that maximizes the contribution to the overall score of selecting the route, and ϕ_{ij} is the pheromone intensity for the route. The coefficient to control the influence of ϕ_{ij} is α, and β is the heuristic coefficient to control the influence of d_{ij}. Their typical values are $\alpha \approx \beta \approx 1$.

The local pheromone update is:

$$\phi_{ij} \leftarrow (1 - \sigma)\phi_{ij} + \sigma \phi_0 \tag{3.19}$$

where ϕ_{ij} represents the pheromone for the graph edge (i, j), σ is the local pheromone factor, and ϕ_0 is the initial pheromone value. At the end of each cycle, the pheromone is updated and decayed using the best desired path, as follows:

$$\phi_{ij} \leftarrow (1 - \rho)\phi_{i,j} + \rho \Delta \phi_{i,j} \tag{3.20}$$

where ρ is the decay factor, and $\Delta \phi_{i,j}$ is the best used edge $(i,)$.

$$\Delta\phi_{i,j} = \begin{cases} 1/L_{Best} & \text{if ant used } (i, j)\text{edge in its last tour} \\ 0 & \text{otherwise} \end{cases}$$

L_{Best} can be set to either the length of the best iteration so far (L_{IB}) or the best solution found since the start of the algorithm (L_{BS}) (Brownlee, 2012). *ACO* generates a melody T_{max} through the following steps:

randomly choose a vertex for the initial position of each ant
initialize pheromone values:$\phi_{ij} \leftarrow \phi_0 \forall i, j$

$$t \leftarrow 0$$

while $t < T_{max}$:
choose the next MIDI event j according to the transition rule
deposit pheromones on chosen edge (ϕ_{ij})
move to vertex j and play the corresponding MIDI event

$$t \leftarrow t + 1$$

3.3.4 Particle Swarm Optimization (PSO)

Particle swarm optimization (PSO) is a population-based stochastic optimization technique, developed by Kennedy and Eberhart in 1995. *PSO* begins by searching the space of an objective function and adjusting the trails of individual agents (or particles) in a quasi-stochastic manner. The position of each particle is updated based on the agent's history (current and best previous locations), other members of the swarm (the global optimizer value), and random perturbations (Brownlee, 2012).

The new position of each particle is computed as the sum of its previous position with a quantity that is estimated according to several factors, depending on the *PSO* variant and eventually the swarm flock around a desired area.

There are two models of the *PSO* algorithm with different neighbourhood structures for each particle: the global best (g^*) and local best. In the global best model, the neighbourhood of a particle consists of the particles in the whole swarm that share information with each other. In the local best model, the neighbourhood of a particle is defined by several fixed particles. Poli (2008) demonstrated that the global best model converges faster than the local best model.

3.3.4.1 Procedure

Particle swarms act similarly to virtual flocks of *Boids* (Reynolds, 1987). However, they have less structured states than *Boids*, and are arranged in a N-dimensional space. *PSO* particles can change their positions by applying simple forces or accelerations. Each particle is composed of vectors $\{x, v, p\}$ where $x = (x_1, \ldots, x_N)$, $v = (v_1, \ldots, v_N)$ are the particle position and velocity, and p is the particle attractor (an N-dimensional vector).

Musical *PSO* differs from the usual *PSO* algorithm because there is no concern about the global and neighbourhood bests. As a result, the musical swarm is not trying to optimize any function. Instead, the target force links the swarm to an external source. Blackwell and Bentley (2002) suggested constraining the *PSO* particles to a target cube to create music.

Musical *PSO* is similar to the flocking behaviour of *Boids* (Reynolds, 1987), since each particle experiences a number of accelerations. The particles follow one or more acceleration forces (i.e., attractive, velocity, avoidance) as described in Table 3.1. An attractive acceleration draws particles toward the target, a velocity matching acceleration encourages motion toward the centre of the flock, and the avoidance acceleration prevents collisions. These accelerations are summed then and added to the particle's initial velocity, which in turn is added to the particle position and advances the particle via:

$$a_i = a_{iavoid} + a_{icentre} + a_{itarget} \tag{3.21}$$

$$\begin{cases} a_{iavoid} = 0, & if\, r_{ij} \geq p \\ a_{iavoid} = 0, & if\, p_{core} < r_{ij} < p \\ a_{iavoid} = a_{core}, & if\, r_{ij} \leq p_{core} \end{cases} \tag{3.22}$$

The accelerations in *PSO* are spring-like attractions (a collision avoiding acceleration and a velocity matching term):

$$a_{icentre} = C_{centre}(x_{centre} - x_i) \tag{3.23}$$

$$a_{itarget} = C_{target}\left(x_{target} - x_i\right) \tag{3.24}$$

Table 3.1 *PSO* particle accelerations (Blackwell, 2003).

k	Description
1	Attractive acceleration towards the swarm centre of mass
2	Attractive acceleration towards the target group centre of mass
3	Attractive acceleration towards a particular target
4	Repulsive acceleration away from a neighbouring particle or from a particular target

where C_{centre} and C_{target} are spring constants, $r_{ij} = x_j - x_i$, x_{centre} and x_{target} are the centres of mass of the swarm (xi, vi) and the target swarm.

In 2002 Blackwell and Bentley proposed an update parameter (UP) consisting of the acceleration constants:

$$UP = C_{avoid}, p_{core}, p, a_{core}, C_{centre}, C_{target}, v_{max}, x_{target} \qquad (3.25)$$

where v_{max} is a clamping or limiting speed and x_{target} is a target cube length limit, which is only relevant for the computation of inter-particle repulsion.

To summarize, musical PSO captures external events as targets, uses the UP algorithm to update particles position within a cube, then considers these positions as MIDI events.

3.3.5 Stochastic Diffusion Search (SDS)

Bishop (1989) suggested the *Stochastic Diffusion Search (SDS)* algorithm for solving population-based and matching problems. Unlike stigmergic communication employed in *AS* and *ACO* (modification of the environment properties), *SDS* uses a direct communication mechanism inspired by the foraging behavior of *Leptothorax acervorum* ants known as tandem calling.

3.3.5.1 Procedure

In *SDS*, a population of agents searches for the best solution in the search space (S). Each point in S has an objective value and function. When operating, each agent maintains a hypothesis about the best solution (a candidate solution), or designates a point in the solution space with no priori assumptions about the representation of hypotheses. Agents follow two phases:

Test Phase (hypothesis evaluation): each agent randomly selects a function (f_i) and evaluates it against the hypothesis $(s_h \in S)$. Depending on the outcome, the agents get divided into one of two clusters:

$$\begin{cases} Active if f_i(s_h) = 0 \\ Passive if f_i(s_h) = 1 \end{cases} \qquad (3.26)$$

Diffusion Phase (exchanging information): each passive agent randomly selects another agent. If the selected agent is active, the passive agent adopts the hypothesis of the active agent. If the selected agent is passive, it generates a random hypothesis from the search space.

Many artists adapted *SDS* to produce *NPR* by assigning agents to 2D coordinates that carry colour attributes (i.e., RGB values) of the input image (al-Rifaie, 2012;

al-Rifaie & Bishop, 2013a, b) and then following test and diffusion phases similar to the original *SDS* algorithm:

Test Phase: here the colour distance of each agents from fc is calculated by:

$$dic = d(fc, Aic) = \sqrt{(Rfc - RAic)2 + (Gfc - GAic)2 + (Bfc - BAic)2}$$

$$(3.27)$$

where fc is an initial focal colour and Aic is the colour (with respective RGB values) associated with the ith agent.

Diffusion Phase: here each of inactive agents randomly picks a value. If the selected agent is active, the inactive agent adapts its distance and colour, and adds paint to the canvas. If the selected agent is passive, the inactive agent generates a random (x, y) coordinate from the search space. The status of the newly modified agent will be defined in the test phase of the next iteration.

More recently al-Rifaie and al-Rifaie (2015) proposed using *SDS* for generative music by vocalizing the agents and comparing the differences between pitches, note durations, and dynamic (or volume) of letters, words or longer string of characters with MIDI numbers.

3.3.6 KANTS

KANTS (Fernandes, 2008a, b) is a swarm clustering algorithm and photograph rendering technique, inspired by the stigmergy behaviour of ants. *KANTS* combines some features of the AS algorithm (Chialvo & Millonas, 1995) with *Kohonen Self-Organizing Map (SOM)* (1982). *SOM* is an unsupervised neural network that imitates the self-organization of the human brain, and is capable of grouping a set of inputs into clusters with similar features.

KANTS was partially inspired by the *KohonAnts* model (Chialvo & Millonas, 1995). However, instead of using the 2D homogeneous lattice structure of *KohonAnts*, *KANTS* uses a 2D grid mapped to each cell (the environment is a grid of vectors). Similar to the stigmergy behaviour of ants, the swarm communicates indirectly via the environment. This results in emergent clusters at a global level.

3.3.6.1 Procedure

KANTS algorithm simulates the emergent properties of artificial ants that move within a 2D grid of vectors mapped to each cell (habitat). The swarm communicates indirectly via the environment (similar to the stigmergy behaviour of ants).

The grid is then mapped to an array ($N \times N \times d$), in which d is the dimension of the data vectors of the target-problem, and $N \times N$ is the dimension of the grid. Initially, the grid vectors are set to a random value, and the ants are randomly placed

in the grid. In each subsequent iteration, ants move around in the lattice and modify the cells' vector values via pheromonal response similar to *AS*:

$$\phi = \left(1 + \frac{\sigma}{1 + \delta\sigma}\right)^{\beta} \tag{3.28}$$

$$p_{ij} = \frac{\phi_{ij}^{\alpha} d_{ij}^{\beta}}{\sum_{i,j=1}^{n} \phi_{ij}^{\alpha} d_{ij}^{\beta}} \tag{3.29}$$

The parameter $\beta(\beta \geq 0)$ is associated with *Osmotropotaxic* sensitivity. *Osmotropotaxis* was recognized by Wilson (1971) as one of two fundamental types of an ant's ability to sense and process pheromones. In other words, parameter controls the degree of randomness with which the ants follow the gradient of pheromone.

The parameter $\delta(\delta \geq 0)$ defines the sensory capacity $(1/\delta)$, which describes ants ability decreases to sense pheromone at high concentrations. This means that ants tend to move away from a trail when the pheromone reaches a high concentration, leading to a peaked function for the average time an ant will stay on a trail, as the concentration of pheromone is varied.

The pheromone density in equation σ is defined as the inverse of the *Euclidean* distance (v_a, v_c) between the vector carried by ant $n(v_{an})$ and the vector in cell (i, j) at time-step $v_{cij}(t)$:

$$\sigma = \frac{1}{d\left(v_{an}, v_{cij}(t)\right)} \tag{3.30}$$

Each cell holds a vector of the same dimension and range as the input. The environment's change depends on the values of the ant's vector. Therefore, ants tend to move toward the zones in the grid which are more similar to themselves (to their associated vectors). So, their position and pheromone content co-adapt, which means eventually ants with similar data items will be closer together in the grid:

$$v_c(t) = v_c(t-1) + \alpha\left[1 - \left(v_a, v_{cij}(t)\right)\right]\left(v_a - v_{cij}(t-1)\right) \tag{3.31}$$

Finally, the grid vectors are all evaporated in each time-step. In *KANTS*, evaporation is achieved by updating the values according to:

$$v_c(t) = v_c(t) - k(v_c(t) - v_{ic}) \tag{3.32}$$

where k is the evaporation rate (a small value, in the range of $[0.001, 0.1]$), and v_{ic} is the vector's initial state at $(t = 0)$.

Fernandes et al. (2012) used *KANTS* for *NPR*. They proposed a technique known as *Pherogenic* sleep drawings, based on a previous study about *KANTS*'s abilities to classify sleep stages. The drawings used a set of 3D vectors (sleep EEG signals) as input data vectors to generate pherogenic input adapted from Mora et al. (2010) which

uses an ant-based edge-detection mechanism called *Pherographia* or *Pheromone Maps* and creates 2D abstract representations of sleep.

Fernandes et al. (2015) further explored the application of *KANTS* for photo renderings using the RGB values of an image as input and contextualized its application for swarm art as shown in Fig. 4.4.

References

al-Rifaie, M. M., Bishop, J. M., & Caines, S. (2012). Creativity and autonomy in swarm intelligence systems. *Cognitive Computation, 4*(3), 320–331. https://doi.org/10.1007/s12559-012-9130-y.

al-Rifaie, M. M., & Bishop, J. M. (2013a, April). Swarmic sketches and attention mechanism. In *International Conference on Evolutionary and Biologically Inspired Music and Art* (pp. 8596). Springer, Berlin, Heidelberg. https://doi.org/10.1007/978-3-642-36955-1_8.

al-Rifaie, M. M., & Bishop, J. M. (2013b). Swarmic paintings and colour attention. In *International Conference on Evolutionary and Biologically Inspired Music and Art* (pp. 97–108). Berlin, Heidelberg: Springer. https://doi.org/10.1007/978-3-642-36955-1_9.

al-Rifaie, A. M., & Al-Rifaie, M. M. (2015). Generative music with stochastic diffusion search. In *International Conference on Evolutionary and Biologically Inspired Music and Art* (pp. 1–14). Cham: Springer. https://doi.org/10.1007/978-3-319-16498-4_1.

Aupetit, S., Bordeau, V., Monmarché, N., Slimane, M., & Venturini, G. (2003, December). Interactive evolution of ant paintings. In *The 2003 Congress on Evolutionary Computation, CEC'03.* (Vol. 2, pp. 1376–1383). IEEE.

Bishop, J. M. (1989). Stochastic searching networks. In *1989 First IEE International Conference on Artificial Neural Networks, (Conf. Publ. No. 313)* (pp. 329–331). IET.

Bisig, D., Schacher, J. C., Neukom, M. (2011). Flowspace-a hybrid ecosystem. In *NIME* (pp. 260–263).

Blackwell, T. (2003). Swarm music: Improvised music with multi-swarms. *Artificial Intelligence and the Simulation of Behaviour, University of Wales, 10*, 142–158.

Blackwell, T. (2007). Swarming and music. In *Evolutionary Computer Music* (pp. 194–217). Springer. https://doi.org/10.1007/978-1-84628-600-1_9.

Blackwell, T. (2008). Swarm granulation. In *The Art of Artificial Evolution* (pp. 103–122). Berlin, Heidelberg: Springer. https://doi.org/10.1007/978-3-540-72877-1_5.

Blackwell, T. M., & Bentley, P. (2002, May). Improvised music with swarms. In *Proceedings of the 2002 Congress on Evolutionary Computation. CEC'02 (Cat. No. 02TH8600)* (Vol. 2, pp. 1462–1467). IEEE.

Boyd, J. E., Hushlak, G., & Jacob, C. J. (2004). SwarmArt: interactive art from swarm intelligence. In *Proceedings of the 12th Annual ACM International Conference on Multimedia* (pp. 628–635). ACM. https://doi.org/10.1145/1027527.1027674.

Brownlee, J. (2012). *Clever algorithms, nature-inspired programming recipes, open source book.*

Braitenberg, V. (1986). *Vehicles: Experiments in synthetic psychology.* MIT press.

Burton, J. L., & Franks, N. R. (1985). The foraging ecology of the army ant Eciton rapax: an ergonomic enigma? *Ecological Entomology, 10*(2), 131–141.

Chan, M. T., Gorbet, R., Beesley, P., & Kulič, D. (2015). Curiosity-based learning algorithm for distributed interactive sculptural systems. In *2015 IEEE/RSJ International Conference on Intelligent Robots and Systems (IROS)* (pp. 3435–3441). IEEE. https://doi.org/10.1109/IROS.2015. 7353856.

Chialvo, D. R., & Millonas, M. M. (1995). How swarms build cognitive maps. In *The Biology and Technology of Intelligent Autonomous Agents* (pp. 439–450). Berlin, Heidelberg: Springer. https://doi.org/10.1007/978-3-642-79629-6_20.

Chu, X., Wu, T., Weir, J. D., Shi, Y., Niu, B., & Li, L. (2018). Learning-interaction-diversification framework for swarm intelligence optimizers: A unified perspective. Neural Computing and Applications, 1-21. https://doi.org/10.1007/s00521-018-3657-0.

Couzin, I. D., Krause, J., Franks, N. R., & Levin, S. A. (2005). Effective leadership and decision-making in animal groups on the move. *Nature, 433*(7025), 513–516.

Delgado-Mata, C., Martinez, J. I., Bee, S., Ruiz-Rodarte, R., & Aylett, R. (2007). On the use of virtual animals with artificial fear in virtual environments. *New Generation Computing, 25*(2), 145–169. https://doi.org/10.1007/s00354-007-0009-5.

Dorigo, M., & Gambardella, L. M. (1997). Ant colony system: A cooperative learning approach to the traveling salesman problem. *IEEE Transactions on Evolutionary Computation, 1*(1), 53–66. https://doi.org/10.1109/4235.585892.

Dorigo, M., Maniezzo, V., & Colorni, A. (1996). Ant system: optimization by a colony of cooperating agents. *IEEE Transactions on Systems, Man and Cybernetics, Part B (Cybernetics), 26*(1), 29–41. https://doi.org/10.1109/3477.484436.

Dorigo, M., Maniezzo, V., & Colorni, A. (1991). *The ant system: An autocatalytic optimizing process.*

Dorigo, M. (1992). *Optimization, learning and natural algorithms (PhD Thesis).* Politecnico di Milano.

Fernandes, C., Mora, A. M., Merelo, J. J., Ramos, V., & Laredo, J. L. J. (2008a). KohonAnts: a self-organizing ant algorithm for clustering and pattern classification. arXiv preprint arXiv:0803.2695.

Fernandes, C., Mora, A. M., Merelo, J. J., Ramos, V., Laredo, J. L., & Rosa, A. (2008b). KANTS: Artifical ant system for classification. In *International Conference on Ant Colony Optimization and Swarm Intelligence* (pp. 339–346). Berlin, Heidelberg: Springer. https://doi.org/10.1007/978-3-540-87527-7_35.

Fernandes, C. M. (2010). Pherographia: Drawing by ants. *Leonardo, 43*(2), 107–112. https://doi.org/10.1162/leon.2010.43.2.107.

Fernandes, C. M., Mora, A., Merelo, J. J., & Rosa, A. C. (2012). Pherogenic Drawings-Generating Colored 2-dimensional Abstract Representations of Sleep EEG with the KANTS Algorithm. In *International Conference on Evolutionary Computation Theory and Applications* (Vol. 2, pp. 72–80). *SCITEPRESS.*

Fernandes, C. M., Mora, A. M., Merelo, J. J., & Rosa, A. C. (2015). Photorealistic rendering with an ant algorithm. In *Computational Intelligence* (pp. 63–77). Springer, Cham. https://doi.org/10.1007/978-3-319-11271-8_5.

Gordon, D. (2010). *Ant encounters: Interaction networks and colony behavior.* Princeton University Press. https://doi.org/10.1515/9781400835447.

Greenfield, G., & Machado, P. (2015). Ant-and ant-colony-inspired alife visual art. *Artificial Life, 21*(3), 293–306. https://doi.org/10.1162/ARTL_a_00170.

Greenfield, G. (2005). Evolutionary methods for ant colony paintings. In *Workshops on applications of evolutionary computation* (pp. 478–487). Springer. https://doi.org/10.1007/978-3-540-32003-6_48.

Greenfield, G. (2006a). Ant paintings using a multiple pheromone model. In R. Sarhangi & J. Sharp (Eds.), *BRIDGES 2006 Conference Proceedings* (pp. 319–326).

Greenfield, G. (2006b). On evolving multi-pheromone ant paintings. In *2006 IEEE World Congress on Computational Intelligence. Vancouver: IEEE Press. WCCI06 Conference Proceedings (DVD-ROM ISBN: 0780394895)* (pp. 7425–7431).

Greenfield, G. (2011). Abstract overlays using a transport network model. In *Proceedings of Bridges 2011: Mathematics, Music, Art, Architecture, Culture* (pp. 45–50). Tessellations Publishing.

Greenfield, G. (2012). Stigmmetry prints from patterns of circles. In *Proceedings of Bridges 2012: Mathematics, Music, Art, Architecture, Culture* (pp. 291–298). Tessellations Publishing.

Greenfield, G. (2013). Ant paintings based on the seed foraging behavior of P. barbatus. In *2013 BRIDGES Conference Proceedings.*

Greenfield, G. (2013). On simulating seed foraging by red harvester ants. In *2013 IEEE Symposium on Artificial Life (ALife)* (pp. 105–112). IEEE. https://doi.org/10.1109/ALIFE.2013.6602438.

Greenfield, G., & Sarhangi, R. (2014). Target curves for pick-up, carry and drop mobile automata. In *Bridges 2014 Conference Proceedings* (pp. 381–384).

Guéret, C., Monmarché, N., & Slimane, M. (2004, September). Ants can play music. In *International Workshop on Ant Colony Optimization and Swarm Intelligence* (pp. 310–317). Springer, Berlin, Heidelberg. https://doi.org/10.1007/978-3-540-28646-2_29.

Hartman, C., & Benes, B. (2006). Autonomous boids. *Computer Animation and Virtual Worlds, 17*(3–4), 199–206. https://doi.org/10.1002/cav.123.

Jacob, C. J., Hushlak, G., Boyd, J. E., Nuytten, P., Sayles, M., & Pilat, M. (2007). Swarmart: Interactive art from swarm intelligence. *Leonardo, 40*(3), 248–254. https://doi.org/10.1162/leon.2007.40.3.248.

Jones, J. (2010). Characteristics of pattern formation and evolution in approximations of Physarum transport networks. *Artificial Life, 16*(2), 127–153. https://doi.org/10.1162/artl.2010.16.2.16202.

Jones, D. (2008). AtomSwarm: A framework for swarm improvisation. In *Workshops on Applications of Evolutionary Computation* (pp. 423–432). Berlin, Heidelberg: Springer. https://doi.org/10.1007/978-3-540-78761-7_45.

Kaplan, F. (2000). *L'Émergence d'un Lexique dans une Population d'Agents Autonomes Ph.D. diss.* University of Paris VI.

Kohonen, T. (1982). Self-organized formation of topologically correct feature maps. *Biological Cybernetics, 43*(1), 59–69. https://doi.org/10.1007/BF00337288.

Machado, P., Martins, T., Amaro, H., Abreu, P. H., Martins, T., Machado, P., & Martins, T. (2013). Evolving stencils for typefaces: Combining machine learning, user's preferences and novelty. *Complexity, 49*, 64–78.

Machado, P., & Pereira, L. (2012). Photogrowth: Non-photorealistic renderings through ant paintings. In *Proceedings of the 14th annual conference on Genetic and evolutionary computation* (pp. 233–240). ACM. https://doi.org/10.1145/2330163.2330197.

Minsky, M. (1982). Music, mind, and meaning. In *Music, mind, and brain* (pp. 1-19). Springer. https://doi.org/10.1007/978-1-4684-8917-0_1.

Mora, A. M., Fernandes, C. M., Herrera, L. J., Castillo, P. A., Merelo, J. J., Rojas, F., & Rosa, A. C. (2010). Sleeping with ants, SVMs, multilayer perceptrons and SOMs. In *2010 10th International Conference on Intelligent Systems Design and Applications* (pp. 126–131). IEEE. https://doi.org/10.1109/ISDA.2010.5687278.

Moura, L. (2002). Swarm paintings-non-human. *ARCHITOPIA Book, Art, Architecture and Science* 1–24.

Oudeyer, P. Y., Kaplan, F., & Hafner, V. V. (2007). Intrinsic motivation systems for autonomous mental development. *IEEE Transactions on Evolutionary Computation, 11*(2), 265–286. https://doi.org/10.1109/TEVC.2006.890271.

Oudeyer, P. Y., Kaplan, F., Hafner, V. V., & Whyte, A. (2005). The playground experiment: Task-independent development of a curious robot. In *Proceedings of the AAAI Spring Symposium on Developmental Robotics* (pp. 42–47). California: Stanford.

Poli, R. (2008). Analysis of the publications on the applications of particle swarm optimisation. *Journal of Artificial Evolution and Applications, 2008*, 1–10. https://doi.org/10.1155/2008/685175.

Ramos, V., & Almeida, F. (2004). Artificial ant colonies in digital image habitats-a mass behaviour effect study on pattern recognition. arXiv preprint cs/0412086.

Reynolds, C. W. (1987). Flocks, herds and schools: A distributed behavioral model. *In SIGGRAPH '87 Conference Proceedings* (Vol. 21, No. 4, pp. 25–34). Anaheim, CA: ACM Press. https://doi.org/10.1145/37401.37406.

Sayles, M., Wu, X., & Boyd, J. E. (2003, January). Caml: Camera markup language for network interaction. In *Internet Imaging IV. International Society for Optics and Photonics.* (Vol. 5018, pp. 248–256). https://doi.org/10.1117/12.476176.

Semet, Y., O'Reilly, U. M., & Durand, F. (2004). An interactive artificial ant approach to non-photorealistic rendering. In *Genetic and Evolutionary Computation Conference* (pp. 188–200). Berlin, Heidelberg: Springer. https://doi.org/10.1007/978-3-540-24854-5_17.

Shiffman, D. (2004). *Swarm, ACM SIGGRAPH 2004 Emerging Technologies Proceedings* (p. 26). New York: ACM Press. https://doi.org/10.1145/1186155.1186182.

Todd, P. M., & Miranda, E. R. (2006). Putting some (artificial) life into models of musical creativity. In *Musical Creativity* (pp. 392–412). Psychology Press.

Tzafestas, E. S. (2000). Integrating drawing tools with behavioral modeling in digital painting. In *Proceedings of the 2000 ACM Workshops on Multimedia* (pp. 39–42). ACM. https://doi.org/10.1145/357744.357756.

Unemi, T., & Bisig, D. (2005). Flocking Orchestra-to play a type of generative music by interaction between human and flocking agents. In *Proceedings of the eighth Generative Art Conference* (pp. 19–21).

Urbano, P. (2006). Consensual paintings. In *Workshops on applications of evolutionary computation* (pp. 622–632). Springer. https://doi.org/10.1007/11732242_59.

Urbano, P. (2011). The T. albipennis sand painting artists. In *European Conference on the Applications of Evolutionary Computation* (pp. 414–423). Heidelberg: Springer, Berlin. https://doi.org/10.1007/978-3-642-20520-0_42.

Urbano, P. (2005a). Playing in the pheromone playground: Experiences in swarm painting. In F. Rothlauf et al. (Eds.), *Applications of Evolutionary Computing, EvoWorkshops 2005 Proceedings* (pp. 478–487). Heidelberg: Springer. https://doi.org/10.1007/978-3-540-32003-6_53.

Urbano, P. (2008). Swarm Exquisite-Corpses Games. In *AAAI Spring Symposium: Creative Intelligent Systems* (pp. 110–116).

von Mammen, S., & Jacob, C. (2007a, September). Genetic swarm grammar programming: Ecological breeding like a gardener. In *2007 IEEE Congress on Evolutionary Computation* (pp. 851–858). IEEE. https://doi.org/10.1109/CEC.2007.4424559.

von Mammen, S., & Jacob, C. (2007b). Swarm grammars: Growing dynamic structures in 3D agent spaces. *Digital Creativity, 18*(1), 54–64. https://doi.org/10.1080/14626260701253622.

von Mammen, S., Wong, J., & Jacob, C. (2008, March). Virtual constructive swarm compositions and inspirations. In *Workshops on Applications of Evolutionary Computation* (pp. 491–496). Springer. https://doi.org/10.1007/978-3-540-78761-7_53.

Walter, W. G. (1951). A machine that learns. *Scientific American, 185*(2), 60–64.

Weisstein, E. W. (2005). Moore neighborhood. From MathWorld-A Wolfram Web Resource. https://mathworld.wolfram.com/MooreNeighborhood.html.

Wilson, E. O. (1971). *The social insects.* The Belknap Press of Harvard University Press.

Wilson, E. O., & Hölldobler, B. (1994). *Journey to the ants: A story of scientific exploration.* Belknap Press of Harvard University Press.

Chapter 4
System Output

In this Sect. 4.1 classify the analyzed swarm systems into five categories based on their type of output. First, I review visual artworks including digital drawing, image rendering, and painting. This is followed by a discussion of moving images including generative videos and movies.

I then consider audio and audio/visual artworks involving musical compositions, improvizations, and soundscapes, followed by a discussion about works with audio-visual output as well as sculptural and modelling outputs. I conclude by discussing immersive and haptic artworks (virtual and augmented reality).

4.1 Visual Output

I categorized the selected works in this section by visual type. These works present visual information and do not occupy space beyond a canvas or a screen. They, therefore, do not create any sense of spatial immersion. In their attempts to demystify swarm intelligence and visualize its features and behaviours, artists and architects have explored swarm agent activity and translated it into digital prints and drawings. This resulted not only in original art but also opened new techniques for solving rendering and visualization problems.

4.1.1 Digital Drawing

Generative art is a contemporary trend that uses autonomous agents to generate artworks by following a set of rules. During the last decade, many artists used swarm intelligence as a new tool to create art such as abstract paintings on a virtual canvas.

Adapted swarm algorithms consist of collective artificial agents, each assigned with a particular colour that follow a set of simple rules. For example, the agents

© The Author(s), under exclusive license to Springer Nature Singapore Pte Ltd. 2021 41
M. Salimi, *Swarm Systems in Art and Architecture*, Computational Synthesis and Creative Systems, https://doi.org/10.1007/978-981-16-4357-6_4

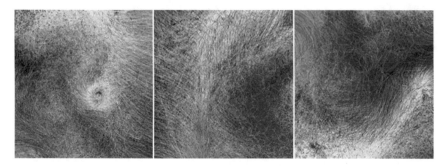

Fig. 4.1 A series of three images that document MicroImage (Software 2) © Image Credit: Reas (2002–2014)

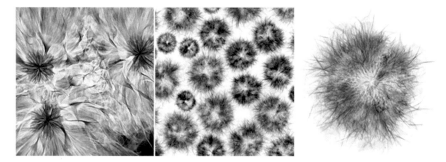

Fig. 4.2 Left, Process 6; center, Process 6 (Image 4), Photo Rag 28.6 in. Edition of 5 + 1 AP; right, Process 6 (Puff 12), Archival pigment print on Hahnemühle Photo Rag 12 in. © Image Credit: Reas (2005)

can move around the 2D or 3D canvas and leave a trace behind. Over time, the trails fade, adding depth and a sense of temporal dynamics to the final image. *MicroImage* (Reas, 2002–2014) and *Process* (Reas, 2005) are two swarm software that generate digital drawings. These works are created by a multi-agent architecture from the repetition of relatively simple rules that explore the concept of emergence (Figs. 4.1 and 4.2).

You Pretty Little Flocker (Eldridge, 2008–12) is another swarm software that produces a series of generative swarm drawings inspired by Reynolds's flocking algorithm (1987). The system generates still images influenced both by user's input and the internal generative model (Fig. 4.3).

4.1.2 Image Rendering

In contrast to traditional computer graphics that emphasize on photorealism, *NPR* not only renders images but also draws inspiration from a variety artistic genre including

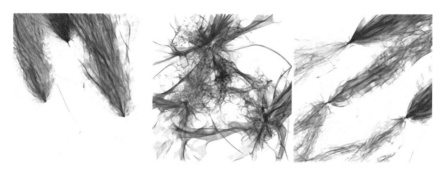

Fig. 4.3 You Pretty Little Flocker (2008) illustrates the effect of altering size preference (SP) on the resultant form. Left, SP = 1; center, SP = 0; right, SP = 0.5. © Image Credit: Eldridge (2015)

paintings, drawings, comics, and digital illustrations. *NPR* embraces techniques long-used by painting artists for example emphasizing the key details such as light, shadow and texture (Gooch, 2001).

Artists have expanded *NPR* rendering techniques by considering natural phenomena such as swarm intelligence. Semet et al. (2014) proposed a hybrid inter-active approach using painterly and pencil sketch renderings, and the *ACO* algorithm to create *NPR* images. Their interactive system lets the user change the initial settings and control the evolution aesthetics of the renderings. A more recent artwork from their system known as *Dancer* (2014) was displayed at the Leonardo Swarm Art Gallery.

Fernandes (2010) proposed drawing with pheromones (*Pherographia*) as a naive approach to drawing by simulating pheromone as a communication tool between the artificial ants. As discussed in Sect. 3.3.2, *Pherographia* is inspired by the stigmergic and cooperative behaviour of ants.

Fernandes et al. (2012, 2013) used *KANTS* to generate non-figurative render-ings. They used data clustering techniques such as *SOM* networks to generate a piece of art that won the Evolutionary Art, Design and Creativity Competition (2012). Here, *KANTS* take the RGB values of photographs as input and generate abstract artistic renderings. The resulting images are called *Pherogenic* paintings, since the pheromone maps of *AS* algorithm are used as the output vectors to generate them. *Pherogenic* paintings (Fernandes et al., 2015) are *Pherographs* (photorealistic renderings) with a *KANTS* algorithm to generate the pheromone maps as shown in Fig. 4.4.

Photogrowth (Machado & Pereira, 2012) is an evolutionary approach for *NPR* inspired by ant-colony techniques similar to those of Semet et al. (2014). *Photogrowth* generates novel outputs from an evolutionary system with sensory parameters as opposed to the fixed parameters used in *Pherographia*.

Kamolov et al. (2013) modified *Photogrowth* model and made it interactive. They added a fitness evaluation (based on behavioural and image features) to control the artworks' evolution. A more recent version of *Photogrowth* is *insta.ants* (Machado & Martins, 2018) which generates unique artworks from Instagram posts. A bot

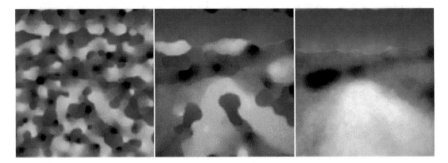

Fig. 4.4 *Pherogenic paintings* (2015) with a photograph as the initial grid, the RGB values of the same photo as input data vectors and different *r* values (the radius of action of each ants). © Image Credit: Fernandes et al. (2015)

systematically collects images from Instagram posts tagged #instaants, and feeds them into the painting system. The resulting digital drawings are exhibited on an Instagram profile (Fig. 4.5).

Machado et al. (2014) extended the responsive fitness function for *NPR* guided by user feedback. The input image was selected by the user, after each run, the user reviewed the results, selected the favorite results, and designed additional set of fitness functions. This process was repeated iteratively resulting in a total of 15 fitness functions and 150 evolutionary runs. The results show that the characteristics of the painting (i.e., line style) are inherent to the ant species not the environment (i.e., input image). So, applying the same ant species to different input images tends to result in ant paintings with similar aesthetic qualities as shown in Fig. 4.6.

In a different technique, al-Rifaie et al. (2012) used ant-foraging and bird-flocking algorithms to create a series of swarm drawings based on random behaviours using *Gaussian* random distance and direction. Next, al-Rifaie and Bishop (2013) proposed *Swarmic Sketches* for *NPR* and computational creativity by deploying the mechanism of colour attention. They combined a modified *PSO* (Shi & Eberhart, 1998) with *SDS*

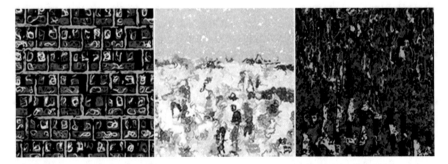

Fig. 4.5 *insta.ants* (2018) examples from Instagram Gallery resulted from different ant species with unique behaviour, sensory capabilities, life span, and reproduction rate. © Image Credit: Machado and Martins (2018)

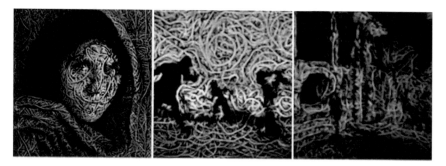

Fig. 4.6 *Ant painting* (2014) NPRs of three different input images using the same evolved ant species that resulted in similar aesthetics. © Image Credit: Machado et al. (2014)

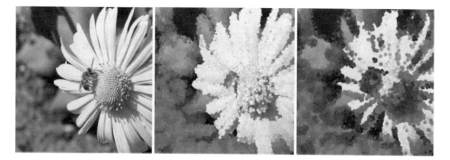

Fig. 4.7 *Swarmic Sketches* (2013) Left, the input; right, two output renderings. While the output images represent the input image to some extent, each is unique and different from the other (due to freedom and constraints of the swarms). © Image Credit: al-Rifaie and Bishop (2013)

algorithms to create unique *NPRs* in which ant species (*PSO* particles) move within a digital canvas in an attempt to satisfy their dynamic roles with *SDS* control for attention to areas with more details (Fig. 4.7).

Another method is to combine several images for creating aesthetic montages. *Aesthetic agents* (Love et al., 2012) is a swarm intelligence–based multi-agent system that produces expressive imagery using different agent populations competing to draw different images (Fig. 4.8).

4.1.3 Drawing and Painting

Swarm drawings demonstrate the potential of a new kind of art (i.e., non-human *art*) based on artificial creativity. The human acts as a leader/influencer of an intelligent system with emergent behaviour. To expand the artistic creation, artists such as Leonel Moura and Italian studio Carlo Ratti Associati used autonomous robots with embedded reactive and stigmergic behaviours inspired by ants.

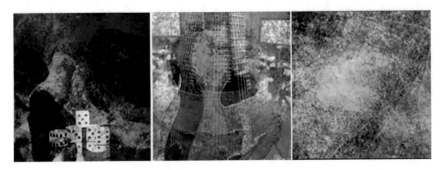

Fig. 4.8 *Aesthetic Agents* (2012) Left, created by assigning Aesthetic Agents to three images (a skull, a lotus flower, dice); center, montage from three images of a guitar; right, abstracted image made from ten different images of a nude figure. © Image Credit: Love et al., (2012)

Leonel Moura (2002) coined the term *swarm art* and was the first to identify it as a new kind of art using painter robots to create *swarm paintings* with distinct patterns and compositional aesthetics. Creativity in these artworks emerges from the self-organizing behaviour of the robots driven by their interaction with the environment and an indirect communication strategy (the colour trace or patch of the other robots). A pioneer artwork in this category is *ARTsBot* (Moura, 2002), a series of painting by 10 ant-like robots that are capable of distributed feedback, and *collective behaviour. The Robots moved by 3 wheels while carrying two marking-pens and therefore were capable of adding and sensing ink (the chromatic stimulus presence) within a canvas. As Moura stated this series of robots was based on Subsumption Architecture* (Brooks, 1986)*which describes the agent as composed of functionally distinct control levels, conceived under a layered approach without a centralized control and action planning center.*

ArtsBot: Art Swarm of Robots (Moura & Pereira, 2004) is a series of swarm paintings created by 10 turtle-like robots (equipped with felt pens and sensors). *ArtsBot* follow an indirect communication mechanism (similar to the stigmergy behaviour of ants) and seek colour, determine if it is hot or cold, choose the corresponding pen and strengthen it by a constant or variable trace as shown in Fig. 4.9.

RAP: Robotic Action Painter (Moura & Ramos, 2007) is a series of *swarm paintings* done by an autonomous robot capable of random initialization, positive feedback, and adjustment of the intensity of colour as a pheromone apparatus. The robot decides when the artwork is complete. Unlike the previous robots which relied on humans to finish the artwork, *RAP* makes autonomous aesthetic decisions on its own.

The Robot Quartet (Wanner, 2012) is a series of drawings created by a group of 4 robots (Fig. 4.10). The robots are individually controlled but together create a repetitive pattern. This artwork explores the poetic space that lies beyond human control over machine. The robots embrace imperfections and its role in artistic expression.

A more advanced and recent ant-like painting robot is *BeBot* (Moura, 2018), built for the Astana Expo2017 (Fig. 4.11). Here, each robot detects its own colour (blue, red or green) and reacts to it. To start the process, some initial lines of colour are

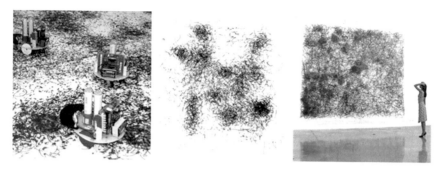

Fig. 4.9 A large painting done by *ArtsBot: Art Swarm of Robots* (2004) for robot exhibition at Stedelijk Museum, Amserdam. © Image Credit: Moura and Pereira (2004)

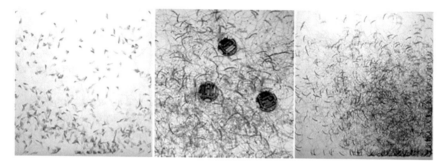

Fig. 4.10 *The Robot Quartet* (2012) Left, *Farewell to Canada*, patterns of different lines-qualities can be read as dancing figures, heart shapes, or falling leaves; right, *Composition 1.1* consists of different curves. The irregular density emerged independently of the algorithm. © Image Credit: Wanner (2012)

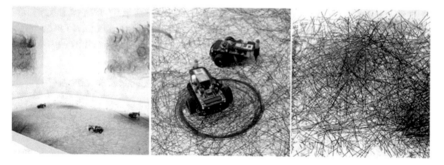

Fig. 4.11 *Bebot* (2017) installation *Artists and Robots* exhibition organized by the Réunion des Musées Nationaux—Grand Palais, at Astana Expo 2017. © Image Credit: Moura (2018)

drawn to which the robots are attracted. Once the canvas is filled with colour, the random behaviour stops. In such a fashion, small groups of robots (4–9) can generate unique paintings derived by emergent behaviours. These paintings demonstrate that creativity—a mechanism similar to intelligence—can be introduced into machines.

4.1.3.1 Swarm-like Painting

While examining drawings and paintings generated by the swarming behaviour of robots, I found other paintings representing swarm-like behaviours that had not explicitly used a swarming techniques or algorithms. For example, *Robotica: Control inside the panopticon* (Stanza, 2008) is an art installation with performative and interactive aspects created by a group of robots following a set of basic painting rules.

Signature Strokes (Wanner, 2014–15) is a series of short performative interventions in which a remotely controlled flying robot (drone) creates drip-paintings on the ground to leave a cyborganic handwriting signature influenced by aerodynamic patterns (Fig. 4.12).

Similarly, the Italian studio Carlo Ratti Associati produced art using drones. *Paint by Drone* (Ratti, 2017) is a portable system that harnesses an array of quadcopters, each loaded with spray-paint, capable of paintings. The drones are controlled by a central flocking system that monitors their positions in real-time. UFO Urban Flying Opera (Ratti, 2019) used a swarm of drones to create a large-scale (14 × 12 m) graffiti painting in Turin, using visual content submitted by hundreds of contributors.

Another example is *Drawing Operations* (Chung, 2015–18), a series of performative drawings based on a collaboration between a human and a group of robotic arms. Chung and these robotic units created improvised drawings with different themes such as mimicry, memory, the future speculations and the narrative of human and machine. Each thematic drawing showcases an evolving robotic behaviour linked to the artist's explorations of art and the artificial intelligence as shown in Fig. 4.13.

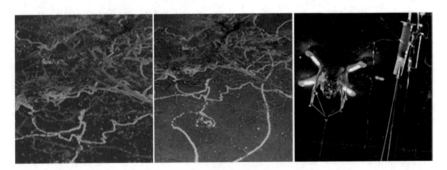

Fig. 4.12 *Signature Strokes* (2015) a play on the idea of *signature strikes* against terrorists by flying robots debuted at DISRUPTION: Opening Reception at the Vancouver Art Gallery, ISEA. © Image Credit: Wanner (2015)

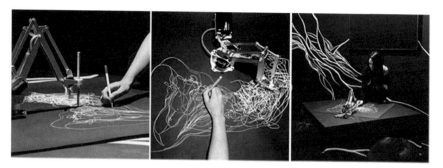

Fig. 4.13 *Drawing Operations* (2015) In collaboration with Yotam Mann. Commissioned by New Inc/New Museum, Redbull Studios New York. © Image Credit: Chung (2018a)

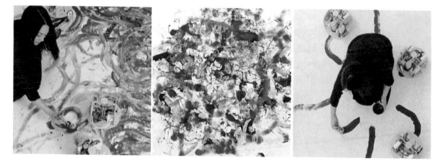

Fig. 4.14 *Omnia per Omnia* (2018) commissioned by Nokia Bell Labs as part of Experiments in Art and Technology artist residency program, organized by New Museum. © Image Credit: Chung (2018b)

Similarly, *Omnia per Omnia* (Chung, 2018b) is a series of landscape paintings, resulted from a collaboration between Chung, a group of robots, and dynamic flow of a city as shown in Fig. 4.14. Here, Chung explores the poetics of different modes of sensing: *human and machine, organic and synthetic, improvisational and computational*. Chung argues her goal as exploration of "the composite agency of human and machine as a speculation on new pluralities" which resulted in a drawing duet, and technological complexities articulated by *multi-agent bodies* (a human and twenty robots).

Likewise, *Exquisite Corpus* (Chung, 2019) is a 30 min performance in three acts between Chung and a group of robots that links Chung's biofeedback and the environment. The piece explores the feedback loop between bodies (the human body, the machinic body, and ecological bodies) and the artist's explorations of art and AI.

4.2 Moving Image Output

In my analysis, I examined artworks with different control systems that generate moving images. These images were controlled by a machine-learning algorithm, live swarm video, screen-based or virtual environments (VR tools).

Soma: self-organizing map ants (Barrass, 2001) is a set of moving images generated by a group of agents within a neural network called *Kohonen* self-organizing map (*SOM*). *SOMA* is a further exploration of a previous model for *laying down a path in walking* (Barrass, 2001). *SOM* controls ant's movement modified by the most recent pattern in the process. In each run the system generates unique drawings with different starting configurations, numbers of ants, trail persistence, sensor configurations, movement capabilities, trail colour, and colour responses as shown in Fig. 4.15 generates artefacts as the outcome of interactions amongst a group of agents within a neural net.

Another example is *SwarmArt* (Jacob & Hushlak, 2003–2005), a series of interactive video installations with moving images, such as virtual paintings. The participant can control the behaviour of the visuals by waving their hand. The swarm drawing examples in Fig. 4.16 illustrate how simulated swarming can be used to generate

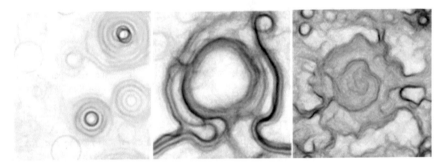

Fig. 4.15 *Soma: self-organizing map ants* (2001) artefacts. © Image Credit: Barrass (2001)

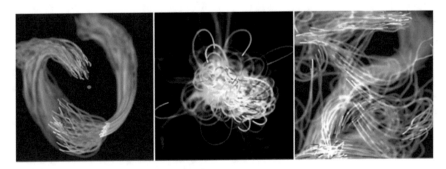

Fig. 4.16 *BoidLand swarm drawings* from *SwarmArt* (2003) installation at Nickle Arts Museum, University of Calgary (2003). © Image Credit: Jacob and Hushlak (2008)

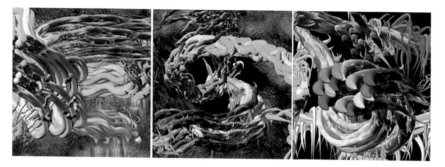

Fig. 4.17 Appearance of *SwarmPainter* (2007) agents, the examples illustrate the movements of the agents (swarm, particle, and texture) on the 2D canvas. © Image Credit: Jacob et al. (2007)

abstract paintings on a virtual canvas. Here the swarm agents follow a user-directed cursor (red dot), which can influence the movement of the swarm. Each agent has a particular colour assigned and leaves a trail behind while it is moving across the 2D or 3D canvas. Over time, the trails are fading, which introduces depth and a sense of temporal dynamics into the pictures.

Similarly, *swarmPAINTER* (Jacob et al., 2007) is a tool to create a large variety of moving images and *SwarmScapes* as shown in Fig. 4.17. Here, the user can influence the swarm behaviour and its characteristics such as appearance, speed, direction, etc. in a 2D or 3D canvas.

Jacob and Hushlak (2008) extended the capability of *swarmPAINTER* by adding an evolutionary algorithm. *evoSwarmPAINTER* can generate evolutionary environments influenced by a user selection. The user controls the future design cycles (generations) by making choices in the current collection of designs, and evaluating them according to specific criteria, such as aesthetics, symmetry, etc. These selections then influence the evolution of the *SwarmScapes* and the behavioural flow of the system.

4.3 Audio Output

Sound art as a conceptual-emotive medium influences art culture. Contemporary artists explore sound in its pure state, simultaneously bridging and blurring the notions of sound, noise, and music. An emerging trend in sound art is to use swarm of musical agents or events to create musical improvizations, sonifications, and orchestrations.

For an interactive system to move past being just a perplexing melodic instrument with a direct reactive mapping of input-to-sonification, it must have some degree of autonomy in the composition and generation of music. Interactive frameworks enable compositional structures through performance and improvisation with the synthesis encoded in the framework of procedures, algorithms, and mappings. The

interaction must be two-sided—the performer influences the music and the music influences the performer. *Interactive Swarm Orchestra (ISO)* (Bisig et al., 2008) is an interactive swarm project for musical improvizations, and sonifications. Bisig et al. proposed a complex system approach using flocking algorithms, *ALife* and generative models to generate/control 3D sound synthesis, positioning, and movement of simultaneous sound event. Moreover, the embedded camera tracking system allows visitors to interact with the acoustic flock and change its spatial distribution or synthesis properties.

Bouchard and Ens (2018) introduced *Flock to Music*, an interactive tool for swarm orchestra based on 2D model of flocking birds. The system generates a composition by interpreting the initial data into a variety of musical parameters: frequency, rhythm, amplitude, chords, modes and timbral combination. The composer can choose the number of *Boids* (the point where they start and end on the x-axis and y-axis), the duration of the composition or a part of a larger composition, and the frame rate along with fifteen other flocking parameters that are directly related to the way birds react to each other while in flight.

Liminal Tones: A/Autumn Swarm (Salimi & Pasquier, 2021a) is a series of sound textures made by multiply (up to 10) DC motors (as sound objects) that sync and swarm together and generate noise music. Salimi & Pasquier used a PSO-based PID controller adapted from Hashim and Mustafa (2020) to control the behaviour of sound objects (speed and oscillation of DC motors) which in turn influence the behaviour of sound objects and the generated sounds (pitch and timbral qualities). In a different approach they further explored swarm dynamics and influence of materiality to generate sound textures (acoustic aesthetics). They used a series of (5–7) small and simple ant like-robots known as BBots (modified BristleBots) that move within a canvas (i.e., wood, ceramic, granite) and generate sound. The results are a series of sound textures with different timber and pitch qualities know as *Liminal Tones: B/Rain Dream (*Salimi & Pasquier, 2021b).

4.3.1 Music Composition

Swarm Tech-Tiles (Blackwell & Jefferies, 2005) is an experimental visual and sonic texture that utilizes audio samples from two channels, scaled to pixel values to create a 2D image with texture. Areas with high texture qualities attract swarms which in turn generate granulated sound, deters attractors and draws other swarms. The textures are connected by swarm *Tech-Tiles* where each of them is either a segment of the image or a sequence of audio samples. An image can be altered to a *Tech-Tile* then be played as a composition. Alternatively, a swarm of small *Tiles* can fly over the image to generate a sonic improvisation. In each case, the spatial (visual) structure is mapped to a temporal (sonic) structure as shown in Fig. 4.18.

Unnamed system (Beyls, 2007) is a music composition operating in a 2D space with a MIDI player. The behaviour of a swarm is directed by their position, energy and attraction levels, the actuation level, and a personality. Swarm movement is

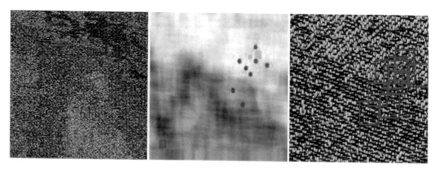

Fig. 4.18 *Swarm Tech-Tiles* (2005) Left, Uniform and Laundry by Janis Jefferies; center & right, background shows a few seconds of woven sound, particles (blue disks), attractors (green circles), and microtextures rendered into sound (red squares). The image also shows texture washing, a dilution of local textures as a result of rendering. © Image Credit: David Ramkalawon & Blackwell and Jefferies (2005)

controlled by a stress factor similar to the cohesion/separation in the flocking algorithm. Individuals form clusters, and sound is produced by the first agent in the cluster with the most energy. The agent's personality also determines the melody's pitch-intervals, duration, and velocities. Other agents in the cluster add to the melody only if their activation level is high enough, whereas all swarm individuals in *Swarm-PI* contribute to the sound produced. *Swarm-PI* (Mauceri & Majercik, 2017) is similar to Blackwell's swarm system (*SWARMUSIC*) however, instead of using audio input as an attractor, Mauceri and Majercik (2017) used audio input as another swarm (in *Swarm-PI*, the human performer is represented with a swarm avatar in the swarm space).

AtomSwarm (Jones, 2008) is a flocking system and complex sonic ecosystem, in which the classical flocking algorithm is combined with genetically-encoded behaviours, hormonal flows, and viral memes. The generated system is thus capable of temporal adaptation, emergent and self-organizing life-like behaviours. The virtual hormones affect the behaviour of individuals and the genetic component regulates and modifies the musical behavior.

The cyclic modulation of swarm rules in *Swarm-PI* is similar to the hormonal cycles in *AtomSwarm*, both serving to promote more varied behaviours. Contrary to unnamed system where only a few agents contribute to the sound produced, all swarm individuals in *Swarm-PI* contribute to the sound.

4.3.2 Music Improvisation

Synthetic swarms, like natural swarms, are unpredictable and therefore ideally suited for improvisation. *SWARMUSIC* (Blackwell, 2001) is an interactive music improvisation that uses the *Boids* algorithm. *SWARMUSIC* consist of multiple swarms of particles that move in a virtual 3D space in which musical events from human

performer(s) are positioned (in *Music Parameter Space*) as attractors. The swarm is drawn towards these attractors, converting spatial patterns into music. Here, each agent acts as a sub-swarm that moves in the virtual space and reacts to the external sound events. The self-organization and interaction between sub-swarms follows a stigmergic mechanism, in which events (at micro, mini, and meso levels) are parameterized according to internal (local) interactions between agents.

Swarm Granulator (Blackwell, 2008; Blackwell & Young, 2004) is a swarm improvisation system similar to *SWARMUSIC*. It operates at the sound grain level rather than the note level and use spatial neighbourhoods and spring or steering accelerations.

4.4 Audio-Visual Output

In this Sect. 4.1 discuss two formats of audiovisual swarm systems: audiovisual installations and audiovisual performances. *Flowspace* (Bisig et al., 2011) is an audiovisual performance system with interactive, immersive, and generative elements (Fig. 4.19). The algorithmic visual and musical compositions are controlled by simulations of flocking behaviour via *ISO Flock* and *ISO Synth* Libraries. The system explores the structures of self-organizing multi-agents and their potential for shaping musical dynamics in the context of an interactive installation.

Dancing with Swarming Particles (Carvalho, 2010) is another interactive installation and performance system. The installation explores the relationship between a human (live performer) and an avatar (virtual performer), and consists of morphing flocking particles (*PSO*).

Garden of Virtual Delights (Martins et al., 2013) is an interactive installation developed for the botanical garden of Coimbra. The goal of the installation is to attract visitors and encourage contemplation of the space.

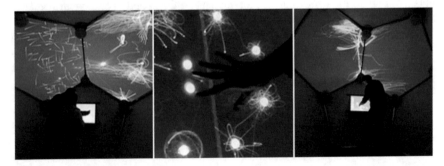

Fig. 4.19 *Flowspace* installation for Milieux Sonores exhibition (about sound, space, and virtuality) that was shown in Kunstraum Walcheturm in Zurich in 2009 and in the Gray Area Foundations for the Arts in San Francisco. © Image Credit: Bisig et al. (2011)

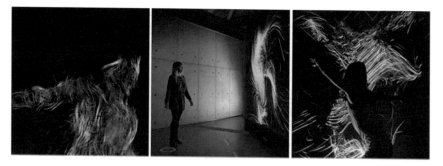

Fig. 4.20 *Nike Flyknit* (2013) installation at Nike Design Week in Milan. The system, as seen here, translates human movements into living threads that swarm across the screens. © Image Credit: Universal Everything (2021)

Another example is *Nike Flyknit* (Universal Everything, 2013), an interactive audiovisual installation which explores movement and the human form. Here, swarming agents wander around a digital cubic display (Fig. 4.20) and the movements of visitors, tracked by motion technology (Kinect), influence a swirling video on each of four sides of the display generating a colourful cascade of silhouettes of intricately intertwined, flowing threads.

4.5 Structural Output

4.5.1 Robotic Sculpture

Composite Swarm (Kokkugia, 2013) is an architectural prototype that explores the relationship between robotic fabrication, composite materials, and algorithmic design as shown in Fig. 4.21. The prototype was intended to test composite tectonics for the future application to larger architectural projects and was supported by the Design Research Institute and the Architectural Robotics Lab at RMIT University.

Similarly, *Composite Skeleton* (Kokkugia, 2015) is another architectural prototype for Design and the Tallinn Architecture Biennale developed at RMIT studio by Roland Snooks and Cam Newnham. In both *Composite Swarm and Composite Skeleton* the complexity of the form and the abundance of decoration make the model fundamentally proficient and minimize the use of material. A swarm algorithm based on the self-organizing behaviour of ants was developed to negotiate and compress surface, structure, and adornment into a single irreducible form. The robot combines fibre-composite and flexible foam, both of which are very fragile, to be self-supportive and make an exceptionally rigid composite. The structural quality is accomplished through a mix of patterns of corrugations and the twofold shape of the general surface. Paradoxically, it is the complexity of the surface and the decorative patterns that makes the structure efficient. As opposed to optimizing the structure,

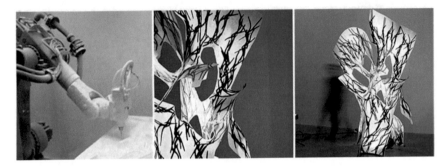

Fig. 4.21 *Composite Swarm* (2013) installation, an architectural prototype developed at Architectural Robotics Lab at RMIT University, School of Architecture and Design. Image Credit: Kokkugia (2021)

the project investigates how structure, surface, and ornament work together to shape an expressive and proficient entity.

Fiberbots (Kayser et al., 2018) are a swarm of robots, embedded with fibreglass filaments, capable of creating tubular structures developed at the Mediated Matter Group at the MIT Media Lab. These structures can be built in parallel and intertwined to rapidly make architectural structures. *Fiberbots* are mobile and use sensor input to control the length and curvature of each tube. The tubes are also influenced by the environmental conditions and flocking behaviour of the group. This approach allows architects to control high-level design parameters that govern the shape of the subsequent structure without having to tediously give directions to every robot by hand. After the structure was built, it remained outside for 7 months spanning fall and winter in Cambridge, Massachusetts without showing wear as shown in Fig. 4.22.

Fig. 4.22 *Fiberbots* (2018) installation, swarm of robots rapidly build high-strength tubular structures by winding fibreglass filament around themselves. © Image Credit: Kayser et al. (2018)

4.5.2 Robotic Construction

The possibility of the emergence of structure via consciousness is explored in numerous works in the field of developmental robotics (Asada et al., 2009; Lungarella et al., 2003; Weng, 2004). Prince et al. (2005) suggested that the continuous integration of new skills was the core concept for developmental robotics. Kompella et al. (2014) proposed the *SKILLABILITY* algorithm that enables an agent exploring its environment and learns feature-based abstractions to build into skills. The robot (agent) first forms lower-dimensional step-like abstractions, or slow features, utilizing *Curiosity Driven Modular Incremental Slow Feature Analysis (CD-MISFA)* (Luciw et al., 2013). These slow features then enhance the robot's state space. Its reward function enhances transitions that produce large changes in these features, corresponding to high-level goals such as grasping or toppling. Kompella et al. (2014) demonstrated that the robot can learn to recognize high-level events and forms of complex action sets from pixel-level data. This proves that complex, yet structured behaviours can emerge through explorations of unstructured and noisy information.

Lee et al. (2007) proposed a developmental system with numerous phases characterized by different competence levels. Different limitations are set at various stages to manage the development process. These constraints help to decrease the intricacy of information sources and actions and the size of the task space, and allow the learning agents to concentrate on tasks which they have the greatest possibility of learning. More difficult tasks could then be created in subsequent stages by building on the experience obtained in the previous levels. The developmental robots discussed in this section are more engaging and life-like, when unpredictability is an attractive quality. Dragan et al. (2014, 2015) demonstrated that the robot's apparent intelligence expanded when participants accepted that the robot was deliberately deceptive. The works therefore examines whether unpredictable behaviours emerging from the learning process will resemble life-like phenomena.

Aerial robotics swarm printing (AADRL Studio Robert Stuart-Smith, 2013–2015) is an experimental research project into non-standard construction processes, using flying robots as 3D printers. The experiment merges design and production into a single process influenced by the emergent behaviour of flying robots and composite materials. As opposed to traditional construction techniques, *aerial robotics swarm printing* allows flexibility for a variety of environments via real-time structural feedback.

Aerial robotics swarm construction (AADRL Studio Robert Stuart-Smith, 2013–2015) is a thread construction technique utilizing flying robots to create real-time and on-site design and assembly as shown in Fig. 4.23. Here, the swarm performs in an autonomous and choreographed manner, adjusting to the spatial properties of the environment. The proposed threading technique exploits the structural capability of tensile elements such as cables in order to span large distances, both horizontally and vertically, while maintaining structural stability.

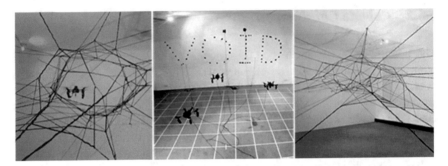

Fig. 4.23 *Aerial robotics swarm construction* (2013–2015), Studio Robert Stuart-Smith at AADRL Architectural Association Design Research Lab, London. © Image Credit: Stuart-Smith (2016)

4.6 Modeling (Form Finding) Output

Swarm modelling is an agent-based modelling technique that adapts an inductive form of reasoning and shifts the modern digital design towards a generative form of modelling that incorporates temporalities and the uncertainty of biological systems. Here a model is an evolving system that constantly adjusts to environmental variations and highlights the interaction between agents (Hörl & Burton, 2017). Roland Snooks and Robert Stuart-Smith at Kokkugia proposed swarm modelling to design the Taipei Performing Arts Center, in which interactive self-organizing agents modelled the form as being one and many (Leach, 2009).

Fibrous Tower (Kokkugia, 2008) is a series of speculative experiments, part of an experimental study into fibrous tower skeletons. The experiments explore the generation of ornamental, structural, and spatial order through an agent-based algorithmic design methodology as shown in Fig. 4.24. Several iterations of the tower have been developed. The initial study located the fibrous network in the thickness of a comparatively simple shell geometry enabling the use of conventional techniques to construct a highly differentiated tower. Subsequent iterations have tested the spatial

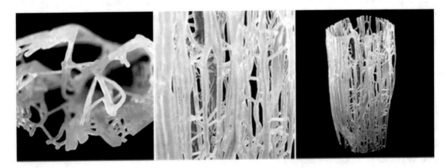

Fig. 4.24 *Fibrous Tower* (2008), an exploration of ornamental, structural, and spatial orders using an agent-based algorithmic design methodology. © Image Credit: Kokkugia (2021)

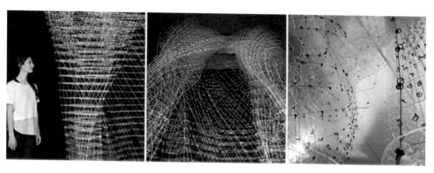

Fig. 4.25 The *A(g)ntense* (2014) installation at the BlindSpot Initiative, Los Angeles. © Image Credit: Sugihara and ATLV (2014)

possibilities of woven interior structure and atriums, which are separate from the exterior shell.

Similarly, *A(g)ntense* (Sugihara, 2014) is a swarm formation and agent-based self-optimization of tensile and compression structure. Sugihara and team used swarm agents and tension/compression force machanism to generate a stable tensile wire structure and a self-organized form by layers of rigid sheet materials as shown in Fig. 4.25. *A(g)ntense* is made out of 30 horizontal layers of acrylic sheets and 150 strings of fishing wires and explores form and self-optimization without any deformation or twist under gravity.

4.7 Other Forms (Software, VR, Simulations, etc.)

So far, I have discussed common outputs of swarm systems. In this Sect. 4.1 consider other emerging outputs using swarm agents. For example, *Coral* (Bisig & Schiesser, 2013) is a proof of concept interface that explores the physical and haptic extension of a swarm simulation. *Coral* interface acts as an intermediate mechanism for the creation of generative music and imagery consists of modular units that can be combined in random numbers and setups. Every unit is connected to an artificial agent in the swarm simulation. In response to previous swarm robotic paintings and as an attempt to McCormack's penultimate challenge, Greenfield (2006) proposed *S-robot* paintings (simulated collective robots) capable of learning and artificial creativity as shown in Fig. 4.26. S-robots, is loosely based on a software model for Khepera robot simulation by Harlan et al. (2000). An *S-robot* is an agent with four binary valued proximity sensors and three channel color sensors. Similarly, Jacob (2008) proposed utilizing swarm as part of *Dancing with Swarms* to simulate, investigate, and harness the emergent properties of complex systems such as bacterial growth, gene regulation as shown in Fig. 4.27.

Keijiro Takahashi (2015) developed *Swarm* as part of *Kvant* effect suite for Unity. His package includes *KvantSwarm* as shown in Fig. 4.28 for Flowing line

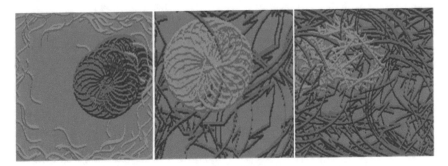

Fig. 4.26 *S-robot* paintings using different controllers and painting motifs (i.e., double hooked curve and zigzag sequence). © Image Credit: Greenfield (2006)

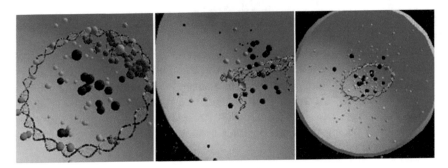

Fig. 4.27 *Dancing with Swarms* (2008) example of utilizing swarm model for gene regulation processes around the lactose operon in the bacterium E. coli. © Image Credit: Jacob (2008)

Fig. 4.28 *KvantSwarm* (2015) three instances form Crawler swarm test. © Image Credit: Takahashi (2015)

rendering (https://github.com/keijiro/KvantSwarm), *KvantStream* for swarm particle simulation, *KvantLattice* for fractal terrain and more.

de Andrade et al. (2020) introduced a swarm tool called *Visual PSO* (https://github.com/DiogoDeAndrade/VisualPSO) as an open software that is inspired by

Fig. 4.29 *Swarm Landscapes* (2020) three instances using Visual PSO showing the explored area of a *Perlin* landscape function. © Image Credit: de Andrade et al. (2020)

another *PSO* tool knowns as *OpenPSO.NET* created with Unity for optimization. These Libraries allow users to easily create and use custom functions (i.e., *Perlin noise*) and an image input to solve optimization problems. Here different functions are visualized as terrains, using a custom shader (i.e., glowing contour lines, and an effect to make the outlines of the search space more visible) as shown in Fig. 4.29.

In the Eyes of the Animal (Marshmallow Laser Feast, 2015) is a VR experience that transforms the user as an animal in a forest, providing a view of the world unknown to humans. The user can experience the visual and sensory perception of different creatures (e.g., a midge, then a dragonfly, followed by a frog, and finally an owl). The midge and dragonfly experience are simulated via swarming techniques.

Fly Simulator (Sommerer & Mignonneau, 2018) is an interactive artwork that simulates flocking of flies developed for Ars Electronica 2018 and Speculum Artium in Trbovlje. It consists of 1000 artificial flies that display flocking patterns. The user's head position influences the swarming of the flies, which makes the user feel like they have become a fly.

Mutator VR: Vortex (Latham et al., 2015–2019) is an interactive virtual reality experience with semi-autonomous swarm agents called *mutoids*. The user can interact with procedurally generated microworlds (each with unique visual elements, sounds, dynamics) as shown in Fig. 4.30.

Fig. 4.30 *Mutator VR: Vortex* centre (2015–2019), Left & center, VR shape-shifting alien environments with worm-like structures and interactive mutoid agents, right, *Mutator VR* exhibition at Shoom 30 Rave, London, 2018. © Image Credit: William Latham (2019)

References

http://www.leonelmoura.com.

https://www.universaleverything.com.

al-Rifaie, M. M., Bishop, J. M., & Caines, S. (2012). Creativity and autonomy in swarm intelligence systems. *Cognitive Computation, 4*(3), 320–331. https://doi.org/10.1007/s12559-012-9130-y.

al-Rifaie, M. M., & Bishop, J. M. (2013). Swarmic paintings and colour attention. In *International Conference on Evolutionary and Biologically Inspired Music and Art* (pp. 97–108). Berlin, Heidelberg: Springer. https://doi.org/10.1007/978-3-642-36955-1_9.

Asada, M., Hosoda, K., Kuniyoshi, Y., Ishiguro, H., Inui, T., Yoshikawa, Y., & Yoshida, C. (2009). Cognitive developmental robotics: A survey. *IEEE Transactions on Autonomous Mental Development, 1*(1), 12–34. https://doi.org/10.1109/TAMD.2009.2021702.

Barrass, T. (2001). Visualising the emergence of shared behavioural pathways in a crowd. Artist's Presentation. In A. Dorin (Ed.), *Proceedings of Second Iteration* (pp. 22–23). Melbourne: CEMA.

Beyls, P. (2007). Interaction and Self-organisation in a Society of Musical Agents. In *Proceedings of ECAL 2007 Workshop on Music and Artificial Life (MusicAL 2007).*

Bisig, D., & Schiesser, S. (2013). Coral, a Physical and Haptic Extension of a Swarm Simulation. In *Proceedings of the New Interfaces for Musical Expression Conference.* Daejeon + Seoul, South Korea.

Bisig, D., Schacher, J. C., Neukom, M. (2011). Flowspace-A Hybrid Ecosystem. In *NIME* (pp. 260-263).

Bisig, D., Neukom, M., & Flury, J. (2008). Interactive Swarm Orchestra an Artificial Life Approach to Computer Music. In *ICMC.*

Blackwell, T., & Jefferies, J. (2005). Swarm Tech-Tiles Tim. In *Workshops on Applications of Evolutionary Computation* (pp. 468–477). Berlin, Heidelberg: Springer. https://doi.org/10.1007/978-3-540-32003-6_47.

Blackwell, T., & Young, M. (2004). Swarm granulator. In *Workshops on Applications of Evolutionary Computation* (pp. 399–408). Berlin, Heidelberg: Springer. https://doi.org/10.1007/978-3-540-24653-4_41.

Blackwell, T. (2008). Swarm granulation. In *The Art of Artificial Evolution* (pp. 103–122). Berlin, Heidelberg: Springer. https://doi.org/10.1007/978-3-540-72877-1_5.

Bouchard and Ens, (2018). https://www.livestructures.com. (Linda Bouchard).

Brooks, R. (1986). A robust layered control system for a mobile robot. *IEEE Journal on Robotics and Automation, 2*(1), 14–23.

Carvalho, R. (2010). Dance with the Swarming Particles. https://www.academia.edu/5566193/Dance_with_the_Swarming_Particles_Project_Report.

Chung, S. (2018a). Drawing Operations. https://sougwen.com/project/drawing-operations.

Chung, S. (2019). Exquisite Corpus. https://sougwen.com/project/exquisite-corpus.

Chung, S. Omnia per Omnia. (2018b). https://sougwen.com/project/omniaperomnia.

Dragan, A. D., Bauman, S., Forlizzi, J., & Srinivasa, S. S. (2015). Effects of robot motion on human-robot collaboration. In *Proceedings of the Tenth Annual ACM/IEEE International Conference on Human-Robot Interaction* (pp. 51–58). ACM. https://doi.org/10.1145/2696454.2696473.

Dragan, A. D., Holladay, R. M., & Srinivasa, S. S. (2014). An Analysis of Deceptive Robot Motion. In *Robotics: Science and Systems* (p. 10). https://doi.org/10.15607/RSS.2014.X.010.

de Andrade, D., Fachada, N., Fernandes, C. M., & Rosa, A. C. (2020). Generative Art with Swarm Landscapes. *Entropy, 22*(11), 1284.

Eldridge, A. (2015). You pretty little flocker: Exploring the aesthetic state space of creative ecosystems. *Artificial Life, 21*(3), 289–292. https://doi.org/10.1162/ARTL_a_00169.

Fernandes, C. M. (2010). Pherographia: Drawing by ants. *Leonardo, 43*(2), 107–112. https://doi.org/10.1162/leon.2010.43.2.107.

Fernandes, C. M., Mora, A. M., Merelo, J. J., & Rosa, A. C. (2013). KANTS: A stigmergic ant algorithm for cluster analysis and swarm art. *IEEE Transactions on Cybernetics, 44*(6), 843–856. https://doi.org/10.1109/TCYB.2013.2273495.

Fernandes, C. M., Mora, A., Merelo, J. J., & Rosa, A. C. (2012). Pherogenic Drawings-Generating Colored 2-dimensional Abstract Representations of Sleep EEG with the KANTS Algorithm. In *International Conference on Evolutionary Computation Theory and Applications* (Vol. 2, pp. 72–80). SCITEPRESS.

Fernandes, C. M., Mora, A. M., Merelo, J. J., & Rosa, A. C. (2015). Photorealistic rendering with an ant algorithm. In *Computational Intelligence* (pp. 63–77). Springer, Cham. https://doi.org/10.1007/978-3-319-11271-8_5.

Greenfield, G. (2006). Robot paintings evolved using simulated robots. In *Workshops on Applications of Evolutionary Computation* (pp. 611–621). Berlin, Heidelberg, Springer.

Gooch, B., & Gooch, A. (2001). Non-photorealistic rendering. AK Peters/CRC Press. https://doi.org/10.1201/9781439864173.

Harlan, R., Levine, D., & McClarigan, S. (2000). The Khepera robot and kRobot class: a platform for introducing robotics in the undergraduate curriculum. New York: Technical Report 4, Bonaventure Undergraduate Robotics Laboratory, St. Bonaventure University.

Hashim, F., & Mustafa, N. (2020). Design of a Predictive PID Controller Using Particle Swarm Optimization. *International Journal of Electronics and Telecommunications, 66*(4), 737–743.

Hörl, E., & Burton, J. E. (Eds.). (2017). *General Ecology: The New Ecological Paradigm.* Bloomsbury Publishing. https://doi.org/10.1007/978-3-662-44335-4_2.

Jacob, C. J., Hushlak, G., Boyd, J. E., Nuytten, P., Sayles, M., & Pilat, M. (2007). Swarmart: Interactive art from swarm intelligence. *Leonardo, 40*(3), 248–254. https://doi.org/10.1162/leon.2007.40.3.248.

Jacob, C., & Hushlak, G. (2008). Evolutionary and swarm design in science, art, and music. In *The art of artificial evolution* (pp. 145–166). Berlin, Heidelberg: Springer. https://doi.org/10.1007/978-3-540-72877-1_7.

Jacob, C. (2008). Dancing with Swarms: Utilizing Swarm Intelligence to Build, Investigate, and Control Complex Systems. In *Design by Evolution* (pp. 69–94). Berlin, Heidelberg, Springer.

Jones, D. (2008). AtomSwarm: A framework for swarm improvisation. In *Workshops on Applications of Evolutionary Computation* (pp. 423–432). Berlin, Heidelberg: Springer. https://doi.org/10.1007/978-3-540-78761-7_45.

Kamolov, R., Machado, P., & Cruz, P. (2013, July). Musical flocks. In *ACM SIGGRAPH 2013 Posters* (p. 93). ACM. https://doi.org/10.1145/2503385.2503487.

Kayser, M., Cai, L., Falcone, S., Bader, C., Inglessis, N., Darweesh, B., & Oxman, N. (2018). FIBERBOTS: An autonomous swarm-based robotic system for digital fabrication of fiber-based composites. *Construction Robotics, 2*(1–4), 67–79. https://doi.org/10.1007/s41693-018-0013-y.

Keijiro Takahashi, (2015). https://www.keijiro.tokyo.

Kokkugia. https://www.kokkugia.com.

Kompella, V. R., Stollenga, M. F., Luciw, M. D., & Schmidhuber, J. (2014). Explore to see, learn to perceive, get the actions for free: Skillability. In *2014 International Joint Conference on Neural Networks (IJCNN)* (pp. 2705–2712). IEEE. https://doi.org/10.1109/IJCNN.2014.6889784.

Leach, N. (2009). Swarm Urbanism. *Architectural Design, 79*(4), 56–63. https://doi.org/10.1002/ad.918.

Lee, M. H., Meng, Q., & Chao, F. (2007). Staged competence learning in developmental robotics. *Adaptive Behavior, 15*(3), 241–255. https://doi.org/10.1177/1059712307082085.

Love, J., Pasquier, P., Wyvill, B., Gibson, S., & Tzanetakis, G. (2011, August). Aesthetic agents: swarm-based nonphotorealistic rendering using multiple images. In *Proceedings of the International Symposium on Computational Aesthetics in Graphics, Visualization, and Imaging* (pp. 47–54). ACM. https://doi.org/10.1145/2030441.2030452.

Luciw, M. D., Kompella, V. R., Kazerounian, S., & Schmidhuber, J. (2013). An intrinsic value system for developing multiple invariant representations with incremental slowness learning. *Frontiers in Neurorobotics, 7*, 9. https://doi.org/10.3389/fnbot.2013.00009.

Lungarella, M., Metta, G., Pfeifer, R., & Sandini, G. (2003). Developmental robotics: A survey. *Connection Science, 15*(4), 151–190. https://doi.org/10.1080/0954009031000165511O.

Machado, P., & Pereira, L. (2012). Photogrowth: non-photorealistic renderings through ant paintings. In *Proceedings of the 14th Annual Conference on Genetic and Evolutionary Computation* (pp. 233–240). ACM. https://doi.org/10.1145/2330163.2330197.

Machado, P., & Martins, T. (2018). insta.ants. https://cdv.dei.uc.pt/insta-ants/.

Machado, P., Martins, T., Amaro, H., & Abreu, P. H. (2014). An interface for fitness function design. In *International Conference on Evolutionary and Biologically Inspired Music and Art* (pp. 13–25). Berlin, Heidelberg: Springer. https://doi.org/10.1007/978-3-662-44335-4_2.

Martins, T., Machado, P., & Rebelo, A. (2013). The garden of virtual delights: Virtual fauna for a botanical garden. In *ACM SIGGRAPH 2013 Posters* (p. 26). ACM. https://doi.org/10.1145/2503385.2503413.

Mauceri, F., & Majercik, S. M. (2017). A Swarm Environment for Experimental Performance and Improvisation. In *International Conference on Evolutionary and Biologically Inspired Music and Art* (pp. 190–200). Cham: Springer. https://doi.org/10.1007/978-3-319-55750-2_13.

Moura, L. (2002). Swarm paintings-non-human. ARCHITOPIA Book, Art, Architecture and Science, 1–24.

Moura, L., & Pereira, H. G. (2004). Man+ robots: symbiotic art. Institut d'art contemporain.

Moura, L., & Ramos, V. (2007). Swarm paintings-nonhuman art. *ARCHITOPIA book, art, architecture and science*, 5–24.

Moura, L. (2018). Robot Art: An Interview with Leonel Moura. In *Arts* (Vol. 7, No. 3, p. 28). Multidisciplinary Digital Publishing Institute. https://doi.org/10.3390/arts7030028.

Prince, C., Helder, N., & Hollich, G. (2005). Ongoing emergence: A core concept in epigenetic robotics.

Reas, (2005). https://reas.com.

Ratti, C. (2017). Il progetto paint by drone. Available via CARLORATTI. http://www.carloratti.com/wp-content/uploads/2017/10/2017_10_01_AdV_-_Strategie_di_Comunicazione_pag.14.pdf.

Ratti, (2019). https://carloratti.com.

Salimi, M., & Pasquier, P. (2021). Exploiting Swarm Aesthetics in Sound Art. In *Proceedings of the Art Machines 2: International Symposium on Machine Learning and Art 2021, Art Machines 2.*

Salimi, M., & Pasquier, P. (2021a). Liminal Tones: Swarm Aesthetics and Materiality in Sound Art. In *Proceedings of the International Conference on Swarm Intelligence (ICSI'21).*

Semet, Y., O'Reilly, U. M., & Durand, F. (2014). Non-photorealistic rendering with interactive, agent-based computation. *Leonardo, 47*(1), 14–14.

Shi, Y., & Eberhart, R. C. (1998). Parameter selection in particle swarm optimization. In *International Conference on Evolutionary Programming* (pp. 591–600). Berlin, Heidelberg: Springer. https://doi.org/10.1007/BFb0040810.

Sommerer, C., & Mignonneau, L. (2018). Creating Interactive Art—Conceptual and Technological Considerations. In *Explorations in Art and Technology* (pp. 363–370). Springer, London.

Stanza, (2008). https://www.stanza.co.uk.

Stuart-Smith, R. (2016). Behavioural Production: Autonomous Swarm-Constructed Architecture. *Architectural Design, 86*(2), 54–59. https://doi.org/10.1002/ad.2024.

Sugihara, S. (2014). A(g)ntense: Installation of swarm formation and agent based self-optimization of tensile and compression structure.

Sugihara & ATLV, (2014). https://www.aan1.net/satorusugihara. (Satoru Sugihara).

Takahashi, (2015). https://www.keijiro.tokyo.

Wanner, A. (2012). The Robot Quartet. http://pixelstorm.ch/pro_robotquartet.php?lang=en.

Wanner, A. (2015). Signature Strokes. http://pixelstorm.ch/?lang=en.

Weng, J. (2004). Developmental robotics: Theory and experiments. *International Journal of Humanoid Robotics, 1*(02), 199–236. https://doi.org/10.1142/S0219843604000149.

William Latham, (2019). https://mutatorvr.co.uk. (William Latham).

Chapter 5
Presentation Format

In the depictions of the selected works, there were a variety of presentation formats including screen-based, installation, performance, and musical compositions. In this section, I review them in greater detail and introduce different presentational types for swarm systems.

5.1 Soundscape/Sonic Ecosystem

Insects, plants, and natural ecosystems have been the source of inspiration for many artists and architects. Some artists have promoted natural swarm ecosystems to enhance existing swarm models (Dorin, 2008; McCormack, 2007). These approaches offer new models beyond simple agent-agent interaction to augmented virtual organisms. The agents in these virtual ecosystems are capable of interactions and dynamic growth (similar to biological systems) with their environment and human.

Trails II (Bisig & Kocher, 2013) is an audiovisual environment that employs generative algorithms to explore the aesthetic relationships between music and imagery. The system utilizes both present temporal proportions and flocking behaviours for a balanced but unpredictable composition as shown in Fig. 5.1. The algorithmic uncertainty between the natural and artificial is simulated in music and visually as concurrent layers of natural and synthetic instruments using *ISO Flock* and *ISO Synth*.

Revive (Tatar et al., 2018) is an interactive audiovisual ecosystem consists of a musical artificial intelligence player, human electronic musicians, and audio-reactive visual agents in a complex multimedia environment as shown in Fig. 5.2. The context of the project is experimental electronic music involving structured improvisation, using cues and automated parameters. Sonic actions of performers are emphasized by audio-reactive visual swarm agents. The behaviours and contents of sonic and visual agents change as the performance unfolds.

© The Author(s), under exclusive license to Springer Nature Singapore Pte Ltd. 2021
M. Salimi, *Swarm Systems in Art and Architecture*, Computational Synthesis and Creative Systems, https://doi.org/10.1007/978-981-16-4357-6_5

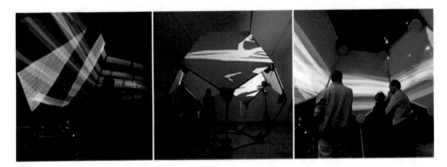

Fig. 5.1 *Trails II* (2013) audiovisual composition on the surround audio and video installation entitled *Dodecahedron* at the National Museum of contemporary art in Athens, Greece. © Image Credit Bisig & Kocher (2013)

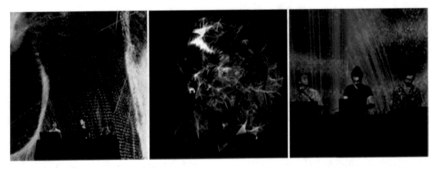

Fig. 5.2 *Revive* (2018) performance for MUTEK festival at societe des arts technologiques (SAT), Montreal. © Image Credit Tatar et al. (2018)

5.2 Visual Maps

I have reviewed three different visual outputs of swarm systems in Sect. 5.4.1. In this section, I introduce using swarm simulation as a visualization tool to represent otherwise invisible data and generate visual maps.

Data visualization studies show swarm representations can reveal hidden patterns in big data. Visual representations can help to understand hidden patterns in data. In the field of data aesthetics, data is used to create aesthetic visualizations.

Some artists have begun to use swarm agents as a visualization tool to explore the aesthetic dimensions of data. Visualization tools let the user/viewer discover new possibilities and create different aesthetics from repetitive patterns. The outcomes are diverse emergent visual artefacts (maps) that are usually both stimulating and aesthetically appealing.

Data Aesthetics can be used to create aesthetic visualizations with a varied range of visual artefacts. For example, *EMVIZ {Efforts + Movement + Motion + Metaphor + Visualization}* (Subyen et al., 2011) is an interactive artistic visualization engine that

produces dynamic visual representations of *Laban Basic-Efforts* (Bartenieff & Lewis, 2008). The movement data is obtained from a real-time machine-learning model that uses Laban movement analysis to extract movement qualities from a moving body. *EMVIZ* maps the *Laban Basic-Efforts* to design rules, drawing parameters, and colour palettes and creates visual representations that amplify audience ability to appreciate and differentiate between movement qualities as shown in Fig. 5.3.

Another example is *Musical Flocks* (Kamolov et al., 2013), a musical visualization that produces animations by simulating the behaviour of reactive agents to music as shown in Fig. 5.4.

Similarly, Rodrigues et al. (2015) proposed *Fireflies Visualization*, a sound visualization tool inspired by fireflies. In it, sound beats are represented by light sources that attract the artificial fireflies (agents). The agents close to the light gain energy and become more bioluminescent. Unlike real fireflies, the artificial flies follow a sound and create dynamic visualizations (cumulating movements and artifacts) caused by perturbations of sound events.

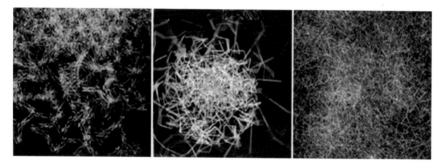

Fig. 5.3 *EMVIZ* (2011) Laban's Basic-Efforts represented by a poetic and communicative mapping to colour and visual forms. Left, Flick; center, Glide; right, Punch mode at the Surrey Art Gallery. © Image Credit Subyen et al. (2011)

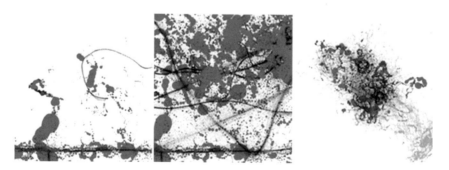

Fig. 5.4 *Musical Flocks* (2013) generated from the genre, tempo of the music, intensity of the sound, and instruments played. © Image Credit Kamolov et al. (2013)

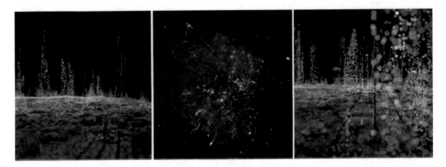

Fig. 5.5 *LATLONG* (2016) at 350 Mission Building in City of San Francisco. © Image Credit SOM, Builders WSP, Parsons Brinckerhoff, Design + Code,, Quadrature & schnellebuntebilder 2021

LATLONG (Arup et al., 2016) is a real-time visualization of twitter activity in San Francisco as shown in Fig. 5.5. The project was commissioned for art project *Virtual Depictions: San Francisco* by Refik Anadol with Kilroy Realty Corporation / John Kilroy and Skidmore, Owings & Merrill LLP (SOM) Architects. *LATLONG* transforms daily tweets into particles that illuminate the cityscape, rising and floating from where they were written. Every tweet emits swarm particles and gets mapped to a point-cloud model of the iconic coastline of San Francisco.

The Computational Design and Visualization Lab (CDV) at the University of Coimbra (CISUC) has undertaken different Data Aesthetics projects. The goal of these projects is to engage the audience and create emergent visualizations of data to convey meaningful information (i.e., consumption patterns, city flows, etc.) in alluring ways. For example, *Visualisation Model* (Machado et al., 2018) is a series of swarm systems that create emergent visualizations about Portuguese consumption routines as shown in Fig. 5.6. The system simulates the flocking behaviour of birds (*PSO*) in an environment (i.e., the canvas) and reacts to changes over time. Different

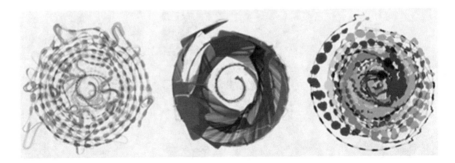

Fig. 5.6 *Visualization Model* (2018) three samples from the interactive evolutionary system that illustrate the variety of visual artefacts that the system can create. © Image Credit Machado et al. (2018)

random initializations of the visualization models create a wide variety of behaviours such as zigzagging patterns, resulting from strong forces, or stagnation in the centre.

5.3 Installation

The screen (internet, television, video, and combinations thereof) is thriving in our visual and infotechno culture. Digital screens are ubiquitous and can display output to many audiences. Almost half (52/100) of the analyzed work uses some kind of screen to present their result(s). For example, *Swarm* (Shiffman, 2002) is a screen-based interactive video installation that displays the pattern of flocking birds using Reynolds's *Boids* model as a constantly moving brush stroke as shown in Fig. 5.7. The system recognizes the natural paths made by agents' movements and uses them as painterly strokes to outline segments of a live video to input onto the visual display. The paths followed by each agent are based on their relational interaction with those around them. The system, therefore, acts as a drawing machine which aimlessly takes contributions from its video input and displays it in an iterative way. However, one could not deny that it truly looks like a painting.

Another example is *Portrait on the Fly* (Sommerer et al., 2015), an interactive installation that focuses on the selfie-culture and the continuous change, transience, and impermanence of our era as shown in Fig. 5.8. Once the audience is detected, their silhouette appears on the screen as a swarm of a few thousand flies. The image is in a constant state of flux. Even the slightest movement by the audience member drives the flies away which constructs and deconstructs the silhouette image.

Planar (Martins et al., 2020) is an installation that captures the sounds of Coimbra, Portugal, using a flocking algorithm to simulate moving particles to generate a dynamic abstract image of the city. The particles move randomly and float over the different soundscapes that change in size according to their proximity to the flock. As a result, different soundscapes emerge and fade as the particles move around and

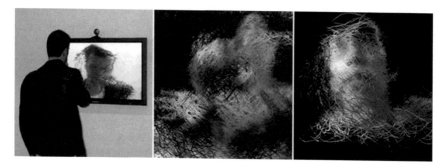

Fig. 5.7 *Swarm* (2002) video installation at Savannah College of Art and Design (SCAD), Savannah. © Image Credit Shiffman (2004)

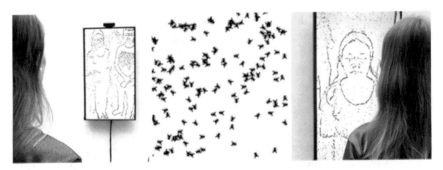

Fig. 5.8 *Portrait on the Fly* (2015) installation at FUSE festival, international symposium of electronic arts (ISEA) at vancouver art gallery, vancouver. © Image Credit Sommerer & Mignonneau, 2016

are in constant communication with the visuals controlling the auditory composition, dynamically updating the queue of sounds making up the overall soundscape.

5.3.1 Visual Installation

Many artists have explored the behavioural and aesthetic characteristics of swarms. Visual installations are the usual format of swarm systems used to create dance movement, compositions or imagery. Daniel Bisig is a pioneer artist in swarm practice who has explored swarm intelligence in a few experimental projects such as *Interactive Swarm Orchestra (ISO) and Interactive Swarm Space (ISS)*.

The *ISO* system examines the use of flocking algorithms to control sound synthesis and spatialization, and create conceptual and practical swarm computer music. The goal of the *ISS* system is to develop new tools and systems to create meaningful relationships between swarm behaviour, interaction, perception, and artistic expression. These autonomous, self-organized, and spatially distributed systems explore the possibilities and challenges that artificial systems pose for artistic practice and performance.

Cycles (Bisig & Unemi, 2009) is an interactive installation utilizing *ISO* and flocking agents to create a personal connection between simulated life forms and the visitor's hand as shown in Fig. 5.9. The installation explores notions of transience and identity, drawing on Buddhist philosophy. Bridging the gap between the virtual and physical world, a hybrid entity blends artificial and natural properties.

Mechthild (Bisig et al., 2011) is a swarm simulation installation that controls the typographical animation for a mystic excerpt from the works of Mechthild von Magdeburg (1207–82). The swarm simulations are shown as moving images that make an allegorical and literal representation of the original text as shown in Fig. 5.10.

The Treachery of Sanctuary (Milk, 2012) consists of three solid white frames reflected in a still reflecting pool. Entering the space before the pool, the audience

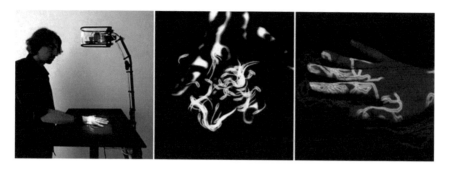

Fig. 5.9 *Cycles* (2009) installations Left, the table version of the installation; center and right, the simulation software depicts the chemicals and agents that respond to the hand's presence. © Image Credit Bisig & Unemi (2010)

Fig. 5.10 *Mechthild* (2011) installations for *Mystik* exhibition at the Museum Rietberg in Zurich, Switzerland. © Image Credit Bisig et al. (2011)

sees their shadow appear inside the main frame, as if they have stepped in front of a bright light. A flock of *Boids* at the top of each frame and transforms the shadows into hundreds of individual agents, dissolving the silhouette completely, leaving no trace behind. The installation is a large-scale interactive triptych—a story of birth, death, and transfiguration.

5.3.2 Audio Installation

The application of swarm aesthetics to artistic creations is not limited to visual outputs. Musicians and musical researchers apply the swarm approach to create sound art. For example, *Sound Agents* (Codognet & Pasquet, 2009) is a sound-based installation that relates a virtual space to a physical 3D space. The multi-agent system simulates the foraging behaviour of ants and creates sound synthesis for a generative music performance.

Fig. 5.11 *Emergent Harmony* (2018) sound system, designed and built from september to december 2018 at the interactive architecture lab, bartlett school of architecture, UCL. © Image Credit Tricaud, 2018

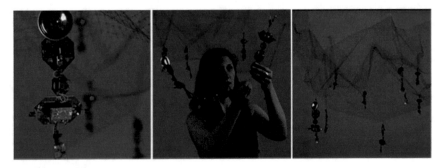

Fig. 5.12 *Sound Insects* (2018) installation, designed and built from may to june 2018 at the interactive architecture lab, barlett school of architecture, UCL. © Image Credit Tricaud, 2018

Another example is *Emergent Harmony* (Tricaud, 2018), a self-organizing modular sound system that creates emergent music as shown in Fig. 5.11. The system is made up of numerous autonomous sound modules that tune in to their environment and respond to sound signals coming from other modules or from the audience. Similarly, *Sound Insects* (Tricaud, 2018) is an immersive interactive sound installation made of unique electronic modules that work with each another through audio feedback to create ordered musical patterns as shown in Fig. 5.12.

5.3.3 Multisensory Installation

The multisensory perspective *in* art in which sensory stimulation can be controlled (intensified or reduced) has also found its way into swarm art. Some artists have used swarm algorithms to control the output of their art system to influence the motivation, interests, leisure, relaxation, therapy etc. of their audiences. *Swarm Wall* (Correll et al., 2013a) is a large-scale interactive wall with evolving fields of colour,

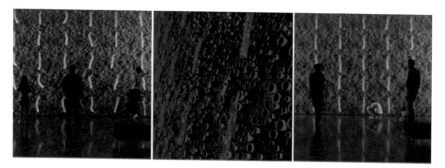

Fig. 5.13 *Swarm Wall* (2013) site-specific installation at CU art museum, Boulder. © Image Credit Michael Theodore & Matthew Campbell, 2013

light, and sound, driven by a distributed form of artificial intelligence as shown in Fig. 5.13. Consisting of 70 intelligent nodes, the wall presents a swarming effect when human movement is detected. Each node's actions are based on its own plan and on the actions of its immediate neighbours, but together they act as a swarm. Distributed control and local sensing enable the wall to emulate a life-like, interactive experience for the audience.

endo/exo (Harriman et al., 2014) is an interactive installation merging kinetic sculpture, sound art, fiber art, and light art, while exploring new forms of sound generation as shown in Fig. 5.14. It uses a networked microcontroller platform called Honeycomb (Correll et al., 2013) which has identical nodes that cause emergent behaviours based on local interaction and communication.

Another interesting multisensory environment is Swarm Arena (NTT, 2018) that was designed and built in collaboration with Ars Electronica Futurelab as shown in Fig. 5.15. Swarm Arena is a synchronized group of autonomous robots capable of spatio-temporal interaction with a human and a (musical) performer. The swarm, augmented by the music system and human inputs, forms a multi-cellular organism

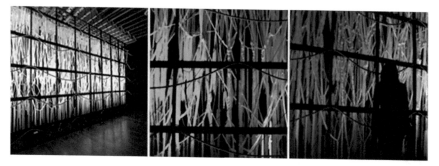

Fig. 5.14 *Endo/exo* (2014) installation view for Oanism/mechanism exhibition at David B. Smith gallery, Denver. © Image Credit Michael Theodore & Matthew Campbell, 2014

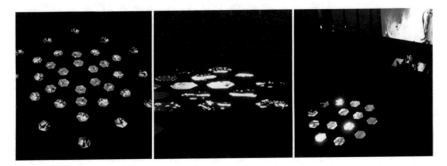

Fig. 5.15 *Swarm Arena* (2018) installation at *Miraikan* national museum of emerging sciene and innovation, Tokyo. © Image Credit Arts Electronica Futurelab, 2021; NTT & Raphael Schaumburg-Lippe

that questions the relationship between human spectators and bots, and opens the possibility of such interaction for a large group of spectators (e.g., in a stadium).

5.3.4 Light Installation

Swarm Light (Random International, 2010) is an experimental light installation with a collective consciousness which reacts to the viewer's audible presence as shown in Fig. 5.16. The installation consists of 1000 LED modules organized in a 3D network and is capable of sound analysis that allows the swarm to respond to the variant noise level. *Light Strings* (Seo & Corness, 2012) is a kinesthetic interactive and immersive installation by offering full body interaction and touch as the main modalities for interaction. It consists of fibre optics mediated with virtual agents that respond to human movement as shown in Fig. 5.17. This multi-agent system has different modes including ambient, exploration, play, and meditation. It displays

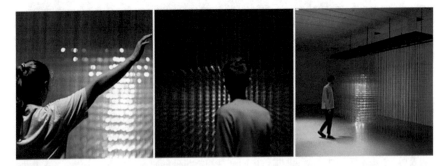

Fig. 5.16 *Our Future Selves* (2019) Exhibited as part of the solo show physical algorithm at paradise city art space, Seoul, South Korea. © Image Credit Random International, 2019

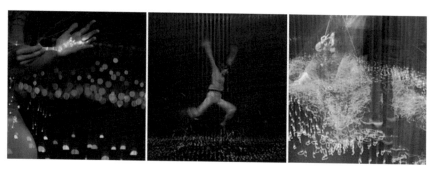

Fig. 5.17 *Light Strings* (2012) at SIGGRAPH Asia 2012: *Echo.* © Image Credit Seo & Corness (2012)

swarm-like behaviours within the floating environment of the strings. Here, a unique form of interaction has been realized that could result in even stronger immersive experiences.

SWARM (Arts Collective Neon Golden, 2015) is an immersive light installation in which a swarm acts as an irregular 3D display. The installation consists of 1920 LED modules organized as a point-cloud hanging from the ceiling. Human movement influences the LED network and the static chaotic structure is transformed into a vibrant experience. The light direction is controlled by the *Boids* algorithm in a multi-agent system, and resembles the flocking and separation patterns of birds.

5.4 Performance, Dance, and Choreography

5.4.1 Performance

Performance, dance, and choreograph, like other installations, need human input (either recorded or real-time) for a complete presentation. However, unlike other installations, the author/performer in collaboration with the swarm system generates the output, and the audience is only a passive observer. Another difference is that choreography, dance, and like performances are usually rehearsed ahead of time and aesthetically articulated, since the author is a performer as well as the creator of the system.

Swarms (Bisig & Ventura, 2008) is a dance performance that employs an interactive swarm simulation. The dancer controls the swarm behaviour with their posture and movements. The swarm's progression throughout the performance synchronizes with the choreography and is projected on the performer's body and the stage behind them as shown in Fig. 5.18. *2047* (Bisig & Ventura, 2009) is another dance performance that uses interactive swarm simulations.

STOCOS (Bisig & Palacio, 2012) is the third part of a trilogy focused on the analysis and development of the interaction between sonic gesture and dance in 3D

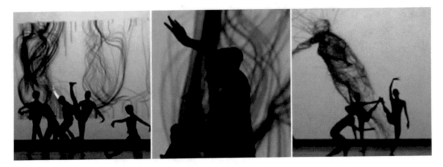

Fig. 5.18 *Swarms* (2008) dance performance, choreography by Pablo Ventuera. © Image Credit Bisig & Ventura (2008)

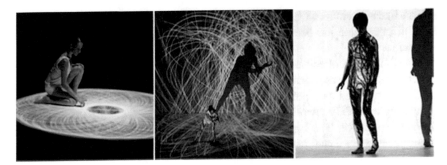

Fig. 5.19 *STOCOS* (2012) Left, *Plane Scene* the swarm's visualization moves in a rotating space the supersedes the physical appearance of the stage; center, *Rain Scene*, the swarm behaves similarly to rain disturbed by gusts of wind; right, *Blood Scene* the blood vessel-like patterns on a dancer are caused by a swarm whose movement and appearance is confined to the dancer's body. © Image Credit Bisig & Palacia (2012)

sound environments as shown in Fig. 5.19. By combining stochastic processes and swarm simulations (ISO Flock and ISO Synth), *STOCOS* creates a space in which natural and artificial entities, sounds, and visuals coexist, interrelate, and generate behavioural and aesthetic characteristics (dance movements, musical compositions, and interactive visuals).

Woher diese Zärtlichkeit (Bisig et al., 2012) is a theatrical performance (a play and concert) that combines poetry and music using ISO Flock as shown in Fig. 5.20. The system generates real-time swarm visualizations on the stage in the form of a large rectangular metallic sculpture. Throughout the show, swarm particles merge into and dissolve from words in Marina Zwetajewa's poems.

(swarm-like) Performance

While reviewing performance art that used swarm behavior, I found examples in which mimicked swarms and swarm-like movements were generated without the use of a swarm algorithm.

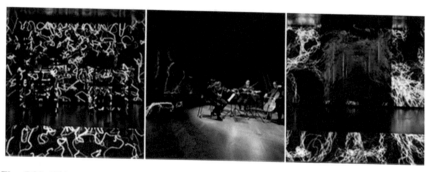

Fig. 5.20 *Woher dieseZartlichkeit* (2012) a play and concert at Rigiblick theatre in Zurich, Switzerland. © Image Credit Bisig et al., 2012

Amorphogenesis (del Val et al., 2014) is a meta-architectural and performance instrument (hybrid of installation and performance) that merges Flexinamics Metastructures and Metagaming design (del Val, 2018), and spatialized life electroacoustic sound, light, and robotics. The environment enhances indeterminacy and unpredictability, and augments emergent behaviours and movements. The free movement of human bodies in the surrounding environment expands and blurs the notions of predictable trajectories and micro-sensations. The project is part of Metatopia's performative architectures and utilizes mindfulness to prompt subtle deviations from known patterns, gestures, postures, temporalities, or proximities. Metatopia Studio is a metaformative and performative architectural studio that creates site-specific and body-specific installations and interventions, and is directed by Jaime del Val.

Disalignments (del Val & Romero, 2014) is a similar project that involves urban interventions and anti-choreographic movement and perception techniques, using swarm-like behaviours. These movements in unconventional temporalities, axes, vicinities, spaces, and contacts permeate environmental indeterminacy and activate proprioceptive or alloceptive swarm-like bodies (del Val, 2014). These improvisation techniques activate the artist' body as diffuse swarms of micro-perceptions focus on proprioception.

5.4.2 Dance

24 Drones (Mikiko & Elevenplay, 2016) is a dance performance in collaboration with Rhizomatiks that creates a sense of hope and a new representation of the world, in which virtual and physical components coexist as shown in Fig. 5.21. The performance uses drones as an artistic medium, to expand and create new expression in collaboration with human dancer(s).

Similarly, *Zoological* (Random International, 2017) is a performance of a group of autonomous flying drones that move collectively in a flock and a group of dancers as shown in Fig. 5.22. The behaviour of the drones is influenced both by its surrounding environment and the human movement.

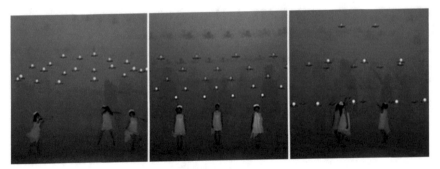

Fig. 5.21 Three dancers, Saya Shinohara, Yuka Numata, and Erisa Wakisaka interacting with 24 Drones (2016) at America's Got Talent. © Image Credit Mikiko & Elevenplay, 2021

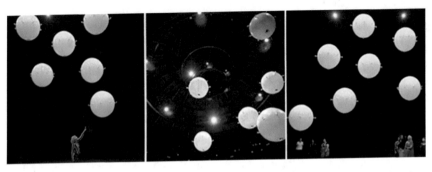

Fig. 5.22 *Zoological* (2017) ± *Human* exhibition curated by Wayne McGregor for bloomberg summer at the roundhouse, London. © Image Credit Random International, 2017

Shin'm 2.0 (Kang et al., 2012) is the second version of the *Shin'm* (2009) dance performance as shown in Fig. 5.23. By using the Kinect sensor, spatialized sound, and two video projections, the artists create an interactive nebula-bubble structure (swarm-like) in one corner of the exhibition space. The nebula bubbles constantly

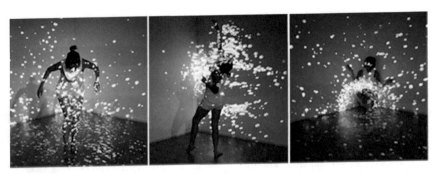

Fig. 5.23 *Shin'm 2.0* (2012) dance performance at SIGGRAPH Asia 2012: *Echo*. © Image Credit Kang et al. (2012)

circulate through a "black hole" in the centre which gradually takes the form of the performer's body. A sound texture is added to enhance the attachment and dissipation of the bubbles to the body.

5.4.3 Choreography

While most dances have open endings for their users/audience members to explore (with or without guidance), choreography is largely deterministic in its content and what and how the creator/performer(s) move. In most cases, performer(s) know exactly how to interact with the system to trigger specific patterns and behaviours, and to achieve predictable results to use or avoid.

Drone 100 (Intel, 2015) is a choreography of drones designed and built in collaboration with Ars Electronica Futurelab as a new way of storytelling using a blank canvas (the night sky) as shown in Fig. 5.24. Likewise, *2047 Apologue* (Verity Studios, 2017) is spectacular choreography of synchronized drones in collaboration with the Ars Electronica Futurelab, which employs 100 small flying robots. Directed by *Zhang Yimou,* the show explores the relationship between people and technology as shown in Fig. 5.25.

A more recent example of drones in action is *2047 Apologue 3* (Verity Studios, 2019) directed by *Zhang Yimou for a* conceptual theatre show in Beijing as shown in Fig. 5.26. This is a social commentary on the environmental impact of consumer behaviour, made of 66 Lucie microdrones disguised in plastic bags that float, twist and turn around a large tree on the stage. Combined with traditional Chinese performing arts, the work has a strong impact and appealing aesthetics.

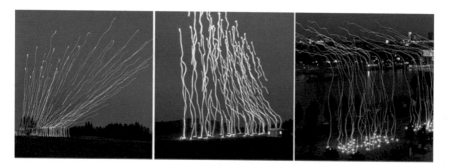

Fig. 5.24 *Drone 100* (2015) painting the sky in different shapes with 100 drones over Tornesch, Germany. © Image Credit Martin Hieslmair Arts Electronica Futurelab, 2021 & Intel

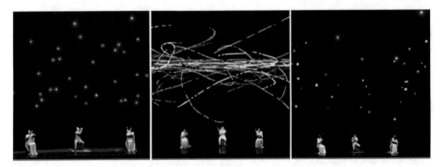

Fig. 5.25 *2047 Apologue* (2017) show at national centre for the performing arts (or NCPA) directed by ZhangYimou, Bejing. © Image Credit Verity Studios (2021)

Fig. 5.26 Drones coordinated with dancers, traditional Chinese performers, a large tree stage element, and falling plastic bags for *2047 Apologue 3* (2019) show at National Centre for the Performing Arts, Beijing. © Image Credit Verity Studios, (2021)

5.5 Sculpture

5.5.1 Kinetic Sculpture

Kinetic sculptures are usually made of moving components controlled by an internal mechanism or an external stimulus, such as light or air. To create natural movements, artists mimic the behaviour of natural swarms. *FLUIDIC: Sculpture in Motion* (studio WHITEvoid, 2013) is a kinetic sculpture that acts as a liquid surface in a dynamic flow inspired by life, its instinctive rhythms, and the ability to adapt and evolve as shown in Fig. 5.27. The sculpture represents swarm behaviours such as aggregation and clustering. The floating point-cloud of 12,000 spheres is in constant motion, reacting and adapting to human interaction.

In my analysis, I found a few kinetic sculptures that moves like natural swarms without actually using a swarm algorithm as part of their control systems. *Patterned by Nature* (Hypersonic, Sosolimited & Plebian Design, 2012) is a site-specific sculptural ribbon (10 ft. × 90 ft.) composed of 3600 sandwiches of LCD glass. The display

Fig. 5.27 *FLUIDIC: Sculpture in Motion* (2013) for Hyundai's advanced design center at temporary museum for new design. © Image Credit WHITEvoid studio, 2013

Fig. 5.28 *Diffusion Choir* (2016) commissioned by Biomed Realty for the headquarters of Shire, Cambridge. © Image Credit Sosolimited; Plebian Design & Hypersonic (2021)

cycles through clips of 20 patterns found in nature, ranging from flying birds to strobing cuttlefish skin as shown in Fig. 5.28. These moving images are rendered using a combination of mathematical modelling and actual footage.

(swarm-like) Sculpture

As mentioned, I have found several sculptural works representing swarm-like behaviours that did not use a swarm algorithm. *Diffusion Choir* (Hypersonic, Sosolimited & Plebian Design, 2016) is a kinetic sculpture that celebrates the beauty of harmony in a group moving as a single entity as shown in Fig. 5.29. The sculpture consists of 400 kinetic components and mimics the flocking behaviour of birds. Hanging from the ceiling, the kinetic modules soar through the space, open and close individually, then exit and join the choreographed motion. This periodic coalescing motion is controlled by a real-time flocking algorithm.

Another example of a swarm-like sculpture is *Liquid Shard* (Poetic Kinetics, 2016). This is a site-specific kinetic sculpture made of holographic mylar and monofilament for Pershing Square in Los Angeles. The sculpture which is in constant flux resembles the schooling behaviour of fish and the mesmerizing motion of

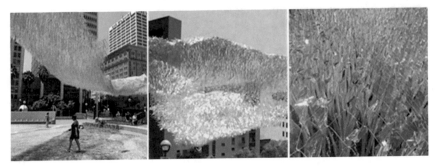

Fig. 5.29 *Liquid Shard* (2016) a collaboration with architectural association visiting school Los Angeles (AAVSLA), SuperArchitects and NOW art at pershing square, Los Angeles (Poetic Kinetics, 2016). © Image Credit Patrick Shearn, Desiree Barlow & Poetic Kinetics, 2021

Fig. 5.30 *Patterned by Nature* (2012) installation at atrium of the research centre at the North Caroline Museum of natureal sciences in Raleigh. © Image Credit Sosolimited; Plebian Design & Hypersonic, 2021

sea flora. Viewers can pause to watch it slow down and observe the wind slowly undulating and transforming the piece as shown in Fig. 5.30.

5.6 Pavilion

Architects have studied swarm intelligence for structural properties and parametric design (Oosterhuis, 2006; 2008; Stuart-Smith, 2016). *Liquidkristal* (Lovegrove & Andrasek, 2012) is a curved, flowing pavilion made of glass panels open to exploration by visitors as shown in Fig. 5.31. A swarm video was projected onto the pavilion to highlight the reflective qualities of the glass material. The pavilion thus adopts a shifting range of colours, based on the play of light caused by its surrounding environment and the warm projections.

A more recent project is *Silk Pavilion* (Oxman et al., 2013), developed at Mediated Matter Group at the MIT Media Lab. This project investigates the relationship

Fig. 5.31 The progression of the swarming video causes a flow of colours and imagery at *Liquid-kristal* (2012) pavilion, the triennale de milano durng Milan design week. Image Credit Lovegrove (2021)

between digital and biological fabrication for architectural production as shown in Fig. 5.32. *Silk Pavilion* was created by 26 polygonal boards (made of silk threads), influenced by the silkworm's ability to generate a 3D cocoon from a single silk thread. The overall geometry of the pavilion was created using an algorithm that assigns a single continuous thread across patches, providing various degrees of density. A swarm of 6500 silkworms was used to reinforce the gaps across CNC-deposited silk fibers. This project is one of the few I found that used both artificial and natural agents (silkworms) to form multi-swarms, and collaboratively create a dynamic and fluid form.

In a follow up project *Silk Pavilion II* (2019–2020) Oxman et al. further explored co-creation among 17,532 silkworms, kinetic apparatus and humans. The Pavilion is comprised of 3 layers: an internal structure of braided steel-wire ropes, a 2D fabric on which the silkworms are positioned, and a 3D knit scaffold that is biologically spun by silkworms as shown in Fig. 5.33.

Fig. 5.32 *Silk Pavilion* (2013) In collaboration with Prof. Fiorenzo Omenetto (TUFTS University) and Dr. James Weaver (WYSS Institute, Harvard University). © Image Credit Neri Oxman and the Mediated Matter Group, MIT Media Lab, 2021

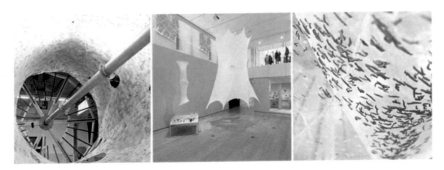

Fig. 5.33 *Silk Pavilion II* (2019–2020) Commissioned by the museum of modern art for Neri Oxman: material ecology exhibition. © Image Credit Neri Oxman and the mediated matter group, MIT Media Lab, 2021

5.7 Ecosystem

5.7.1 Adaptive Ecologies

Theodore Spyropoulos coined the term adaptive ecologies to refer to the social and cultural complexities that demand networked systems, and as he claims, will ultimately be "time-based, reconfigurable and evolutionary" (Spyropoulos, 2013). In architectural practice, adaptive ecologies serve as a platform for open communication which serves as a stimulus for participation, and offers dynamic and visceral relationships between humans and machine in an evolving space. Architecture, therefore becomes "a host to enable scenario-based exchanges that amplify space as an interface for communication."

Spyropoulos and his brother (Stephen) practice architecture from their studio Minimaforms. They view architecture as a new form of communication to explore participatory and interactive frameworks, by applying a generative view of space and exploration of behavioural models (i.e., swarms).

Emotive City (Minimaforms, 2015) is an experimental project for Nesta's FutureFest festival in London. It is a prototype of a future mobile, self-organized, self-aware, and structured city, where architecture responds to and participates in the social and cultural challenges of its environment.

The interdisciplinary and forward-thinking potential of adaptive ecologies in digital design and fabrication along with communication technologies is relevant to our era. which demands to construct spaces of social and material interaction. This approach toward timeless and autonomous architecture demands a shift from limited and fixed relations typical in our built-environment toward systems that are evolving, relational, and ephemeral. Adaptive ecologies need new forms of materiality and information that move beyond geometry and objectification, to create architecture of conversational partners and participatory systems.

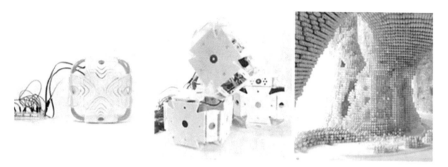

Fig. 5.34 *HyperCell* (2015) developed at the AADRL Studio Theodore with the technical support of Mostafa El-Sayed and Apostolis Despotidis. © Image Credit Spyropoulos (2021)

Spyropoulos also runs AADRL (Architectural Association, Design Research Lab), an experimental architecture and design studio in London. In this studio, students design habitable spaces using machines (robots), swarms, and etymological sense. They have designed systems capable of learning, self-organization, and construction. I reviewed a selection of student proposals which, according to Spyropoulos, "go beyond the set and finished" to become driving forces for the future of architecture. For example, *HyperCell* (Vardoulaki et al., 2015) is a dynamic architectural system that can respond to changes through self-awareness, mobility, softness, and re-configurability as shown in Fig. 5.34. *HyperCell* is a time-based system which has no final structure, but is in ceaseless re-formation. The system is an ecology of constant change, based on local decision-making and interactions between cells. The cells can collectively make structures and exhibit self-assembly (similar to natural swarms). Cells can meet up without predetermined directions to make meaningful structures. The system creates continuous re-forming structures that change according to the population of the cells.

Nomad (Aranchii et al., 2015) is an architectural assembly system that has attributes of autonomy and mobility. It also has the ability to communicate and make decisions. Nomad is capable of creating any space and adopting it to changing conditions without influence from outside or human control. Designed as a set of equal elements, the system can transform, move, recognize neighbours, and attach itself to other modules with some machine intelligence. Eventually modules form large clusters and display emergent behaviours similar to natural swarms.

OWO (Pereyaslavtsev et al., 2015) is a flexible and evolving self-organized system, which operates on different scales. It shifts from conventional static and heavy fabrication methods to an adaptive model. Moving away from the notion of matter as something permanent and static toward a dynamic system correlation, *OWO* explores a behavioural strategy that engages social and material interaction of self-aware components.

Similarly, *Space Oddity* (Andia et al., 2015) aims to dismiss the traditional typologies of space, and explores the idea of the "space can," a conservative and rigid model for space architecture as shown in Fig. 5.35. The objective of *Space Oddity* was to

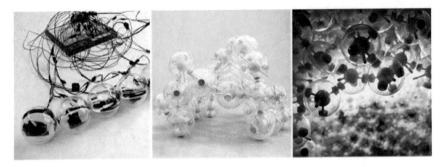

Fig. 5.35 Space Oddity (2015) developed at the AADRL Studio Theodore with the technical support of Shajay Bhooshan, Mustafa El Sayed and Manuel Jimenez Garcia. © Image Credit Spyropoulos (2021)

challenge technology and the concept of the prototype that deals with the physics and parameters of space. Realizing the difficulties inherent in this proposition, *Space Oddity* focuses on two areas: organizational behaviour and material behaviour. Organizational behaviour investigates the notion of a bottom-up approach for the assembly and reconfiguration of one and more parts, pushing for a self-organizing prototype. Material behaviour explores the possibilities of rearranging matter through implicit forces that allow for a constant reconfiguration of a global formation.

5.7.2 Liminal Responsive Architecture (swarm-like)

In architectural practice, there is a tendency toward liminal and responsive architecture. These are ecologies of interconnected networking environments that challenge the limited, fixed structure of the past and move it to open systems that can adapt, evolve, sense, and respond. This represents a shift from passive occupancy to the active and evolving ecologies of interacting agents. Architectural studies and the current practice in this category push the boundaries between art, architecture, and design. The nature of the work produced is interdisciplinary, exploring digital design and fabrication with new computational technologies.

Philip Bessley and his colleagues at the Living Architecture Systems Group have been using this approach. Although there is some behavioural resemblance to the swarming of social insects, the Living Architecture Systems Group claims there are no direct implications of swarm algorithms in their practice. Rather these living environments are driven by curiosity exploration as discussed in Sect. 3.2.5.

Implant Matrix (Beesley & Elsworthy, 2006) is a smart geotextile that could be used to fortify landscapes and futuristic architecture. The lattice is capable of mechanical empathy and responds to its inhabitants like an erotic prey. The structure reacts to human presence with delicate grasping and sucking movements, ingesting natural materials and joining them to create a hybrid being.

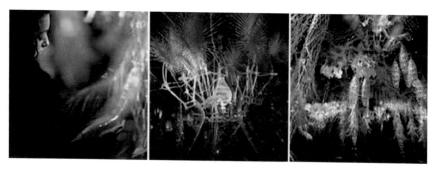

Fig. 5.36 *Hylozoic Ground* (2010) installation, a forest of acrylic fronds that move as though breathing, for the Canada pavilion at the Venice Architecture Biennale. © Image Credit Beesley, 2010

Hylozoic Ground (Beesley, 2010) is a responsive textile made of hundreds of lightweight, digitally-fabricated components that are fitted with microchips and proximity sensors, and respond to human presence as shown in Fig. 5.36. These responsive environment capacities function like a giant lung that breathes in and out around its inhabitants. Arrays of touch sensors and shape-memory alloy actuators make influxes of empathic movement, luring humans into the eerie luminous complexities of an imaginary landscape, a delicate forest of light.

Hylozoic Series: Stoa (Beesley, 2011), *Vesica* (Beesley, 2012) and *Sibyl* (Beesley, 2012) are series of kinetic sculptures consisting of microcontroller networks that control the interactive behaviours of individual agents. In these projects, the resulting complex behaviours are the product of communication among nodes and the interaction with the spectators. The *Hylozoic Series* depends on the superposition of different layers of basic arrangements of prescribed actuations to create complexities in their responsive behaviours. The execution of these prescribed behaviours varies in the different installations. For example, *Aurora* (2010) and *Sentient Veil* (2017) seek after-intimacy and sensitivity through multifaceted tiny segments and layers of diffusive arrays of light chains that are suspended from the ceiling with an IR proximity sensor at the base.

A more recent project, *Sentient Chamber* (Beesley, 2016), is a detached hall with embedded electronics and programming controls. This exploratory design acts as a proving concept for continuous interdisciplinary research in architecture, visual art, computer science, engineering, and synthetic biology. Similarly, *Aegis and Amatria* (Beesley, 2018) produces a constantly-changing and evolving intelligent soundscape generated by the sound originator Salvador Breed, *4DSOUND* (regarding sound by its sculptural and architectural qualities), and the viewer's response and movement as shown in Fig. 5.37. Acting as the first living labs and sculptural canopies, they are made up of a network of responsive fronds that spread a creative adaptive mesh empowered with artificial intelligence. The AI in the model is customized with a *CIA* algorithm. As a result, the framework is always searching for and discovering new behaviours.

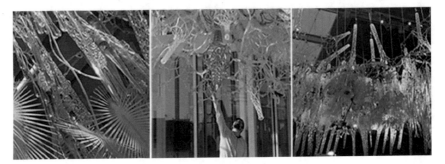

Fig. 5.37 *Amatria* architectual (2018) prototype and test bed for artificial intelligence at Luddy hall for network science center at the school of informatics, computing, and engineering, Indiana University, Bloomington. © Image Credit: Beesley, 2018

5.8 Swarm Tectonic and Swarm Urbanism

Steven Johnson (2002) proposed that a city was a manifestation of emergence and a dynamic adaptive system, influenced by interactions with neighbours, informational feedback loops, pattern recognition, and indirect control. In his opinion "the city is a pattern in time," a collective that is more than the sum of its individual parts.

Neil Leach (2009) developed a new computational methodology for modelling urban forms and software to simulate emergent logics, inspired by a colony of ants or flock of birds.

Architects Roland Snooks and Robert Stuart-Smith (2009) speculated about an urban design methodology based on the emergent capacities of swarm intelligence in their ongoing practice at Kokkugia as shown in Fig. 5.38.

Applying swarm logics to urbanism enables a shift from notions of the master-plan to that of master-algorithm as an urban design tool. This shift changes the urban design concept from a sequential array of decisions at reducing scales to an emergent

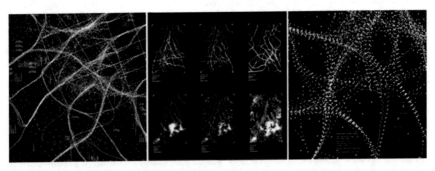

Fig. 5.38 *Swarm Urbanism* (2011) a speculative proposal posits an urban design methodology based on the emergent capacities of swarm intelligence in rethinking of the current redevelopment of the Melbourne Docklands. © Image Credit Leach & Snooks (2011)

complex urban system arising from a set of micro or local interactions. The urban objectives are programmed into a set of autonomous self-organizing agents. This results in a system that is a responsive to the political, economic, and social changes in urban environment.

Lightswarm (Futureforms, 2016) is a smart façade (in a state of perpetual flux) that can sense, compute, respond, and interact with its surroundings as shown in Fig. 5.39. The noises harvested from the lobby of the Yerba Buena Center for the Arts and the surrounding city (San Francisco) activate the south façade with a playful swarm of light. During the day, filtered sunlight produces ever-changing patterns of shadow. In the evening, the façade is transformed into a dynamic electro-luminescent composition visible from the interior lobby, the garden, and the city beyond. It is what the artists call "… urban sensors—instruments to sense the city, visualize its auditory pulse, and amplify its latent energies into cascades of light."

Swarm Study IX (Random International, 2016) is an interactive façade that explores the notion of architecture as something dynamic and adaptive as shown in Fig. 5.40. By exploiting the acrobatic efficiency of the flocking algorithm using light, the façade interacts with its surroundings (natural phenomena) and human

Fig. 5.39 *Lightswarm* (2016) at Yerba Buena Center for the Arts (YBCA), San Francisco. © Image Credit Futureforms, (2021)

Fig. 5.40 Swarm Study IX (2016) inhabits the facade of Hauptbahnbof Chemnitz main railway station, Germany. © Image Credit Jan Bitter & Random International, 2021

activities. As the swarm moves, each light source acts according to its own set of criteria in relation to its neighbours.

References

https://ars.electronica.art/news/de/.

Arts Collective Neon Golden, (2015). https://www.neongolden.net.

Arup et al, (2016). https://www.arup.com.

Bartenieff, I., & Lewis, D. (2013). Body movement: Coping with the environment. Routledge.

Beesley, P., & Elsworthy, W. (2006). Implant matrix. In Responsive architectures: Subtle technologies (pp. 168–171).

Beesley. http://www.philipbeesleyarchitect.com.

Bisig, D., Kocher, P. (2013). Trails II. In Proceedings of the Consciousness Reframed Conference. Cairo, Egypt.

Bisig, D., Neukom, M., Flury, J. (2008). Interactive swarm orchestra an artificial life approach to computer music. In ICMC.

Bisig, D., Palacio, P. (2012). STOCOS-Dance in a synergistic environment. In Proceedings of the Gen-erative Art Conference (Lucca, 2012).

Bisig, D., & Unemi, T. (2009). Swarms on stage-swarm simulations for dance performance. In The Proceedings of the Generative Art Conference. Milano, Italy.

Bisig, D., & Unemi, T. (2010). Cycles-blending natural and artificial properties in a generative artwork. In Proceedings of the 13th Generative Art Conference, Milan, Italy (pp. 140–154).

Bisig, D., Schacher, J. C., & Neukom, M. (2011). Flowspace-a hybrid ecosystem. In NIME (pp. 260–263).

Codognet, P., & Pasquet, O. (2009, December). Swarm intelligence for generative music. In 2009 11th IEEE International Symposium on Multimedia (pp. 1–8). IEEE.

Correll, N., Farrow, N., & Ma, S. (2013, February). Honeycomb: A platform for computational robotic materials. In Proceedings of the 7th International Conference on Tangible, Embedded and Embodied Interaction (pp. 419–422). ACM.

Correll, N., Farrow, N., Sugawara, K., & Theodore, M. (2013a). The swarm-wall: Toward life's uncanny valley. In IEEE, International Conference on Robotics and Automation.

del Val, J. (2014). Microtimes: Towards a politics of indeterminacy. Performance Research, 19(3), 144–149.

del Val, J. (2018). Ontohacking: Onto-ecological politics in the Algoricene. Leonardo, 51(2), 187–188.

Dorin, A. (2008). A survey of virtual ecosystems in generative electronic art. In Romero, J., & Machado, P., (Ed.), The art of artificial evolution: A handbook on evolutionary art and music, natural computing series (pp. 289–309). Springer.

Futureforms, (2016). https://www.futureforms.us.

Futureforms (2021). Lightswarm.

Harriman, J., Theodore, M., Correll, N., & Ewen, H. (2014). endo/exo Making Art and Music with Distributed Computing. In NIME (pp. 383–386).

Hypersonic, Sosolimited & Plebian Design. https://www.hypersonic.cc.

Johnson, S. (2002). Emergence. In The connected lives of ants, cities and software (1st ed., pp. 288). Scribner. (ISBN: 9780684868769).

Kamolov, R., Machado, P., & Cruz, P. (2013, July). Musical flocks. In ACM SIGGRAPH 2013 Posters (pp. 93). ACM.

Kang, E. Donald, C., & Garcia-Snyder, D. (2012, November). Shin'm 2.0. In SIGGRAPH Asia 2012 Art Gallery (p. 17). ACM.

Leach, N. (2009). Swarm urbanism. Architectural design, 79(4), 56–63.

Leach, N., & Snooks, R. (2011). Swarm intelligence: Architectures of Multi-Agent Systems.

Lovegrove & Andrasek, (2012). http://www.rosslovegrove.com.

Lovegrove, R. (2021). Liquidkristal. Spyropoulos, T. (2021). Spyropoulos Studio.

Machado, P., & Martins, T. (2018). insta.ants. https://cdv.dei.uc.pt/insta-ants/.

Martins, T., Martins, P., & Seiça, M. Planar. (2020, July). https://cdv.dei.uc.pt/planar.

McCormack, J. (2007). Artificial ecosystems for creative discovery. In Lipson, H., (Ed.), Proceedings of Genetic and Evolutionary Computation Conference (GECCO 2007) (pp. 301–307). London, England.

Milk, C. (2012). The treachery of sanctuary. Installation. The Creators Project. Accessed May, 1, 2013.

Mikiko & Elevenplay. https://elevenplay.net/about.

NTT, (2018). Japanese telecommunications company NTT.

Oosterhuis, K. (2006). Swarm architecture II. In The architecture co-laboratory: Game set and match II, on computer games, advanced geometries, and digital technologies (pp.14–28).

Oosterhuis, K., & Biloria, N. (2008). Interactions with proactive architectural spaces: the muscle projects. *Communications of the ACM, 51*(6), 70—78.https://doi.org/10.1145/1349026.1349041.

Oxman, N., Laucks, J., Kayser, M., Gonzalez Uribe, C. D., & Duro-Royo, J. (2013). *Biological computation for digital design and fabrication.*

Poetic Kinetics, (2016). https://www.poetickinetics.com.

Random International. https://www.random-international.com.

Rodrigues, A., Machado, P., Martins, P., & Cardoso, A. (2015, September). Sound visualization through a swarm of fireflies. In Portuguese Conference on Artificial Intelligence (pp. 664–670). Springer.

Roland Snooks & Robert Stuart-Smith, (2009). https://www.kokkugia.com. (Roland Snooks and Robert Stuart-Smith studio).

Seo, J., & Corness, G. (2012). Light strings: kinesthetic immersive environment. In SIGGRAPH ASIA Art Gallery (pp. 15–1).

Shiffman, (2002). https://shiffman.net.

Shiffman, D. (2004). In Swarm, ACM SIGGRAPH 2004 Emerging Technologies Proceedings (pp. 26). ACM Press.

Sommerer, C., & Mignonneau, L. (2016). A personal media art archive based on the symbol of the fly. *Archiving and Questioning Immateriality, 5,* 87.

Sommerer, C., Mignonneau, L., & Weil, F. (2015). The Art of Human to Plant Interaction. *The Green Thread: Dialogues with the Vegetal World,* 233.

Spyropoulos, T. (2021). Spyropoulos Studio. https://drl.aaschool.ac.uk/spyropoulos-studio.

Stuart-Smith, R. (2016). Behavioural production: Autonomous swarm-constructed architecture. *Architectural Design, 86*(2), 54–59.

Subyen, P., Maranan, D., Schiphorst, T., Pasquier, P., & Bartram, L. (2011, August). EMVIZ: the poetics of movement quality visualization. In Proceedings of the International Symposium on Computational Aesthetics in Graphics, Visualization, and Imaging (pp. 121–128). ACM.

Tatar, K., Pasquier, P., & Siu, R. (2018, April). REVIVE: An audio-visual performance with musical and visual AI agents. In Extended Abstracts of the 2018 CHI Conference on Human Factors in Computing Systems (p. Art13). ACM.

Tricaud, (2018). https://www.margueritetricaud.com/emergent-harmony.

Verity Studios. https://www.veritystudios.com.

WHITEvoid, (2013). https://www.whitevoid.com.

Chapter 6
Challenges and Potentials

6.1 Challenges

In my search for swarm art and architecture, I conducted an extensive review of catalogues, books, websites, journals, and conference papers. In this process, I identified a few main challenges for the development and advancement of the swarm for art and architecture. One such challenge was the limited documentation of swarm systems, crucial for understanding the specifics of particular works for analysis through a lens of my proposed taxonomy (Table I) and as listed in Table 7.2. Many of the systems included here have not been documented in detail. Regardless of this challenge, I have attempted to provide an overall picture of swarm art and architecture based on the landscape of the works that I found, focusing on their common features instead of explicit concepts.

The other challenges I discerned can be categorized as theoretical, technical, experiential, or strategic.

6.1.1 *Theoretical Challenges*

Most swarm systems can be viewed as a system with two phases that explore and exploit their environment. The focus of the exploration and exploitation stages are the freedom and control levels of constraints. During the initial phase, freedom is boosted and swarm agents focus more on exploration. Agents form a population of local positions which search for better solutions. By encouraging exploitation, constraint becomes more emphasized as agents focus more on exploitation of the best positions and storing them.

Finding a balance between exploration and exploitation has been an ongoing theoretical challenge in swarm intelligence research. Despite many years of research and hundreds of different swarm algorithms, swarm algorithms usually perform weaker

© The Author(s), under exclusive license to Springer Nature Singapore Pte Ltd. 2021
M. Salimi, *Swarm Systems in Art and Architecture*, Computational Synthesis and Creative Systems, https://doi.org/10.1007/978-981-16-4357-6_6

in one of the exploration or exploitation phases. For example, PSO usually performs better during the exploitation phase and is weak for exploration.

To overcome this challenge, artists and architects often combine a few algorithms. However, this complicates the architecture and makes it challenging to control and direct the overall behaviour of swarm.

6.1.2 Technical Challenges

6.1.2.1 Control

One of the main technical challenges of swarm systems is the control which is usually very complicated. There are four main possibilities to control swarm systems: changing between the algorithms that determine the behaviour of the swarm; altering the initial parameters; controlling explicit agents (leaders); and modifying the environment to have an impact on the behaviour of swarm (Kolling et al., 2015).

First, you can switch between algorithms to get a desired behaviour. For example, al-Rifaie & Bishop (2013) suggested combining SDS and PSO algorithms to overcome PSO weakness in the exploration phase. As a result, they were able to influence the behaviour of swarm agents in a desired direction.

Second, you can change the parameters of the swarm algorithm, such as the size of the swarm population, the maximum or minimum distance between neighbours, or the characteristics of each node to influence the behaviour of swarms. Changing how the neighbours interact with each other and the environment at the local level will influence the behaviour of the swarm at the group level (Kira & Potter, 2009).

Third, you can control the actions of a selected swarm's nodes (leaders). The selected agent can direct the other agents, or other agents might respond to its actions or signals.

Finally, you can adjust the environment that swarms operate in to influence their behavior. This is generally achieved through the deployment of virtual agents such as virtual pheromones that command swarm agents to (not) further explore an area. Other virtual agents include proxies, attractors, and predators, which are simulated nodes or adversaries to which the agents respond (Kolling et al., 2015). It is important to note that altering the environment requires a good understanding of how swarm agents might respond and therefore is less suitable for non-experts (Kolling et al., 2013).

Many of the avenues to control swarm behaviour depend on the parameters of the nodes, proxies, attractors or predators, and you can explicitly control the swarm behaviour. This is because swarm behaviour at the group level emerges from iterative changes and endless experiments in how nodes act or respond to other nodes or the environment (Brambilla et al., 2014).

6.1.2.2 Replicability

Another major technical challenges of swarm systems is the lack of documentation, as mentioned before. This leads not only to misunderstanding the underlying concepts but also makes it difficult to replicate the system. I found in the majority of art and architectural projects I analyzed that the steps of inquiry were not documented in a rigorous way. Most of the projects I analyzed were only documented in a website presentation or as part of the artist/architect portfolio, with a brief description of the concept.

Some artists/architects provided conceptual and theoretical insights about their work, by documenting the setup of their work and other technical details. For example, Daniel Bisig (http://swarms.cc), Leonel Moura (http://www.leonelmoura.com), and Roland Snooks, Penousal Machado (https://cdv.dei.uc.pt), and Robert Stuart-Smith (https://www.kokkugia.com) documented their ongoing practice and exploration of swarms, in their websites.

Other technical and detail descriptions can be found in published books and papers, often including a description of the hardware and software with precise details that could allow for replicability, as done by Leonel Moura in multiple publications (Moura & Pereira, 2004; Moura & Ramos, 2007). Likewise, Tim Blackwell documented his work in swarm systems by posting his compositions, musical improvizations, and codes in the form of web posts or audio clips (Blackwell, 2003, 2007, 2008).

Despite an argument that there is no need or aim to replicate art/architecture, proper documentation makes insight to the technical nuances, approaches, and refinements of swarm systems easier. Plus, well-documented projects help the field grow by getting through the unknown and offering new possibilities for creative outputs. Hopefully in future more artists/architects embrace documentation as a part of their practice.

6.1.2.3 Real-time Update

Another important technical challenge in swarm systems is the bandwidth limit. Real-time updates of all nodes in a large swarm demand significant bandwidth. Therefore, it is very challenging to communicate with the swarm in real-time, especially in hierarchical setups (Harriott et al., 2014).

6.1.3 Experiential Challenges

6.1.3.1 Operation

It is difficult to operate swarms in practice. The cognitive complexity of controlling a swarm is high and increases with the swarm size. Also, each added node exponentially

increases the possible interaction states within the swarm and the environment, and results in the so-called *state-space explosion problem*. State-space explosion is a common problem in model checking (i.e., verifying emergent behaviours) that arises when the states of the model are abundant (i.e., the number of states to explore is beyond computational capabilities). This can lead to a loss of situational awareness (SA) (Hussein & Abbass, 2018), which is the perception of the features of the system over time and space, the comprehension of their meaning, and the prediction of their status in the near future. Numerous studies have indicated that SA significantly affects human decision-making and task performance (Endsley, 2017; Riley & Strater, 2006). As a rule, controlling individual nodes via commands becomes more difficult as the size of the swarm increases (Brown et al., 2014).

To control swarms effectively, the artist/architect should have an abstract picture of the state of the swarm, and the important features for the desired emergent behaviour. In practice, it is challenging to perceive this abstract picture. The absence of an accurate perception makes it difficult to predict the exact impact of a command (local level) over the emergent swarm behaviour (group level) (Roundtree et al., 2019; Walker et al., 2016).

6.1.3.2 Ambiguity

Swarm systems consist of many lateral or horizontal causalities, and comprehension of the complex underlying rules in most cases is very difficult. It is also very difficult to understand the behaviour of swarms just from the functions of its agents. Although, there is no need to fully understand how a computational collective system works to be able to replicate, use, and make them better. However, understanding what nodes are responsible for, and the reason for certain behaviours makes it easier to use them for artistic/architectural creation.

6.1.3.3 Sensitivity

The behaviour of individual agents is similar to noise since their action is mostly stochastic. However, even a small adjustment in the initial conditions (individual agents) results in a completely different global behaviour.

6.1.4 Strategic Challenges

Swarms pose several strategic problems such as predictability, reliability, transparency, and open-sourcing.

6.1.4.1 Predictability

Swarm systems are redundant, complex, and unpredictable due to the absence of central control. The initial parameters of the nodes should be set through a trial and error procedure, to achieve a desired behaviour. This is one the major drawbacks of swarm systems and makes the selection mechanism non-optimal.

6.1.4.2 Transparency and Open-Sourcing

As mentioned before, one of the key challenges is the limited documentation and detail or technical information about swarm systems, which is important for understanding the specifics of particular system or the overall aesthetics.

6.2 Potentials

Despite the challenges, swarm systems have many potentials that can be explored in art and architecture, including emergence and novelty. The exploration and exploitation phases of swarms provide valuable venues for artificial creativity. Creativity and autonomy in swarms help artists/architects develop new techniques. Plus, the emergent and self-organization behaviours of swarms generate novel aesthetics and forms.

6.2.1 Emergence

A unique capacity of swarms is emergence. This refers to a complex collective phenomenon that arises from relatively simple rules and the interaction between individual agents and their environment. Emergence is closely related to complexity and self-organization concepts. Complexity is defined as behaviours or properties of a system resulting from the interaction of its parts, that are not found in the individual feature itself. Self-organization (as discussed in Sect. 1.1.2) is defined as "... a process in which pattern at the global level of a system emerges solely from numerous interactions among the lower-level components of the system." Several of the self-organizing features are essential for emergent behaviours. These include: positive feedback, which amplifies fluctuations; negative feedback, which enhances stabilization; multi-stability, for concurrence of multiple stable states; and state transitions that lead to dramatic change of the system behaviour i.e., bifurcations (Camazine et al., 2003).

6.2.1.1 Simplicity

Swarm systems consist of relatively simple agents which collectively achieve complex tasks (Bonabeau et al., 1999; Şahin, 2004; Qu et al., 2006).

6.2.1.2 Robustness

Robustness derives from the decentralized nature of swarms. It means there is no single point of failure in swarms, and it can continue despite the failure of its individuals or disturbances in the environment.

6.2.1.3 Adaptability

Swarms systems can adapt quickly to changes in their environment, which makes them flexible (Şahin, 2004; Liu & Winfield, 2010). Swarms are also able to evolve and shift the locus of adaptation over time from one part of the system to another (i.e., from the swarm to the agents or from individual agents to a population). This particular behaviour is only possible in collective systems and non-collective systems cannot evolve (in the biological sense).

6.2.1.4 Scalability

The size of a swarm population has little to no influence on their coordination mechanism.

6.2.1.5 Autonomy

Swarm systems are autonomous and not directed by an external control or centralized guidance (Kassabalidis et al., 2001; Li et al., 2015; Ulbrich et al., 2016).

6.2.1.6 Parallelism

Swarm systems naturally use parallel computation for problem solving and are well suited for large-scale tasks (Kassabalidis et al., 2001; Tan & Zheng, 2013). The population of a swarm is usually large, and it can deal with multiple targets in one task or multiple targets distributed in an environment.

6.2.2 Novelty

Swarm systems are novelty-driven for three reasons. First, swarm systems are often governed by chaos control due to their sensitive dependence on initial conditions. This means that the natural tendency of a swarm system is to diverge exponentially in phase space and their long-term behaviour is unpredictable.

Second, swarm systems are capable of probabilistic transition and parallel search of the possible hyperspace without any explicit assumption. The parallel search, generates novel possibilities by exploring exponential combinations of the individual agents.

Finally, swarm systems do not calculate the behaviour of the individual agents, so imperfection and individual variances can be allowed. In swarm systems with heritability characters, these imperfections lead to perpetual novelty, otherwise known as evolution (Kelly, 2009).

References

al-Rifaie, M. M., & Bishop, J. M. (2013, April). Swarmic sketches and attention mechanism. In *International Conference on Evolutionary and Biologically Inspired Music and Art* (pp. 85–96). Springer, Berlin, Heidelberg. https://doi.org/10.1007/978-3-642-36955-1_8.

Blackwell, T. (2003). Swarm music: Improvised music with multi-swarms. *Artificial Intelligence and the Simulation of Behaviour, University of Wales, 10,* 142–158.

Blackwell, T. (2007). Swarming and music. In *Evolutionary computer music* (pp. 194–217). Springer. https://doi.org/10.1007/978-1-84628-600-1_9.

Blackwell, T. (2008). Swarm granulation. In *The art of artificial evolution* (pp. 103–122). Springer. https://doi.org/10.1007/978-3-540-72877-1_5.

Bonabeau, E., Marco, D. D. R. D. F., Dorigo, M., Théraulaz, G., & Theraulaz, G. (1999). Swarm intelligence: from natural to artificial systems (No. 1). Oxford University Press.

Brambilla, M., Dorigo, M., & Birattari, M. (2014). Formal methods for the design and analysis of robot swarms (Doctoral dissertation, Ph. D. thesis, Universite Libre de Bruxelles, Berlin, Heidelberg).

Brown, D. S., Kerman, S. C., & Goodrich, M. A. (2014). Human-swarm interactions based on managing attractors. In Proceedings of the 2014 ACM/IEEE international conference on Human-robot interaction (pp. 90–97). https://doi.org/10.1145/2559636.2559661.

Camazine, S., Deneubourg, J. L., Franks, N. R., Sneyd, J., Bonabeau, E., & Theraula, G. (2003). *Self-organization in biological systems.* Princeton University Press.

Endsley, M. R. (2017). From here to autonomy: Lessons learned from human-automation research. *Human Factors, 59*(1), 5–27. https://doi.org/10.1177/0018720816681350.

Harriott, C. E., Seiffert, A. E., Hayes, S. T., & Adams, J. A. (2014). Biologically-inspired human-swarm interaction metrics. In *Proceedings of the Human Factors and Ergonomics Society Annual Meeting* (Vol. 58, No. 1, pp. 1471–1475). Sage CA: Los Angeles, CA: SAGE Publications. https://doi.org/10.1177/1541931214581307.

Hussein, A., & Abbass, H. (2018). Mixed initiative systems for human-swarm interaction: Opportunities and challenges. In 2018 2nd Annual Systems Modelling Conference (SMC) (pp. 1–8). IEEE. https://doi.org/10.1109/SYSMC.2018.8509744.

Kassabalidis, I., El-Sharkawi, M. A., Marks, R. J., Arabshahi, P., & Gray, A. A. (2001, November). Swarm intelligence for routing in communication networks. In GLOBECOM'01. IEEE Global Telecommunications Conference (Cat. No. 01CH37270) (Vol. 6, pp. 3613–3617). IEEE.

Kelly, K. (2009). *Out of control: The new biology of machines, social systems, and the economic world*. Hachette UK.

Kira, Z., & Potter, M. A. (2009). Exerting human control over decentralized robot swarms. In 2009 4th International Conference on Autonomous Robots and Agents (pp. 566–571). IEEE. https://doi.org/10.1109/ICARA.2000.4803934.

Kolling, A., Sycara, K., Nunnally, S., & Lewis, M. (2013). Human swarm interaction: An experimental study of two types of interaction with foraging swarms. *Journal of Human-Robot Interaction, 2*(2). https://doi.org/10.5898/JHRI.2.2.Kolling.

Kolling, A., Walker, P., Chakraborty, N., Sycara, K., & Lewis, M. (2015). Human interaction with robot swarms: A survey. *IEEE Transactions on Human-Machine Systems, 46*(1), 9–26. https://doi.org/10.1109/THMS.2015.2480801.

Li, J. J., Zhang, R. B., & Yang, Y. (2015, August). Multi AUV intelligent autonomous learning mechanism based on QPSO algorithm. In International Conference on Intelligent Computing (pp. 60–67). Springer. https://doi.org/10.1007/978-3-319-22186-1_6.

Liu, W., & Winfield, A. F. (2010). Modeling and optimization of adaptive foraging in swarm robotic systems. *The International Journal of Robotics Research, 29*(14), 1743–1760. https://doi.org/10.1177/0278364910375139.

Moura, L., & Pereira, H. G. (2004). Man+ robots: symbiotic art. Institut d'art contemporain.

Moura, L., & Ramos, V. (2007). Swarm paintings-nonhuman art. In *ARCHITOPIA book, art, architecture and science* (pp. 5–24).

Qu, D., Qu, H., & Liu, Y. (2006). Emergence in swarming pervasive computing and chaos analysis. In 2006 First International Symposium on Pervasive Computing and Applications (pp. 83–89). IEEE. https://doi.org/10.1109/SPCA.2006.297531.

Riley, J. M., & Strater, L. D. (2006, October). Effects of robot control mode on situation awareness and performance in a navigation task. In Proceedings of the Human Factors and Ergonomics Society annual meeting (Vol. 50, No. 3, pp. 540–544). Sage CA, SAGE Publications. https://doi.org/10.1177/154193120605000369.

Roundtree, K. A., Goodrich, M. A., & Adams, J. A. (2019). Transparency: Transitioning from human-machine systems to human-swarm systems. *Journal of Cognitive Engineering and Decision Making, 13*(3), 171–195. https://doi.org/10.1177/1555343419842776.

Şahin, E. (2004). Swarm robotics: From sources of inspiration to domains of application. In International workshop on swarm robotics (pp. 10–20). Springer. https://doi.org/10.1007/978-3-540-30552-1_2.

Tan, Y., & Zheng, Z. Y. (2013). Research advance in swarm robotics. *Defence Technology, 9*(1), 18–39. https://doi.org/10.1016/j.dt.2013.03.001.

Ulbrich, F., Rotter, S. S., & Rojas, R. (2016). Adapting to the traffic swarm: Swarm behaviour for autonomous cars. In *Handbook of research on design, control, and modeling of swarm robotics* (pp. 263–285). IGI Global. https://doi.org/10.4018/978-1-4666-9572-6.ch010.

Walker, P., Lewis, M., & Sycara, K. (2016). Characterizing human perception of emergent swarm behaviors. In 2016 IEEE International Conference on Systems, Man, and Cybernetics (SMC) (pp. 002436–002441). IEEE. https://doi.org/10.1109/SMC.2016.7844604.

Chapter 7
Conclusion

When considering the samples of swarm systems described here, one cannot help but be impressed by the wide diversity of artistic/architectural approaches. These systems all used swarm principles as a common denominator, but their conceptual contexts, methods of realization and forms of audience engagement vary considerably.

In one context addressed the relationship and overlap between artificial man-made systems and natural processes as a juxtaposition of swarm behaviours and technical devices. Alternatively, swarm phenomena can be used as cultural metaphors that symbolize the possibility of breaking away from established conventions and embracing principles of ambiguity and indeterminacy.

Another context emphasized the relationship between individuals and groups by exploring how the latter arose from the former through principles of self-organization and emergence. Toward this end, swarm principles can be adopted as mechanisms of coordination which allow individual entities to organize themselves into a coherent whole. Examples of this approach includes agents that communicate with each other to form a musical orchestra or modular robotic elements that combine to form a composite entity that exhibits higher level formal and behavioural faculties.

A third context highlighted the potential of swarms to serve as universal principles through which creative processes could be formalized. Some approaches employ swarms as generative mechanisms for creating different types of media such as video and audio. Other approaches adopt swarm principles to experiment with social forms of computational creativity.

The methods employed by artists when creating swarm arts are also varied. Some artists focus their creative decision-making on the design of the properties and behaviours of the swarms. These artists develop unique types of simulations and robotic objects that then form the core of the artistic work. Other artists content themselves with employing conventional, unmodified swarm simulations and focus their creative attention on the presentation of the simulation in an unconventional medium or format. Finally, some artists did not employ swarm models but instead look to natural swarms as a source of inspiration. They used swarm-like behaviours to derive the overall aesthetic of their artwork.

© The Author(s), under exclusive license to Springer Nature Singapore Pte Ltd. 2021 103
M. Salimi, *Swarm Systems in Art and Architecture*, Computational Synthesis and Creative Systems, https://doi.org/10.1007/978-981-16-4357-6_7

Swarm systems offers interesting possibilities for the engagement of audiences. All systems presented here, regardless of being interactive or not, place great emphasis on making swarm principles readily apparent. This could be achieved by using distributed objects that communicate with each other and/or using acoustic and visual elements that propagate through space. Interactive swarms extend aspects of the group coordination into principles for interaction i.e., swarms that change their movement in response to the audience's movement, or musical agents that gather utterances of the audience. In this way, both agents and visitors possess a similar level of agency and can engage with each other as if they were part of a single swarm.

Here, I conclude my analysis of the swarm systems in art and architecture. My goal was to provide a brief analysis of selected systems to serve as examples in the presented taxonomy. I hope that my taxonomy inspires discussion and stimulates the creation of a larger body of swarm systems.

7.1 Acknowledgements

I acknowledge the Springer reviewers for their comments and suggestions that helped shape and improve this book. A big thank you goes to all artists/architects who responded to my survey and provided necessary information and images, without whom this book would not be as comprehensive. I want to specially thank Dr. Daniel Bisig for writing the forward and sharing his amazing insights; Leonel Moura and Linda Bouchard for sharing their experiences, challenges, and technical subtleties of swarm systems. I also thank Dr. Nikolaus Correll whose insights in the early days helped in framing the scope of the book; Dr. Carlos Castellanos, and Dr. Mirjana Prpa for their input about the structure and chapter organizations; Mio Sugino for formatting suggestions; Nancy Wills and Aerin Caley for proof reading and copy editing. Finally, I thank my PhD senior supervisor Dr. Philippe Pasquier and co-supervisors Dr. Steve DiPaola, and Dr. Gabriela Aceves Sepúlveda at School of Interactive Art and Technology (SIAT) at Simon Fraser University (SFU) for their inspiration and support in shaping the current version of the book.

7.2 Additional Materials

Illustrations of presented artworks, links to the artists and artworks, and other resources can be found here: https://swarm-art-architecture.tumblr.com

7.3 Taxonomy

The taxonomy consists of two tables. Table 7.1 introduces 118 artworks by their titles, year, authors' names and provides references. Table 7.2 details each artwork across taxonomy categories.

Table 7.1 Selected swarm systems

#	Title	Year	Author(s)	Category	References
1	Ant brush	2000	Elpida Tzafestas	Art	Tzafestas (2000)
2	Soma: self-organising map ants	2001	Tim Barrass	Art	Barrass (2001)
3	SWARMUSIC	2001	Tim Blackwell	Art	Blackwell (2003, 2007)
4	MicroImage	2001–2004	Casey Reas	Art	Reas (2004)
5	Swarm	2002	Daniel Shiffman	Art	Shiffman (2004)
6	Ant painting	2003	Sebastien Aupetit, Vincent Bordeau, Nicolas Monmarché, Mohamed Slimane, and Gilles Venturini	Art	Monmarché et al. (2003)
7	Ant painting	2014	Penousal Machado, Tiago Martins, Hugo Amaro, and Pedro Abreu	Art	Machado et al. (2014)
8	SwarmArt	2003–2005	Jeffrey Boyd, Gerald Hushlak, and Christian Jacob	Art	Jacob & Hushlak (2008)
9	ArtsBot: art swarm of robots	2004	Leonel Moura and Henrique Garcia Pereira	Art	Moura and Pereira (2004)
10	Swarm granulator	2004–2008	Tim Blackwell, Michael Young, Mette Bille, and Panos Ghikas	Art	Blackwell and Young (2004); Blackwell (2008)
11	Process	2004–2014	Casey Reas	Art	Reas (2015)
12	Ant painting	2005–2006	Gary Greenfield	Art	Greenfield (2005)
13	Swarm tech-tiles	2005	Tim Blackwell and Janis Jefferies	Art	Blackwell & Jefferies (2005, ,2005a)
14	Gaugant paintings	2006	Paulo Urbano	Art	Urbano (2006)
15	S-robot paintings	2006	Gary Greenfield	Art	Greenfield (2006)

(continued)

Table 7.1 (continued)

#	Title	Year	Author(s)	Category	References
16	RAP: Robotic Action Painter	2006	Leonel Moura	Art	Moura (2018)
17	Swarmpieces I–III	2006	Tim Blackwell and Michael Young	Art	Miranda and Al Biles (2007)
18	Swarm exquisite-corpse	2007	Paulo Urbano	Art	Urbano (2008)
19	Swarm grammar	2007	Sebastian von Mammen and Christian Jacob	Art	von Mammen, and Jacob, (2007)
20	SwarmPAINTER	2007	Christian Jacob and Gerald Hushlak	Art	Jacob et al. (2007)
21	Unnamed system	2007	Peter Beyls	Art	Beyls (2007)
22	AtomSwarm	2008	Daniel Jones	Art	Jones (2008)
23	Dancing with swarms	2008	Christian Jacob	Art	Jacob (2008)
24	Fibrous tower	2008	Kokkugia	Architecture	Snooks et al. (2009)
25	Robotica: control inside the panopticon	2008	Stanza	Art	Stanza (2009)
26	Swarms	2008	Daniel Bisig and Pablo Ventura	Art	Bisig and Unemi (2009)
27	You pretty little flocker	2008–2012	Alice Eldridge	Art	Eldridge (2015)
28	2047	2009	Pablo Ventura and Daniel Bisig	Art	Ventura and Bisig (2016)
29	Cycles	2009	Daniel Bisig and Tatsuo Unemi	Art	Bisig and Unemi (2010)
30	Sound agents	2009	Philippe Codognet and Olivier Pasquet	Art	Codognet and Pasquet (2009)
31	Swarm urbanism	2009	Kokkugia	Architecture	Leach and Snooks (2011)
32	Hylozoic ground	2010	Philip Beesley	Architecture	Beesley (2021)
33	Swarm light I-XIII	2010–2018	Random International	Art	Random International (2021)
34	Dancing with swarming particles	2010	Rodrigo Carvalho	Art	Carvalho (2010)
35	EMVIZ	2011	Pat Subyen, Diego Maranan, Thecla Schiphorst, Philippe Pasquier, Lyn Bartram	Art	Subyen et al. (2011)
36	Flowspace	2011	Daniel Bisig	Art	Bisig et al. (2011)

(continued)

Table 7.1 (continued)

#	Title	Year	Author(s)	Category	References
37	Hylozoic series: Stoa, Sibyl, Vesica	2011	Philip Beesley	Architecture	Beesley (2021)
38	Mechthild	2011	Daniel Bisig	Art	Bisig et al. (2011)
39	Sand paintings	2011	Paulo Urbano	Art	Urbano (2011)
40	Transport network overlay	2011	Gary Greenfield	Art	Greenfield (2011)
41	Aesthetic agents	2012	Justin Love and Philippe Pasquier	Art	Love et al. (2011)
42	Light strings	2012	Jinsil Hwaryoung Seo, Greg Corness	Art	Seo and Corness (2012)
43	Liquidkristal	2012	Ross Lovegrove and Alisa Andrasek	Architecture	Lovegrove (2021)
44	Patterned by Nature	2012	Plebian, Hypersonic, Patten Studio and Sosolimited	Architecture	Hypersonic (2021)
45	Photogrowth	2012	Penousal Machado and Luís Pereira	Art	Machado and Pereira (2012)
46	Pherographia	2013		Art	Greenfield and Machado (2014, 2015)
47	Shin'm 2.0	2012	Eunsu Kang, Donald Craig, and Diana Garcia-Snyder	Art	Kang et al. (2012)
48	STOCOS	2012	Daniel Bisig	Art	Bisig and Palacio (2012)
49	The robot quartet	2012	Andres Wanner	Art	Wanner (2013)
50	The treachery of sanctuary	2012	Chris Milk	Art	Milk (2012)
51	Woher diese Zärtlichkeit	2012	Daniel Bisig	Art	Bisig et al. (2012)
52	Stigmmetry prints	2012–2014	Gary Greenfield	Art	Greenfield (2012)
53	Composite swarm	2013	Roland Snooks, James Pazzi, Marc Gibson	Architecture	Kokkugia (2021)
54	Composite skeleton	2013	Roland Snooks, Cam Newnham, Yian Chen, James Hall, Zhao Fei, Shibo Du, Sebastian Nicht, Wentao Guo, Han Chen, Andre Cheung, Ziyu Meng, Elisa Perez Mosos, Bowen Nie, Jack Bakker	Architecture	Kokkugia (2021)
55	Coral	2013	Daniel Bisig and Sebastien Schiesser		Kokkugia (2021)

(continued)

Table 7.1 (continued)

#	Title	Year	Author(s)	Category	References
56	FLUIDIC: sculpture in motion	2013	WHITEvoid design and art studio	Art	WHITEvoid (2021)
57	Garden of virtual delights	2013	Tiago Martins, Penousal Machado, Artur Rebelo	Art	Martins et al. (2013)
58	Musical flocks	2013	Ruslan Kamolov, Penousal Machado, and Pedro Cruz	Art	Kamolov et al. (2013)
59	Nike flyknit	2013	Universal everything	Art	Universal Everything (2021)
60	Swarm wall	2013	Nikolaus Correll, Nicholas Farrow, Ken Sugawara, and Michael Theodore	Art	Correll et al. (2013)
61	Swarmic sketches	2013	Mohammad Majid al-Rifaie and John Mark Bishop	Art	al-Rifaie & Bishop (2013)
62	Trails II	2013	Daniel Bisig and Pablo Ventura	Art	Bisig and Kocher (2013)
63	Aerial robotic swarm construction	2013–2015	Robert Stuart-Smith, Tyson Hosmer, Manos Matsis, Alejandra Rojas, Karthikeyan Arunachalam, Maria Garcia, Melhem Sfeir	Architecture	Stuart-Smith (2016)
64	A(g)ntense	2014	Satoru Sugihara	Architecture	Sugihara (2014)
65	AntiBot	2014	Theodore Spyropoulos, Leyla Asrar Haghighi, Dachuan Jing, Baiye Ma, Yuchen Zhu	Architecture	Spyropoulos (2021)
66	Collapse collide	2014	Saman Dadgostar, Sofia Miranta Papageorgiou, Akber Khan, Felipe Sepulveda Rojas	Architecture	Spyropoulos (2021)
67	Dancer	2014	Yann Semet, Fredo Durand and Una-May O'Reilly	Art	Semet et al. (2014)
68	endo/exo	2014	Michael Theodore	Art	Theodore et al. (2014)
69	Silk pavilion	2014	Neri Oxman, Jared Laucks, Markus Kayser, Jorge Duro-Royo, and Carlos Gonzales-Uribe	Architecture	Oxman (2021)
70	Signature strokes	2014–2015	Andres Wanner	Art	Wanner (2015)
71	Drone 100	2015	Ars Electronica Futurelab and Intel	Art	Ars Electronica Futurelab (2021)
72	Emotive city	2015	Minimaforms	Architecture	Spyropoulos (2016)

(continued)

Table 7.1 (continued)

#	Title	Year	Author(s)	Category	References
73	Fireflies visualization	2015	Ana Rodrigues, Penousal Machado, Pedro Martins, and Amílcar Cardoso	Art	Rodrigues et al. (2015)
74	HyperCell	2015	Theodore Spyropoulos, Pavlina Vardoulaki, Ahmed Shokir, Cosku Çinkiliç, Houzhe Xu	Architecture	Spyropoulos (2021)
75	In the eyes of the animal	2015	Marshmallow Laser Feast	Art	Marshmallow Laser Feast (2021)
76	KvantSwarm	2015	Keijiro Takahashi	Art	Takahashi (2021)
77	Nomad	2015	Theodore Spyropoulos, Dmytro Aranchii, Paul Bart, Yuqiu Jiang, Flavia Santos	Architecture	Spyropoulos (2021)
78	OWO	2015	Theodore Spyropoulos, Ilya Pereyaslavtsev, Agata Banaszek, Antonios Thodis, Camilla Degli Esposti	Architecture	Spyropoulos (2021)
79	Pherogenic paintings	2015	Carlos Fernandes, Antonio Mora, Juan Julián Merelo, Agostinho Rosa	Art	Fernandes et al. (2015)
80	Portrait on the fly	2015	Christa Sommerer and Laurent Mignonneau	Art	Sommerer and Mignonneau (2016)
81	ROTO	2015	Theodore Spyropoulos, Octavian Mihai Gheorghiu, Natasha Gill, Nhan Vo, Sergey Krupin	Architecture	Spyropoulos (2021)
82	Space oddity	2015	Theodore Spyropoulos, Sebastian Andia, Rodrigo Chain, Apostles Despotidis, Thomas Jensen	Architecture	Spyropoulos (2021)
83	SWARM	2015	Arts collective Neon Golden	Art	Arts collective Neon Golden (2015)
84	Drawing operations	2015–2018	Sougwen Chung	Art	Chung (2018)
85	24 Drones	2016	Mikiko and Elevenplay	Art	Elevenplay (2021)
86	Delta	2016	Theodore Spyropoulos, Necdet Yagiz Özkan, Anju Veerappa Satish, Avneesh Rathor, Irina Igorevna Safonova	Architecture	Spyropoulos (2021)
87	Diffusion choir	2016	Sosolimited, Plebian Design, and Hypersonic	Architecture	Hypersonic (2021)

(continued)

Table 7.1 (continued)

#	Title	Year	Author(s)	Category	References
88	LATLONG	2016	SOM, Builders WSP, Parsons Brinckerhoff, Design + Code, schnellebuntebilder, & Quadrature	Art	Schnellebuntebilder Studio (2021)
89	Lightswarm	2016	Futureforms	Architecture	Futureforms (2021)
90	Liquid shard	2016	Poetic Kinetics	Architecture	Poetic Kinetics (2021)
91	Swarm study IX	2016	Random International	Architecture	Random International (2021)
92	XO	2016	Theodore Spyropoulos, Aleksandar Bursac, Georgia Tsoli, Lisa Kuhnhausen, Suzan Ibrahim	Architecture	Spyropoulos (2021)
93	Protocell	2016–2017	Theodore Spyropoulos, Ece Bahar Elmaci Badanoz, Lara Niovi Vartziotis, Ogulcan Sulucay, Qiquan Lu	Architecture	Spyropoulos (2021)
94	Synergia	2016–2017	Theodore Spyropoulos, Hitesh Chandra Katiyar, Rui Qu, Ian Yeonsuk Kim, Astrid von Mühlenbrock	Architecture	Spyropoulos (2021)
95	2047 Apologue	2017	Verity Studios	Art	Verity Studios (2021)
96	BeBot	2017	Leonel Moura	Art	Moura (2018)
97	Paint by drone	2017	Carlo Ratti	Art	Ratti (2017)
98	Mutator VR: Vortex	2015–2019	Lance Putnam, Stephen Todd, William Latham, and Duncan Williams	Art	Latham et al. (2017,2019)s
)99	Slinky(bot)	2017	Theodore Spyropoulos, Joumana Abdelkhalek, Aya Riad, Hanbing Zhao, Qin Xia	Architecture	Spyropoulos (2021)
100	Swarm-PI	2017	Frank Mauceri, Stephen M. Majercik	Art	Mauceri & Majerci (2017)
101	Zoological	2017	Random International	Art	Random International (2021)
102	Aegis and Amatria	2018	Philip Beesley	Architecture	Beesley (2021)
103	Emergent harmony	2018	Marguerite Tricaud	Art	Tricaud (2021)

(continued)

Table 7.1 (continued)

#	Title	Year	Author(s)	Category	References
104	Fiberbots	2018	Markus Kayser, Levi Cai, Christoph Bader, Sara Falcone, Nassia Inglessis, Barrak Darweesh, João Costa, and Neri Oxman	Architecture	Kayser et al. (2018)
105	Flock to music	2018	Linda Bouchard	Art	Bouchard (2020)
106	insta.ants	2018	Penousal Machado and Tiago Martins	Art	Machado and Martins (2018)
107	Omnia per omnia	2018	Sougwen Chung	Art	Chung (2018a)
108	Revive	2018	Kıvanç Tatar, Philippe Pasquier, Remy Siu	Art	Tatar et al. (2018)
109	Sound insects	2018	Marguerite Tricaud	Art	Tricaud (2021)
110	Visualisation model	2018	Catarina Maçãs, Nuno Lourenço, and Penousal Machado	Art	Machado et al. (2018)
111	2047 Apologue 3	2019	Verity Studios	Art	Verity Studios (2021)
112	Exquisite corpus	2019	Sougwen Chung	Art	Chung (2019)
113	Our future selves	2019	Random International	Art	Random International (2021)
114	Swarm arena	2019	Ars Electronica Futurelab and NTT	Art	Ars Electronica Futurelab (2021)
115	Boidance	2020	Clément Caporal, Cecília De Lima and Rui Filipe Antunes	Art	Caporal et al. (2020)
116	Planar	2020	Tiago Martins, Pedro Martins and Mariana Seiça	Art	Martins et al. (2020)
117	Silk pavilion II	2020	João Costa; Christoph Bader; Sunanda Sharma; Felix Kraemer; Susan Williams; Jean Disset; Neri Oxman. Undergraduate researcher: Sara Wilson	Architecture	Oxman (2021)
118	Swarm landscapes	2020	Diogo de Andrade, Nuno Fachada, Carlos Fernandes and Agostinho Rosa	Art	Fernandes et al. (2020)
119	Liminal tones: A / autumn swarm	2021	Mahsoo Salimi and Philippe Pasquier	Art	Salimi & Pasquier (2021)
120	Liminal tones: B /Rain Dream	2021	Mahsoo Salimi and Philippe Pasquier	Art	Salimi & Pasquier (2021a)

Table 7.2 Taxonomy of the swarm systems

#	Title	Output	Format	Feature(s)	Model	Algorithm(s)	Agent Architecture	Dynamic Architecture	Audience
1	Ant brush	Visual/digital drawings	Drawing tool	Self-organization	Seed foraging	ACO	Reactive	Static	Passive
2	Soma: self-organising map ants	Moving images	Drawing Tool	Self-organization	Stigmergy/ Pheromones	ACO	Reactive	Static	Passive
3	SWARMUSIC	Music composition	Performance	Emergence	Flocking	PSO	Deliberative	Dynamic-Interactive	Active
4	MicroImage	Visual/digital drawings	Drawing tool	Emergence	Flocking	Boids	Reactive	Dynamic-Passive	Passive
5	Swarm	Moving images	Drawing tool	Emergence	Flocking	Boids	Reactive	Dynamic-Interactive	Active
6	Ant painting	Visual/digital Drawings	Drawing tool	Self-organization	Seed foraging	ACO & GA	Deliberative	Static	Passive
7	Ant painting	Visual/image rendering	Drawing tool	Self-organization	Stigmergy/pheromones	ACO	Deliberative	Dynamic-Interactive	Active
8	SwarmArt	Moving images	Drawing tool	Self-organization	Flocking	Boids	Layered/ Hybrid	Dynamic-Interactive	Active
9	ArtsBot: art swarm of robots	Drawings and paintings	Installation	Emergence	Stigmergy/ Primitive Pheromones	ACO	Reactive	Dynamic-Passive	Passive
10	Swarm granulator	Music composition	Performance	Emergence	Flocking	PSO	Deliberative	Dynamic-Interactive	Active
11	Process	Visual/digital drawings	Drawing tool	Emergence	Flocking	Boids	Reactive	Dynamic-Passive	Passive

(continued)

Table 7.2 (continued)

#	Title	Output	Format	Feature(s)	Model	Algorithm(s)	Agent Architecture	Dynamic Architecture	Audience
12	Ant painting	Visual/digital drawings	Drawing tool	Self-organization	Stigmergy/primitive pheromone, seed foraging	ACO & EA	Reactive	Static	Passive
13	Swarm tech-tiles	Audio/music composition	Performance	Self-organization	ALife, stigmergy	PSO	Deliberative	Dynamic-Interactive	Active
14	Gaugant paintings	Visual	Drawing tool	Emergence	Stigmergy/ sand grain foraging	ACO & EA	Deliberative	Dynamic-Interactive	Active
15	S-robot paintings	Simulations	Drawing tool	Self-organization	ALife, stigmergy	PSO & GA	Layered/Hybrid	Dynamic-Interactive	Active
16	RAP: robotic action painter	Drawings and paintings	Installation	Emergence	Stigmergy/primitive pheromones	ACO	Reactive	Dynamic-Passive	Passive
17	Swarmpieces I-III	Music composition	Performance	Emergence	Flocking	PSO	Deliberative	Dynamic-Interactive	Active
18	Swarm exquisite-corpses	Visual	Drawing tool	Emergence	Stigmergy/ Sand Grain Foraging	ACO	Reactive	Dynamic-Passive	Passive
19	Swarm grammar	Visual/digital drawings	Performance	Emergence	Swarm Grammar	PSO & GA	Layered/Hybrid	Static	Passive
20	swarmPAINTER	Visual/digital drawings	Drawing tool	Self-organization	Flocking	Boids & GA	Reactive	Dynamic-Interactive	Active
21	unnamed system	Audio/music composition	Performance	Emergence	Flocking	PSO & GA	Deliberative	Dynamic-Interactive	Active
22	AtomSwarm	Audio/music composition	Performance	Emergence	Stigmergy	ACO	Deliberative	Static	Passive

(continued)

Table 7.2 (continued)

#	Title	Output	Format	Feature(s)	Model	Algorithm(s)	Agent Architecture	Dynamic Architecture	Audience
23	Dancing with swarms	Simulations	Drawing Tool	Emergence	Stigmergy	Boids & GA	Layered/Hybrid	Dynamic-Interactive	Active
24	Fibrous tower	Modeling (form findings)	Pavilion	Emergence	Stigmergy	ACO	Reactive	Dynamic-Passive	Passive
25	Robotica: control inside the panopticon	Drawings and paintings	Visual installation	Emergence	Stigmergy/pheromones	ACO	Reactive	Dynamic-Passive	Passive
26	Swarms	Visual	Performance	Emergence	ISO flock	PSO & GA	Cognitive	Dynamic-Interactive	Active
27	You pretty little flocker	Visual/digital drawings	Drawing tool	Self-organization	Flocking	Boids	Reactive	Static	Passive
28	2047	Visual	Performance	Self-organization	ISO Flock	PSO & GA	Cognitive	Dynamic-Interactive	Active
29	Cycles	Visual	Installation	Self-organization	ISO Flock	PSO & GA	Deliberative	Dynamic-Interactive	Active
30	Sound agents	Music composition	Soundscape	Emergence	Foraging	ACO	Deliberative	Dynamic-Passive	Passive
31	Swarm urbanism	Visual	Visual maps	Emergence	Stigmergy	ACO	Reactive	Dynamic-Passive	Passive
32	Hylozoic ground	Other	Liminal responsive architecture	Emergence	Swarm-like	IAC	Layered/Hybrid	Dynamic-Interactive	Active
33	Swarm light I-XIII	Audio-visual	Light installation	Emergence	Stigmergy/complex environments	ACO & PSO	Deliberative	Dynamic-Interactive	Active
34	Dancing with swarming particles	Audio-visual	Installation	Self-organization	Flocking	PSO	Deliberative	Dynamic-Interactive	Active

(continued)

Table 7.2 (continued)

#	Title	Output	Format	Feature(s)	Model	Algorithm(s)	Agent Architecture	Dynamic Architecture	Audience
35	EMVIZ	Sonic ecosystem	Dance	Emergence	Swarm-like	None	Deliberative	Dynamic-Interactive	Active
36	Flowspace	Audio-visual	Installation	Self-organization	ISO Flock & ISO Synth	PSO & GA	Cognitive	Dynamic-Interactive	Active
37	Hylozoic series: stoa, sibyl, vesica	Other/Haptic	Liminal responsive architecture	Emergence	Swarm-like	IAC	Layered/Hybrid	Dynamic-Interactive	Active
38	Mechthild	Moving images	Visual installation	Self-organization	ISO flock	PSO & GA	Cognitive	Dynamic-Interactive	Active
39	Sand paintings	Visual/digital drawings	Drawing tool	Self-organization	Sand grain Foraging	ACO	Reactive	Static	Passive
40	Transport network overlay	Visual/digital drawings	Drawing tool	Self-organization	Seed foraging	ACO	Reactive	Static	Passive
41	Aesthetic agents	Visual/image rendering	Drawing tool	Self-organization	Stigmergy/pheromones	ACO	Reactive	Static	Passive
42	Light strings	Audio-visual	Light installation	Emergence	Flocking	PSO	Reactive	Dynamic-Interactive	Active
43	Liquidkristal	Moving images	Pavilion	Emergence	Flocking	PSO	Reactive	Dynamic-Passive	Passive
44	Patterned by nature	Visual	Kinetic sculpture	Self-organization	Swarm-like	None	Reactive	Static	Passive
45	Photogrowth	Visual/image rendering	Drawing tool	Self-organization	Stigmergy/pheromones	ACO	Reactive	Static	Passive
46	Pherographia	Visual/image rendering	Drawing tool	Self-organization	Stigmergy/complex environments	KANTS	Reactive	Static	Passive

(continued)

Table 7.2 (continued)

#	Title	Output	Format	Feature(s)	Model	Algorithm(s)	Agent Architecture	Dynamic Architecture	Audience
47	Shin'm 2.0	Audio-visual	Dance	Emergence	Flocking	None	Reactive	Dynamic-Interactive	Active
48	STOCOS	Audio-visual	Performance	Emergence	ISO flock & ISO synth	PSO & GA	Cognitive	Dynamic-Interactive	Active
49	The robot quartet	Drawings and paintings	Installation	Self-organization	Stigmergy/pheromones	ACO	Reactive	Dynamic-Passive	Passive
50	The sry	Visual	Visual installation	Self-organization	Flocking	PSO & GA	Deliberative	Dynamic-Interactive	Active
51	Woher diese Zärtlichkeit	Moving images	Performance	Self-organization	ISO Flock	PSO & GA	Cognitive	Dynamic-Interactive	Active
52	Stigmmetry prints	Visual/digital drawings	Drawing Tool	Self-organization	Seed foraging, sand grain foraging	ACO	Reactive	Static	Passive
53	Composite swarm	Structure	Pavilion	Self-organization	Stigmergy	PSO	Reactive	Dynamic-Passive	Passive
54	Composite skeleton	Structure	Pavilion	Self-organization	Stigmergy	PSO	Reactive	Dynamic-Passive	Passive
55	Coral	Visual	Installation	Emergence	ISO Flock	PSO & GA	Cognitive	Dynamic-Interactive	Active
56	FLUIDIC: sculpture in motion	Visual	Kinetic sculpture	Self-organization	Flocking	PSO	Reactive	Dynamic-Passive	Passive
57	Garden of virtual delights	Audio-visual	Pavilion	Self-organization	Stigmergy/complex environments	PSO	Deliberative	Dynamic-Interactive	Active
58	Musical flocks	Visual	Visual maps	Self-organization	Flocking	PSO	Deliberative	Dynamic-Passive	Passive

(continued)

Table 7.2 (continued)

#	Title	Output	Format	Feature(s)	Model	Algorithm(s)	Agent Architecture	Dynamic Architecture	Audience
59	Nike flyknit	Moving images	Visual installation	Self-organization	Flocking	PSO	Reactive	Dynamic-Interactive	Active
60	Swarm wall	Audio-visual	Multisensory installation	Self-organization	Flocking	PSO	Deliberative	Dynamic-Interactive	Active
61	Swarmic sketches	Visual/Digital Drawings	Drawing tool	Self-organization	Flocking	PSO & SDS	Reactive	Static	Passive
62	Trails II	Audio-visual	Performance	Self-organization	ISO Flock & ISO Synth	PSO & GA	Cognitive	Static	Active
63	Aerial robotic swarm construction	Robotic constructions	Pavilion	Self-organization	Flocking	PSO	Deliberative	Dynamic-Passive	Passive
64	A(g)ntense	Modeling (Form Findings)	Pavilion	Self-organization	Stigmergy/pheromones	ACO	Reactive	Dynamic-Passive	Passive
65	AntiBot	Structure	Adaptive ecologies	Self-organization	Flocking	PSO	Reactive	Dynamic-Passive	Passive
66	Collapse collide	Structure	Adaptive Ecologies	Self-organization	Flocking	None	Reactive	Dynamic-Passive	Passive
67	Dancer	Visual/image rendering	Drawing tool	Self-organization	Stigmergy/pheromones	ACO	Reactive	Static	Passive
68	endo/exo	Audio	Multisensory installation	Self-organization	Flocking	PSO	Deliberative	Dynamic-Interactive	Active
69	Silk pavilion	Structure	Pavilion	Self-organization	Stigmergy	None	Reactive	Dynamic-Passive	Active

(continued)

Table 7.2 (continued)

#	Title	Output	Format	Feature(s)	Model	Algorithm(s)	Agent Architecture	Dynamic Architecture	Audience
70	Signature strokes	Drawings and paintings	Performance	Self-organization	Stigmergy/pheromones	ACO	Reactive	Dynamic-Passive	Passive
71	Drone 100	Visual	Choreography	Emergence	Flocking	PSO	Reactive	Dynamic-Passive	Active
72	Emotive city	Structure	Adaptive ecologies	Self-organization	Flocking	None	Reactive	Dynamic-Passive	Passive
73	Fireflies visualization	Visual	Visual Maps	Self-organization	Flocking	PSO	Reactive	Dynamic-Passive	Passive
74	HyperCell	Structure	Adaptive ecologies	Emergence	Flocking	None	Reactive	Dynamic-Passive	Passive
75	In the eyes of the animal	VR	Installation	Emergence	Flocking	PSO	Layered/Hybrid	Dynamic-Interactive	Active
76	KvantSwarm	Software	Visualization tool	Self-organization	Flocking	PSO	Layered/Hybrid	Dynamic-Interactive	Active
77	Nomad	Structure	Adaptive ecologies	Self-organization	Flocking	None	Reactive	Dynamic-Passive	Passive
78	OWO	Structure	Adaptive ecologies	Self-organization	Flocking	None	Reactive	Dynamic-Passive	Passive
79	Pherogenic paintings	Visual/image rendering	Drawing tool	Self-organization	Stigmergy/complex environments	KANTS	Reactive	Static	Passive
80	Portrait on the fly	VR	Installation	Self-organization	Flocking	PSO	Deliberative	Dynamic-Interactive	Active
81	ROTO	Structure	Adaptive ecologies	Self-organization	Flocking	None	Reactive	Dynamic-Passive	Passive

(continued)

Table 7.2 (continued)

#	Title	Output	Format	Feature(s)	Model	Algorithm(s)	Agent Architecture	Dynamic Architecture	Audience
82	Space oddity	Structure	Adaptive ecologies	Emergence	Flocking	None	Reactive	Dynamic-Passive	Passive
83	SWARM	Visual	Light installation	Self-organization	Flocking	PSO	Deliberative	Dynamic-Passive	Passive
84	Drawing operations	Drawings and paintings	Installation	Self-organization	Swarm-like	None	Deliberative	Dynamic-Interactive	Active
85	24 Drones	Visual	Dance	Emergence	Flocking	PSO	Reactive	Dynamic-Interactive	Active
86	Delta	Structure	Adaptive ecologies	Self-organization	Flocking	None	Reactive	Dynamic-Passive	Passive
87	Diffusion choir	Other	Kinetic sculpture	Self-organization	Swarm-like	None	Reactive	Dynamic-Passive	Passive
88	LATLONG	Visual	Visual maps	Self-organization	Flocking	PSO	Layered/Hybrid	Dynamic-Passive	Passive
89	Lightswarm	Visual	Swarm tectonic	Self-organization	Flocking	PSO	Deliberative	Dynamic-Interactive	Active
90	Liquid shard	Visual/Haptic	Kinetic sculpture	Self-organization	Swarm-like	None	Reactive	Dynamic-Passive	Passive
91	Swarm study IX	Moving images	Swarm tectonic	Self-organization	Flocking	PSO	Deliberative	Dynamic-Interactive	Active
92	XO	Structure	Adaptive ecologies	Self-organization	Flocking	None	Reactive	Dynamic-Passive	Passive
93	Protocell	Structure	Adaptive ecologies	Self-organization	Flocking	None	Reactive	Dynamic-Passive	Passive

(continued)

Table 7.2 (continued)

#	Title	Output	Format	Feature(s)	Model	Algorithm(s)	Agent Architecture	Dynamic Architecture	Audience
94	Synergia	Structure	Adaptive ecologies	Self-organization	Flocking	None	Reactive	Dynamic-Passive	Passive
95	2047 Apologue	Visual	Choreography	Emergence	Flocking	PSO	Deliberative	Dynamic-Interactive	Active
96	BeBot	Drawings and paintings	Installation	Emergence	Stigmergy/primitive pheromones	ACO	Reactive	Dynamic-Passive	Passive
97	Paint by drone	Drawings and paintings	Performance	Emergence	Flocking	None	Reactive	Dynamic-Interactive	Active
98	Mutator VR: Vortex	VR	Installation	Self-organization	Flocking	None	Layered/Hybrid	Dynamic-Interactive	Active
99	Slinky(bot)	Structure	Adaptive ecologies	Emergence	Flocking	None	Reactive	Dynamic-Passive	Passive
100	Swarm-PI	Music composition	Performance	Emergence	Flocking	PSO	Reactive	Dynamic-Interactive	Active
101	Zoological	Audio-visual	Dance	Emergence	Flocking	PSO	Reactive	Dynamic-Interactive	Active
102	Aegis and amatria	Audio-visual	Liminal responsive architecture	Emergence	Swarm-like	IAC	Layered/Hybrid	Dynamic-Interactive	Active
103	Emergent harmony	Audio	Soundscape	Emergence	Flocking	PSO	Reactive	Dynamic-Interactive	Passive
104	Fiberbots	Structure	Pavilion	Self-organization	Flocking	None	Reactive	Dynamic-Passive	Passive
105	Flock to music	Music composition	Performance	Emergence	Flocking	Boids	Reactive	Dynamic-Interactive	Active

(continued)

Table 7.2 (continued)

#	Title	Output	Format	Feature(s)	Model	Algorithm(s)	Agent Architecture	Dynamic Architecture	Audience
106	insta.ants	Visual/image rendering	Drawing tool	Self-organization	Stigmergy/complex environments	KANTS	Deliberative	Dynamic-Interactive	Passive
107	Omnia per Omnia	Visual	Performance	Self-organization	Swarm-like	None	Deliberative	Dynamic-Interactive	Active
108	Revive	Audio-visual	Performance	Emergence	Flocking	PSO	Reactive	Dynamic-Interactive	Active
109	Sound insects	Audio	Soundscape	Emergence	Flocking	PSO	Reactive	Dynamic-Interactive	Passive
110	Visualisation model	Visual	Visual maps	Self-organization	Flocking	Boids	Reactive	Dynamic-Passive	Active
111	2047 Apologue 3	Visual	Choreography	Emergence	Flocking	PSO	Deliberative	Dynamic-Interactive	Active
112	Exquisite corpus	Visual	Performance	Self-organization	Swarm-like	None	Deliberative	Dynamic-Interactive	Active
113	Our future selves	Audio-visual	Light installation	Emergence	Flocking	PSO	Deliberative	Dynamic-Interactive	Active
114	Swarm arena	Audio-visual	Multisensory installation	Self-organization	Flocking	PSO	Reactive	Dynamic-Interactive	Active
115	Boidance	Software	Visualization tool	Self-organization	Flocking	Boids & GA	Layered/Hybrid	Dynamic-Interactive	Active
116	Planar	Visual	Visual maps	Self-organization	Flocking	PSO	Reactive	Dynamic-Passive	Passive
117	Silk pavilion II	Structure	Pavilion	Self-organization	Stigmergy	None	Reactive	Dynamic-Passive	Active
118	Swarm landscapes	Simulations	Visual maps	Emergence	Flocking	PSO	Deliberative	Dynamic-Interactive	Active
119	Liminal tones (A / Autumn Swarm)	Music composition	Performance	Self-organization	Flocking	PSO	Deliberative	Dynamic-Interactive	Active

(continued)

Table 7.2 (continued)

#	Title	Output	Format	Feature(s)	Model	Algorithm(s)	Agent Architecture	Dynamic Architecture	Audience
120	Liminal tones (B / Rain Dream)	Music composition	Performance	Emergence	Stigmergy/complex environments	AS	Deliberative	Dynamic-Passive	Active

References

Al-Rifaie, M. M., & Bishop, J. M. (2013, April). Swarmic paintings and colour attention. In *International conference on evolutionary and biologically inspired music and art* (pp. 97–108). Springer. https://doi.org/10.1007/978-3-642-36955-1_9

Andrade, D. D., Fachada, N., Fernandes, C. M., & Rosa, A. C. (2020). Generative art with swarm land-scapes.

Ars Electronica Futurelab (2021). https://ars.electronica.art/futurelab/en/

Aupetit, S., Bordeau, V., Monmarché, N., Slimane, M., & Venturini, G. (2003, December). Interactive evolution of ant paintings. In *The 2003 congress on evolutionary computation, CEC'03.* (Vol. 2, pp. 1376-1383). IEEE.

Barrass, T. (2001). Visualising the emergence of shared behavioural pathways in a crowd. Artist's presentation. In A. Dorin (Ed.), Proceedings of Second Iteration (pp. 22–23). CEMA.

Beesley, P. (2021) *Living architecture systems group.* http://www.philipbeesleystudioinc.com

Beyls, P. (2007). Interaction and self-organisation in a society of musical agents. In Proceedings of ECAL 2007 Workshop on Music and Artificial Life (MusicAL 2007).

Bisig, D., & Kocher, P. (2013). Trails II. In Proceedings of the Consciousness Reframed Conference. Cairo, Egypt.

Bisig, D., & Palacio, P. (2012). STOCOS-Dance in a synergistic environment. In Proceedings of the Generative Art Conference (Lucca, 2012)

Bisig, D., & Unemi, T. (2009). Swarms on stage-swarm simulations for dance performance. In The Proceedings of the Generative Art Conference.

Bisig, D., & Unemi, T. (2010). Cycles-blending natural and artificial properties in a generative artwork. In Proceedings of the 13th Generative Art Conference (pp. 140–154).

Bisig, D., Schacher, J. C., & Neukom, M. (2011). Flowspace-a hybrid ecosystem. In *NIME* (pp. 260–263).

Blackwell, T. (2003). Swarm music: Improvised music with multi-swarms. *Artificial Intelligence and the Simulation of Behaviour, University of Wales, 10,* 142–158.

Blackwell, T. (2007). Swarming and music. In *Evolutionary computer music* (pp. 194–217). Springer.

Blackwell, T. (2008). Swarm granulation. In *The art of artificial evolution* (pp. 103–122). Springer. https://doi.org/10.1007/978-3-540-72877-1_5

Blackwell, T., & Jefferies, J. (2005, March). Swarm tech-tiles tim. In *Workshops on applications of evolutionary computation* (pp. 468–477). Springer. https://doi.org/10.1007/978-3-540-32003-6_47

Blackwell, T., & Jefferies, J. (2005a). A sound you can touch. In Proceedings of Generative Arts Practice (pp. 125–133).

Blackwell, T., & Young, M. (2004, April). Swarm granulator. In *Workshops on applications of evolutionary computation* (pp. 399–408). Springer. https://doi.org/10.1007/978-3-540-24653-4_41

Bouchard, L. (2020, Jan). Flock to Music. https://www.livestructures.com/flock-to-music

Caporal, C. (2020). In *Software expanding dance using virtual reality, boids and genetic algorithms.*

Carvalho, R. (2010). *Dance with the swarming particles.* https://www.academia.edu/5566193/Dance_with_the_Swarming_Particles_Project_Report

Chung, S. Omnia per Omnia. (2018a, May). https://sougwen.com/project/omniaperomnia

Chung, S. (2018, May). Drawing Operations. https://sougwen.com/project/drawing-operations

Chung, S. (2019, Nov). Exquisite corpus. https://sougwen.com/project/exquisite-corpus

Codognet, P., & Pasquet, O. (2009, December). Swarm intelligence for generative music. In *2009 11th IEEE International Symposium on Multimedia* (pp. 1–8). IEEE. https://doi.org/10.1109/ISM.2009.38

Correll, N., Farrow, N., & Ma, S. (2013, February). Honeycomb: A platform for computational robotic materials. In Proceedings of the 7th International Conference on Tangible, Embedded and Embodied Interaction (pp. 419–422). ACM. https://doi.org/10.1145/2460625.2460718

Eldridge, A. (2015). You pretty little flocker: Exploring the aesthetic state space of creative ecosystems. *Artificial Life, 21*(3), 289–292. https://doi.org/10.1162/ARTL_a_00169

Elevenplay (2021). https://elevenplay.net/projects

Universal Everything (2021). Nike Flyknit. https://www.universaleverything.com

Futureforms (2021). Lightswarm. https://www.futureforms.us

Greenfield, G. (2005, March). Evolutionary methods for ant colony paintings. In *Workshops on applications of evolutionary computation* (pp. 478–487). Springer. https://doi.org/10.1007/978-3-540-32003-6_48

Greenfield, G. (2006, April). Robot paintings evolved using simulated robots. In *Workshops on applications of evolutionary computation* (pp. 611–621). Springer.

Greenfield, G. (2011). Abstract overlays using a transport network model. In Proceedings of Bridges 2011: Mathematics, music, art, architecture, culture (pp. 45–50). Tessellations Publishing.

Greenfield, G. (2012). Stigmetry prints from patterns of circles. In Proceedings of Bridges 2012: Mathematics, Music, Art, Architecture, Culture (pp. 291–298). Tessellations Publishing.

Greenfield, G., & Machado, P. (2014). Swarm art. *Leonardo, 47*(1), 5–7.

Greenfield, G., & Machado, P. (2015). Ant-and ant-colony-inspired alife visual art. *Artificial Life, 21*(3), 293–306. https://doi.org/10.1162/ARTL_a_00170

Harriman, J., Theodore, M., Correll, N., & Ewen, H. (2014). Endo/exo making art and music with distributed computing. In *NIME* (pp. 383–386).

Hypersonic (2021). https://www.hypersonic.cc

Jacob, C., & Hushlak, G. (2008). Evolutionary and swarm design in science, art, and music. In *The art of artificial evolution* (pp. 145-166). Springer. https://doi.org/10.1162/leon.2007.40.3.248

Jacob, C. J., Hushlak, G., Boyd, J. E., Nuytten, P., Sayles, M., & Pilat, M. (2007). Swarmart: Interactive art from swarm intelligence. *Leonardo, 40*(3), 248–254. https://doi.org/10.1162/leon.2007.40.3.248

Jones, D. (2008, March). AtomSwarm: A framework for swarm improvisation. In *Workshops on applications of evolutionary computation* (pp. 423–432). Springer. https://doi.org/10.1007/978-3-540-78761-7_45

Kamolov, R., Machado, P., & Cruz, P. (2013, July). Musical flocks. In *ACM SIGGRAPH 2013 Posters* (pp. 93). ACM. https://doi.org/10.1145/2503385.2503487

Kang, E. Donald, C., & Garcia-Snyder, D. (2012, November). Shin'm 2.0. In *SIGGRAPH Asia 2012 art gallery* (pp. 17). ACM.

Kayser, M., Cai, L., Falcone, S., Bader, C., Inglessis, N., Darweesh, B., & Oxman, N. (2018). FIBERBOTS: An autonomous swarm-based robotic system for digital fabrication of fiber-based composites. *Construction Robotics, 2*(1–4), 67–79. https://doi.org/10.1007/s41693-018-0013-y

Poetic Kinetics (2021). Liquid shard. https://www.poetickinetics.com

Kokkugia (2021). https://www.kokkugia.com

Leach, N., & Snooks, R. (2011). Swarm intelligence: Architectures of multi-agent systems.

Love, J., Pasquier, P., Wyvill, B., Gibson, S., & Tzanetakis, G. (2011, August). Aesthetic agents: Swarm-based non-photorealistic rendering using multiple images. In Proceedings of the International Symposium on Computational Aesthetics in Graphics, Visualization, and Imaging (pp. 47–54). ACM. https://doi.org/10.1145/2030441.2030452

Lovegrove, R. (2021). Liquidkristal. http://www.rosslovegrove.com/custom_type/lasvit-liquidkristal

Machado, P., & Martins, T. (2018). insta.ants. https://cdv.dei.uc.pt/insta-ants/

Machado, P., & Pereira, L. (2012, July). Photogrowth: Non-photorealistic renderings through ant paintings. In Proceedings of the 14th Annual Conference on Genetic and Evolutionary Computation (pp. 233–240). ACM. https://doi.org/10.1145/2330163.2330197

Machado, P., Martins, T., Amaro, H., & Abreu, P. H. (2014, April). An interface for fitness function design. In *International Conference on Evolutionary and Biologically Inspired Music and Art* (pp. 13–25). Springer. https://doi.org/10.1007/978-3-662-44335-4_2

Marshmallow Laser Feast (2021). *In the eyes of the animal.* http://intheeyesoftheanimal.com

Martins, T., Machado, P., & Rebelo, A. (2013, July). The garden of virtual delights: Virtual fauna for a botanical garden. In *ACM SIGGRAPH 2013 posters* (p. 26). ACM. https://doi.org/10.1145/2503385.2503413

Martins, T., Martins, P., & Seiça, M. Planar. (2020, July). https://cdv.dei.uc.pt/planar

Mauceri, F., & Majercik, S. M. (2017, April). A swarm environment for experimental performance and improvisation. In International conference on evolutionary and biologically inspired music and art (pp. 190–200). Springer, Cham. https://doi.org/10.1007/978-3-319-55750-2_13

Milk, C. (2012). The treachery of sanctuary. *Installation, the creators project*. Accessed May, 1, 2013.

Miranda, E. R., & Al Biles, J. (2007). The accompanying music CD. *Evolutionary Computer Music, 250*.

Moura, L. (2018, September). Robot art: An interview with Leonel Moura. In *Arts* (Vol. 7, No. 3, pp. 28). Multidisciplinary Digital Publishing Institute. https://doi.org/10.3390/arts7030028 https://doi.org/10.3390/arts7030028

Moura, L., & Pereira, H. G. (2004). Man+ robots: Symbiotic art. Institut d'art contemporain.

Oxman, N. (2021). Mediated matter group. https://mediatedmattergroup.com

Putnam, L., Latham, W., & Todd, S. (2017). Flow fields and agents for immersive interaction in Mutator VR: Vortex. *Presence: Teleoperators and Virtual Environments, 26*(2), 138–156.

Putnam, L., Todd, S., Latham, W., & Williams, D. (2019, May). Mutator VR: Vortex artwork and science pedagogy adaptations. In Proceedings of the 8th ACM/EG Expressive Symposium-Posters, Demos, and Artworks (pp. 5–6). The Eurographics Association.

Random International (2021), https://www.random-international.com

Ratti, C. (2017). Il progetto paint by drone. Available via CARLORATTI. http://www.carloratti.com/wp-content/uploads/2017/10/2017_10_01_AdV_-_Strategie_di_Comunicazione_pag.14.pdf

Reas, C. (2004). MicroImage. In *ACM SIGGRAPH 2004 art gallery* (pp. 74).

Reas, C. (2015). PROCESS COMPENDIUM 2004–2010. Paradigms in computing: Making, machines, and models for design agency in architecture, *44*.

Rodrigues, A., Machado, P., Martins, P., & Cardoso, A. (2015, September). Sound visualization through a swarm of fireflies. In portuguese conference on artificial intelligence (pp. 664–670). Springer, Cham. https://doi.org/10.1007/978-3-319-23485-4_67

Salimi, M., & Pasquier, P. (2021). Exploiting swarm aesthetics in sound art. In Proceedings of the Art Machines 2: Internationals 2021, Art Machines 2.

Salimi, M., Pasquier, & P. (2021a). Liminal tones: Swarm aesthetics and materiality in sound art. In Proceedings of the International Conference on Swarm Intelligence (ICSI'21).

Semet, Y., O'Reilly, U. M., & Durand, F. (2014). Non-photorealistic rendering with interactive, agent-based computation. *Leonardo, 47*(1), 14–14.

Seo, J., & Corness, G. (2012). Light strings: Kinesthetic immersive environment. In *SIGGRAPH ASIA Art Gallery* (pp. 15–1).

Shiffman, D. (2004) In Swarm, ACM SIGGRAPH 2004 Emerging Technologies Proceedings(pp. 26), ACM Press. https://doi.org/10.1145/1186155.1186182

Snooks, R., De Marco, R. S. S. J., & Carl, T. (2009). FIBROUS TOWER. Urban environment design.

Sommerer, C., & Mignonneau, L. (2016). A personal media art archive based on the symbol of the fly. *Archiving and Questioning Immateriality, 5*, 87.

Spyropoulos, T. (2016). Behavioural complexity: Constructing frameworks for human-machine ecologies. *Architectural Design, 86*(2), 36–43. https://doi.org/10.1002/ad.2022

Spyropoulos, T. (2021). Spyropoulos studio. https://drl.aaschool.ac.uk/spyropoulos-studio

Stanza. Robotica: Control inside the panopticon. (2009, June). https://www.stanza.co.uk/panopt/

Stuart-Smith, R. (2016). Behavioural production: Autonomous swarm-constructed architecture. *Architectural Design, 86*(2), 54–59. https://doi.org/10.1002/ad.2024

Schnellebuntebilder Studio (2021). LATLONG. https://schnellebuntebilder.de/projects/latlong/

Subyen, P., Maranan, D., Schiphorst, T., Pasquier, P., & Bartram, L. (2011, August). EMVIZ: The poetics of movement quality visualization. In Proceedings of the International Symposium on

Computational Aesthetics in Graphics, Visualization, and Imaging (pp. 121–128). ACM. https://doi.org/10.1145/2030441.2030467

Sugihara, S. (2014). A(g)ntense: Installation of swarm formation and agent based self-optimization of tensile and compression structure.

Takahashi, K. (2021). KvantSwarm. https://github.com/keijiro/KvantSwarm

Tatar, K., Pasquier, P., & Siu, R. (2018, April). REVIVE: An audio-visual performance with musical and visual AI agents. In *Extended abstracts of the 2018 CHI conference on human factors in computing systems* (pp. Art13). ACM. https://doi.org/10.1145/3170427.3177771

Tricaud, M. (2021). https://www.margueritetricaud.com/work

Tzafestas, E. S. (2000, November). Integrating drawing tools with behavioral modeling in digital painting. In Proceedings of the 2000 ACM Workshops on Multimedia (pp. 39–42). ACM. https://doi.org/10.1145/357744.357756

Urbano, P. (2006, April). Consensual paintings. In *Workshops on applications of evolutionary computation* (pp. 622–632). Springer. https://doi.org/10.1007/11732242_59

Urbano, P. (2008). Swarm exquisite-corpses games. In *AAAI spring symposium: Creative intelligent systems* (pp. 110–116).

Urbano, P. (2011, April). The T. albipennis sand painting artists. In *European conference on the applications of evolutionary computation* (pp. 414–423). Springer. https://doi.org/10.1007/978-3-642-20520-0_42

Ventura, P., & Bisig, D. (2016). Algorithmic reflections on choreography. *Human technology, 12*(2).

Verity studios (2021). https://veritystudios.com

von Mammen, S., & Jacob, C. (2007). Swarm grammars: Growing dynamic structures in 3D agent spaces. *Digital Creativity, 18*(1), 54–64. https://doi.org/10.1080/14626260701253622

Wanner, A. (2013). The robot quartet: A drawing installation. Comput. Commun. Aesthet. X xCoAx2013.

Wanner, A. (2015). Signature strokes. http://pixelstorm.ch/?lang=en

WHITEvoid (2021). FLUIDIC—Sculpture in motion. https://www.whitevoid.com

Uncited References

Brambilla, M., Dorigo, M., & Birattari, M. (2014). Formal methods for the design and analysis of robot swarms (Doctoral dissertation, Ph. D. thesis, Universite Libre de Bruxelles).

Dorigo, M., & Di Caro, G. (1999). Ant colony optimization: a new meta-heuristic. In Proceedings of the 1999 congress on evolutionary computation-CEC99 (Cat. No. 99TH8406) (Vol. 2, pp. 1470–1477). IEEE. https://doi.org/10.1109/CEC.1999.782657

Eberhart, R., & Kennedy, J. (1995). A new optimizer using particle swarm theory. In MHS'95. Proceedings of the Sixth International Symposium on Micro Machine and Human Science (pp. 39–43). IEEE. https://doi.org/10.1109/MHS.1995.494215

Fan, S., Salonidis, T., & Lee, B. (2018, July). Swing: Swarm computing for mobile sensing. In 2018 IEEE 38th International Conference on Distributed Computing Sys-tems (ICDCS) (pp. 1107–1117). IEEE.

Fernandes, C. M., Mora, A., Merelo, J. J., Cotta, C., & Rosa, A. C. (2013a, April). Photo rendering with swarms: From figurative to abstract pherogenic imaging. In 2013 IEEE Symposium on Computational Intelligence for Creativity and Affective Computing (CICAC) (pp. 32–39). IEEE. https://doi.org/10.1109/CICAC.2013.6595218

Fernandes, C., Mora, A. M., Merelo, J. J., Ramos, V., & Laredo, J. L. J. (2008). KohonAnts: A self-organizing ant algorithm for clustering and pattern classification. arXiv preprint arXiv:0803.2695

Guéret, C., Monmarché, N., & Slimane, M. (2004, September). Ants can play music. In International Workshop on Ant Colony Optimization and Swarm Intelligence (pp. 310-317). Springer. https://doi.org/10.1007/978-3-540-28646-2_29

Li, X., & Yang, G. (2016). Artificial bee colony algorithm with memory. *Applied Soft Computing, 41*, 362-372.

Li, Z. W., Ren, A. M., Guo, J. F., Yang, T., Goddard, J. D., & Feng, J. K. (2008). Color-tuning mechanism in firefly luminescence: theoretical studies on fluorescence of oxyluciferin in aqueous solution using time dependent density functional theory. *The Journal of Physical Chemistry A, 112*(40), 9796-9800.

McCormack, J. (2009). The evolution of sonic ecosystems. In Komosinski, M., & Adamatzky, A., (Ed.), Artificial Life Models in Software (2nd edn, pp. 393–414). Springer. https://doi.org/10.1007/978-1-84882-285-6_13

Oxman, N., Laucks, J., Kayser, M., Duro-Royo, J., & Gonzales-Uribe, C. (2014, February). Silk pavilion: a case study in fiber-based digital fabrication. In FABRICATE Conference Proceedings (pp. 248-255). ta Verla. https://doi.org/10.2307/j.ctt1tp3c5w.34

Raies, Y., & von Mammen, S. (2021). A swarm grammar-based approach to virtual World generation. In Artificial Intelligence in Music, Sound, Art and Design: 10th International Conference, EvoMUSART 2021, Held as Part of EvoStar 2021, Virtual Event, April 7–9, Proceedings 10 (pp. 459–474). Springer International Publishing.

Tamke, M., Riiber, J., Jungjohann, H., & Thomsen, M. R. (2010). Lamella flock. *Advances in Architectural Geometry*, 37–48 https://doi.org/10.1007/978-3-7091-0309-8_3

Printed in the United States
by Baker & Taylor Publisher Services